ARTS AND CRAFTS BOOK COVERS

MALCOLM HASLAM

RICHARD DENNIS
2012

Produced to accompany the exhibition 'From Rosetti to Voysey: Arts & Crafts Stamped Book Cover Design', at Blackwell, The Arts & Crafts House, 10 May - 15 July 2012

Editing and production by Michelle Wyatt
Colour photography by Magnus Dennis - fig. 19 courtesy of Lakeland Arts Trust
Print and reproduction by Flaydemouse, Yeovil, Somerset
Published by Richard Dennis, The New Chapel, Shepton Beauchamp, Somerset TA19 0JT
©2012 Richard Dennis and Malcolm Haslam
ISBN 978-0-9553741-8-0

CONTENTS

PREFACE

This publication, and the exhibition at Blackwell which it accompanies, represent many years of research by one of the leading authorities on the Arts & Crafts movement into an enlightening subject area hitherto barely explored.

Blackwell, a quintessential Arts & Crafts house designed by MH Baillie Scott in 1898, has since 2001 been a unique arts and heritage venue with a strong track record of exhibitions. Both Arts and Crafts movement design and contemporary craft reflecting the movement's continuing legacy are displayed in Blackwell's period rooms and gallery spaces. It is an apt setting in which to display books, more especially as its first-floor gallery spaces, formerly bedrooms, retain the character of domestic spaces and are peculiarly appropriate for the display of applied arts.

In an age of new technologies the decorated book remains something to be treasured. We all have books, quite possibly even one of the titles looked at in this publication; what we can do now thanks to this meticulous study is to understand the personalities, technologies, market forces and philosophy behind these comparatively humble objects. In so doing, they take on a new significance and become representative in microcosm of the challenges and conflicts being worked through by Arts and Crafts designers during the creatively rich years between 1866 and 1911.

It is particularly pleasing that the main body of this publication, written by Malcolm Haslam, is prefaced by an introduction by Charlotte Gere, bringing together two of the most highly respected names in the field of Arts and Crafts expertise and scholarship.

Dr Kathy Haslam
Curator, Blackwell

AUTHOR'S PREFACE

The three essays - 'Background', 'The Designs', and 'Some Publishers' - treat three important aspects of the subject, and each one can be read independently of the others; they do not form a narrative. The illustrations have been arranged in chronological order, and taken together they show the main trends and developments in the story of Arts and Crafts stamped cloth book cover design.

The foreign book covers have been selected for their more or less direct dependence on British Arts and Crafts design. In "The Artists" section, and in the catalogue, foreign entries follow British, and the countries are shown in alphabetical order.

I am grateful to the trustees of the Lakeland Arts Trust for agreeing to hold the exhibition and for part-sponsoring the publication of this book. I thank most warmly Dr Kathy Haslam, the curator at Blackwell, first for arranging such a splendid and informative display of books which have remained so long in the obscurity of my bookshelves, and second but no less warmly for making many helpful suggestions regarding my text; it has been a joy to work with her. Any errors or omissions are mine alone.

There are too many individuals who have helped me with research leads or bibliographical advice to name them all, but I have to mention with heart-felt gratitude Jerry Cinamon whose work on the designs of Talwin Morris first inspired my interest in book covers. Too late to thank, alas, but not to mention, is John Espey of UCLA, who helped me a number of times with problems about American book covers when, I fear, he was in truth too old and too ill to be bothered by an ignorant limey!

I warmly thank the staff of several libraries for their help. kindness and efficiency, particularly the staff at the National Library of Scotland in Edinburgh, and the National Art Library and the British Library in London.

I am grateful to all at Richard Dennis Publications for helping to oversee the production of such a handsome volume; I thank Richard himself for once again proving to be the most helpful and most polite of publishers, and Michelle Wyatt for her art, her skill and her patience. Thanks as well to Magnus Dennis for his excellent photography and to Jon Blade of Flaydemouse for his skill and efficiency.

Malcolm Haslam

INTRODUCTION

When I married into the Gere family in 1958 I was precipitated into an unaltered Arts and Crafts milieu. Although Charles March Gere, Margaret Gere and Edith Payne (his half-sisters) and Henry Payne (his brother-in-law) were primarily painters, true to the beliefs of the movement they mastered a number of related handicrafts, including book design. Charles had died in the summer of 1957, but Margaret and Edith were still living in Gloucestershire, where artist friends established an Arts and Crafts outpost in the 1900s. Charles and Margaret's pretty village house, Stamages in Painswick, was furnished with massive oak settles, Ernest Gimson's heavy fire-irons, carved coffers, embroidered curtains by another Birmingham colleague Mary Newill, and Morris & Co. patterned cottons. Private press Kelmscott and Ashendene books illustrated by Charles filled the book-shelves, witness to the importance to them and their colleagues of fine books.

They were members of the Birmingham Group, an important offshoot of the London-based Arts and Crafts movement. Charles Gere and his fellow students were in their late teens and early twenties in 1888 when the Arts and Crafts movement burst on the scene with the first showing by the Arts and Crafts Exhibition Society. It was their modern movement and it validated one of the Group's specialisations, the art of the book. Book covers designed by their artistic heroes Rossetti and Philip Webb, William Morris along with Lucy Faulkner (Mrs Orrinsmith) were among the exhibits.

These Birmingham artists identified with late Pre-Raphaelitism. Birmingham-born Burne-Jones was a hero, and his influence pervades the Birmingham style in illustration, print-making, embroidery and stained glass. They were disciples of Morris, whose ideas are, by consensus, at the very root of the Arts and Crafts movement. Products by Morris and his circle were conspicuous in the 1888 exhibition. Morris had an almost mystical reverence for beautiful books; in a lecture, *Some Thoughts on the Ornamented Manuscripts of the Middle Ages* (about 1882), he remarked:

> If I were asked to say what is at once the most important production Art and the thing most longed for, I should answer, A beautiful House; and if I were further asked to name the production next in importance and the thing next to be longed for, I should answer A beautiful Book. To enjoy good houses and good books in self respect and decent comfort, seems to me to be the pleasurable end towards which all societies of human beings ought now to struggle.

Speaking on *The Beauty of Life* in 1880, he said that 'a bookcase with a great many books in it' was the first essential of 'a sitting-room of a healthy person'. In his study at Kelmscott House on the Thames at Hammersmith books were the only decoration.

The Birmingham School of Art under E.R. Taylor, where many of the Birmingham Group studied and eventually taught, put illustration and fine book-production high on the agenda. Distinguished Victorian artists who illustrated books, Rossetti, Millais, Frederic Leighton, Burne-Jones and Walter Crane among them, had raised expectations in the overall 'look' – illustration, typography and design, printing and, importantly, decorative covers – of well-made books. Developments in mechanical book-binding opened up possibilities for decorating ordinary cloth and paper book covers with stamped and embossed designs by increasingly cheaper processes. Now the paradox inherent in the Arts and Crafts book could be resolved, trading expensive craft for inexpensive modern technology. Rossetti and Morris were pioneers in a modern renaissance in book cover design that was quickly taken up by more progressive publishers for their commercially-produced stamped covers. However, beautifully bound and gilt books by Thomas Cobden-Sanderson and others were still admired artistic handicrafts.

In Birmingham Morris particularly noticed the then little-known Arthur Gaskin, Gere and their younger colleague Edmund Hort New. Gere was invited in 1892 to contribute to Morris's Kelmscott Press, with the frontispiece to the Utopian fantasy, *News from Nowhere*. Morris's detailed

and meticulous criticism was a formative experience for him, as his contribution to *The Quest*, an Arts and Crafts periodical for the Birmingham Guild of Handicraft, demonstrates. Gaskin's debt to Morris shows in his 1893 Hans Christian Anderson with its fine cover design. He adapted Morris's essentially backward and handmade view of the 'book beautiful' to the demands of George Allen, his high-volume trade publisher. Gere worked for St John Hornby's private Ashendene Press, balancing these luxury products with a modestly-produced volume of Russian fairy tales. E.H. New's views of Red House in Kent, of Kelmscott Manor and rooms in Kelmscott House adorn J.W. Mackail's finely produced two-volume biography of Morris. He designed a number of book covers, three of which are in the present exhibition.

The Arts and Crafts book was congenial to these artists; as the most democratic of the movement's products, it was within reach of the many people for whom expensive handmade articles were unaffordable. The Temple Topographies of English Counties, for example, issued by J.M. Dent, with gold-blocked cover design, rubricated details and E.H. New's illustrations, cost a mere 1/6 (seven and a half pence) per volume. They have the feel and look of quality. It is probably no coincidence that the recent *Dangerous Book for Boys*, with its Edwardian-style decorated cover, published by a large commercial conglomerate in 2006, was an instant best-seller.

Charlotte Gere, OBE

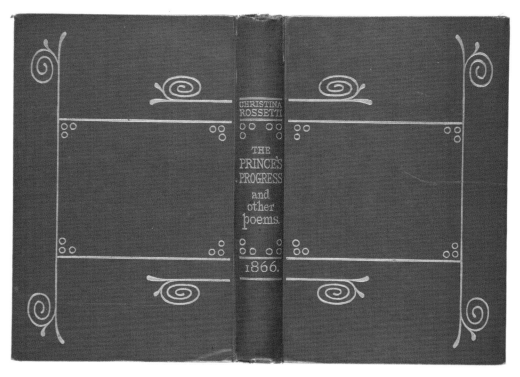

1. Dante Gabriel Rosetti, 1866 (cat. no. 52)

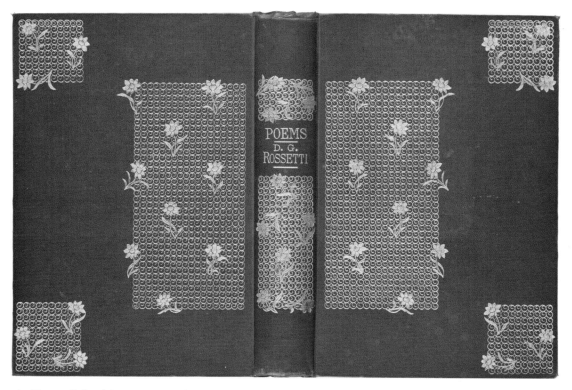

2. Dante Gabriel Rosetti, 1870 (cat. no. 53)

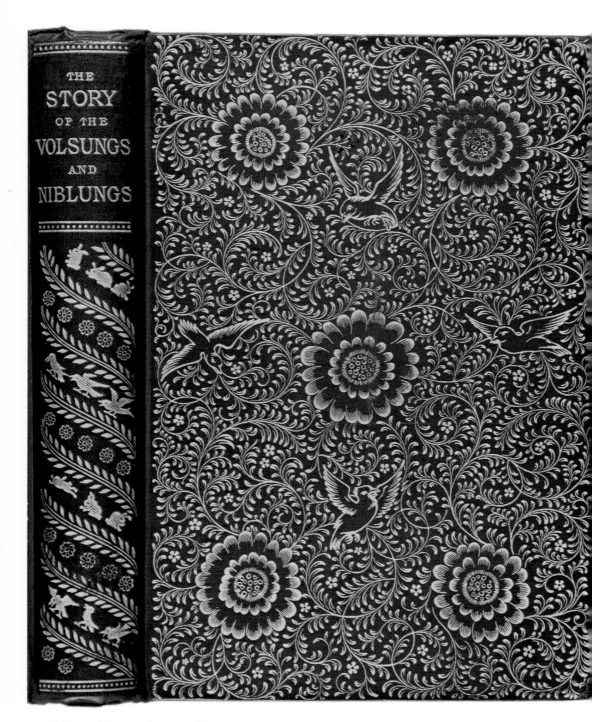

3. Philip Webb, 1870 (cat. no. 65)

THE BACKGROUND

If one had to choose the most significant date in the story of the Arts and Crafts book cover, it might well be 1888. That year three events took place which helped to establish the designing of stamped cloth book covers as an Arts and Crafts activity. In February, covers designed by Dante Gabriel Rossetti (1828-1882), Philip Webb (1831-1915), Lucy (Faulkner) Orrinsmith (1839-1910), and Lewis Foreman Day (1845-1910) were included in a small display of bookbindings that the Society of Arts mounted at its rooms in the Adelphi, London. Then, on 1 October, the Arts and Crafts Exhibition Society opened its inaugural show at the New Gallery in Regent Street; again, stamped cloth book covers were on display. Two months later, the third significant event was held, this time in Liverpool. The first meeting of the National Association for the Advancement of Art and its Application to Industry was the forum for a paper read by John Sedding (1838-91) entitled 'Our Arts and Industries'; without referring directly to the manufacture of books, he urged the participation of Arts and Crafts designers in the design and decoration of mass-produced, everyday goods.

The small exhibition of 'historical and modern bookbindings' at the Society of Arts was opened on 14 February and lasted four days; during that time it was visited by "between four and five hundred persons".[1] It was held in conjunction with a paper which was read before the Applied Art Section of the Society by its assistant secretary, Henry B. Wheatley (1838-1917), an author and editor whose interests included bibliography and early Arthurian texts. His paper, entitled 'The Principles of Design as Applied to Bookbinding', included a ringing endorsement of the stamped cloth book covers of the nascent Arts and Crafts movement. He declared that "some of the finest specimens of modern cloth binding are due to Mr William Morris, to whom art owes so much", and he concluded on a note of high optimism: "We have seen that some of our best artists will do this work [designing cloth covers], and if they are more generally employed we may rest

assured that a large number of beautiful designs will be brought into our homes, and thus help to cultivate our taste."[2]

As visual testimony to Wheatley's views, "the exhibition downstairs" to which he frequently referred in his paper, featured not only richly-jewelled Persian book covers, impressed pigskin bindings of the Middle Ages, Groliers, Roger Paynes and Riviéres, but the cloth covers of *The Story of the Volsungs and Niblungs* (fig. 3), designed by Philip Webb (erroneously attributed by Wheatley to William Morris), *Ballads and Sonnets* (fig. 2) by Dante Gabriel Rossetti, designed by the poet, and *The Works of Tennyson* (fig. 6), designed by Lucy (Faulkner) Orrinsmith who frequently worked for Morris & Co., and whose brother Charles (d.1891) had been an active partner in 'the Firm'. Other cloth-covered books on view were "two volumes, with original designs in gold by Mr Lewis Day" which were probably similar in style to his cover for *A Marriage of Shadows* (fig. 7), issued later that year.[3] Day had been a founder member of both the Art Workers' Guild and the Arts and Crafts Exhibition Society.

The significance of Wheatley's enthusiasm for cloth book covers lay in its rarity among bibliophiles at that date. Throughout the sixty years or so which had elapsed since cloth had been introduced for binding publishers' editions, the material had met with much odium and little praise. The technique of covering the boards of a book with starched cloth, rather than the paper which had been used for many decades, had been developed at the bindery of Archibald Leighton (1784-1841) during the 1820s. Disaffection for the new material had soon been voiced. In 1831 the collector and designer William Beckford (1760-1844) had complained to his bookbinder: "This cloth binding is coarse, bungling work....Blue boards, after all, are far less obtrusive than this vile, glossy, green and scarlet glare."[4] To take away some of the shininess that book buyers had found the least attractive quality of calico, the cloth had been embossed with a wide variety of patterns, some imitating the irregular

surface of leather or vellum, others consisting of ribs vertically, horizontally or diagonally ruled to deflect incident light. To many minds cloth would always be a sham. John Leighton (1822-1912), Archibald's nephew and a prolific designer of cloth covers from the mid-1840s until late in the century, had claimed that "calico has been made to appear every material save what it is - Morocco, Russia, moire [sic] antique, silk, marble paper etc", although he had still considered it "the modern publisher's best friend" and had asserted that "many books in exquisite taste, more particularly on account of their impressed designs" had been issued in cloth covers.[5]

Two important technical developments, both introduced in the early 1830s, had allowed designs to be stamped on cloth covers. The first had been casing, whereby the cloth-covered boards and back could be glued as a single piece (the 'case') to the book's pages, rather than having the boards sewn in as an integral part of the book. The second development had been the adoption of a lever-action press with which to stamp a design on the cloth. The screw-operated arming press (originally used for stamping book covers with the owner's coat of arms) had been found to have been impractical; Tomlinson and Masters explain:

[W]ith this [screw-operated] press the heated block would have had to be placed on the book, and the process was therefore slow and would have required a high degree of skill. The problem was solved by adapting a lever-action printing press to carry a heater box, heated by gas or hot irons, to which the engraved block was attached.[6]

The new process was quick, labour-saving, and therefore cheaper. As Tomlinson and Masters affirm: "The period following the successful adoption of casing and blocking witnessed the establishment of large wholesale binderies that were capable of meeting orders from publishers for many thousands of cloth-bound books a week."[7]

There had been a tendency to make the designs stamped on cloth covers more and more elaborate. A large design had cost no more than a small one and had hidden more of the offensive cloth. John Leighton had been the pioneer and

master of a highly ornate style which had soon become the norm, in part because Leighton had designed so many covers himself and in part because most other designers working between about 1850 and about 1880 had more or less closely followed his manner. Of Leighton's covers Rossetti had wryly remarked: "Whether his designs are good or not, they are at least very elaborate."[8] Walter Pater (1839-94) had expressed a similar lack of conviction about the current style of cover design when he had wanted his book *Studies in the History of the Renaissance* (1873) bound in greyish-blue, paper-covered boards with an olive-green paper back; "nothing could be prettier or more simple," he had written to his publisher, Alexander Macmillan (1818-96). When it had been pointed out to him that cloth was much more practical, and that booksellers were reluctant to take books in paper-covered boards any more, Pater had persisted in his objection and had complained of "the difficulty of getting a book bound in cloth so as to be at all artistic and indeed not quite the other way". Macmillan had then sent him a copy of a chastely bound volume which the publisher had designed himself for another, equally fastidious, author. "His tastes," he had written, "were 'artistic'. He is an intimate friend of Mr Burne-Jones and others who think in that line."[9] Macmillan's argument had proved decisive, Pater had been persuaded, and his book had been issued in cloth-covered boards. One year later, reporting to the Society of Arts on the bookbinding shown at the Annual South Kensington Exhibition of 1874, the civil servant and journalist H. Trueman Wood (1845-1929) had been unable to muster any enthusiasm for contemporary cloth cover design:

To tell the truth, the style which is distinctly the product of our time compares but ill with the solid work of our fathers....However useful and valuable in their own way may be the bright cloth and gold bindings of a modern bookseller's shop, they seem tawdry and poor by the side of the massive tomes over which the ancient workmen lavished weeks and months of patient toil.

Wood had, however, made a doubly significant concession:
Still there must always be abundance of room

for the two sorts of work. The connoisseur of books will never be able to dispense with the one. The ever-growing public of book readers will provide an ample market for the other.[10]

The "ever-growing public of book readers" had recently been converted from a steady stream into a potential torrent by the 1870 Elementary Education Act which had made school attendance compulsory. Wood had seen the implications of a huge increase in literacy for publishing and the bookbinding industry. Furthermore, his acknowledgement of a distinction between "the two sorts of work" had been a significant step towards the position taken by Wheatley when he had first addressed the Society of Arts on the subject of bookbinding in 1880; then he had declared:

There are three totally separate styles of art to be distinguished in the history of Bookbinding, and each one of them appears to have been uninfluenced by the others..(1) the old stamped leather, which was brought to perfection by the Germans; (2) the gilt tooling which came to us from Italy, and (3) the blocked covers of modern cloth bindings.[11]

This had been eight years before his 1888 paper, and his analysis had helped remove any prejudice in the assessment of cloth covers. His words had in effect suggested that the stamped cloth book cover merited its own aesthetic criteria and should not forever be considered merely a poor relation of handbinding.

In 1883 the publisher Charles Kegan Paul (1828-1902) had given a lecture entitled 'The Production and Life of Books' which had been printed in the *Fortnightly Review*. He had shown some condescension towards the "many books not good enough to deserve a leather binding", and he had rated the designs stamped on current cloth covers as "fairly inoffensive in the hands of a person of taste, but also frequently vehicles for pretension, vulgarity, and imitation".[12] Now, Kegan Paul had been close to key figures in the nascent Arts and Crafts movement, and he had recently joined the Society for the Protection of Ancient Buildings, which had "brought [him] into connection with....Mr William Morris";[13] in his 1883 lecture he had presciently suggested that Morris (1834-96) should "design and produce some new types for our choicer

printed books". So his judgement of cloth book cover design at that time may be considered to have been in harmony with prevailing Arts and Crafts opinion.

It was an opinion shared by Wheatley. In his 1888 paper he summarised the evolution of stamped cloth cover design over the past forty years. He probably felt constrained to commend two of John Leighton's earlier, less elaborate covers by the presence in the audience of the artist himself who had loaned several items to the exhibition downstairs.[14] But then Wheatley had gone on to condemn the gilt decoration which had become "so excessive that in due course good taste revolted against this abuse", and plain covers with little or no ornament had been in favour.[15] Dislike of over-ornamented book covers would become part of the general disgust felt by Arts and Crafts designers for what they saw as the sprawling fussiness and imitative historicism of the High Victorian decorative arts. Laurence Housman (1865-1959) would give vivid expression to his disdain for this rhetorical style when he described cloth cover designs "that remind one sometimes of casket-work, sometimes of confectionery, or, in extreme cases of the Albert Memorial".[16]

The Arts and Crafts Exhibition Society had been founded in 1885, and three of its founder members spoke about cloth covers in the discussion which followed Wheatley's lecture at the Society of Arts.[17] Two of them, Walter Crane (1845-1916) and Lewis Day, both cover designers themselves, advocated simplicity in both ends and means. Crane said that "his own efforts in designs for book covers had been rather with a view to production in a cheap form", and he observed that "a good design was not dependent upon expensive materials for its effect". He had put this idea into practice when he had designed the covers for Mrs Molesworth's books for children, where he had used only black ink on red cloth with little or no gold (fig. 5). Day agreed; in his opinion "any real advance in binding must be in the simple direction to which Mr Crane had alluded". Crane, however, also admitted to a predilection for "the old bindings". He enjoyed their "roughness and imperfection - that variation in the tooling and slight irregularity which added so much to the richness of a design". Day, however, pointed

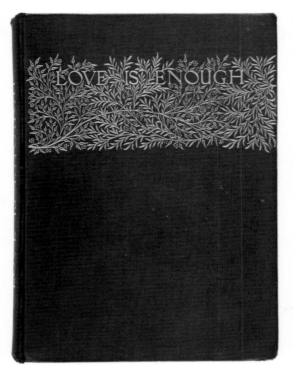

4. William Morris, 1873 (cat. no. 42) 5. Walter Crane, 1878 (cat. no. 7)

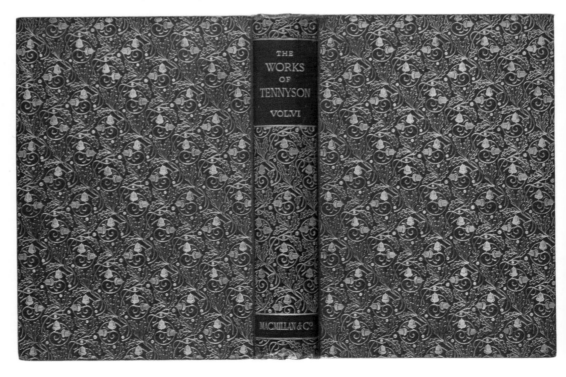

6. Lucy Orrinsmith, 1884 (cat. no. 49)

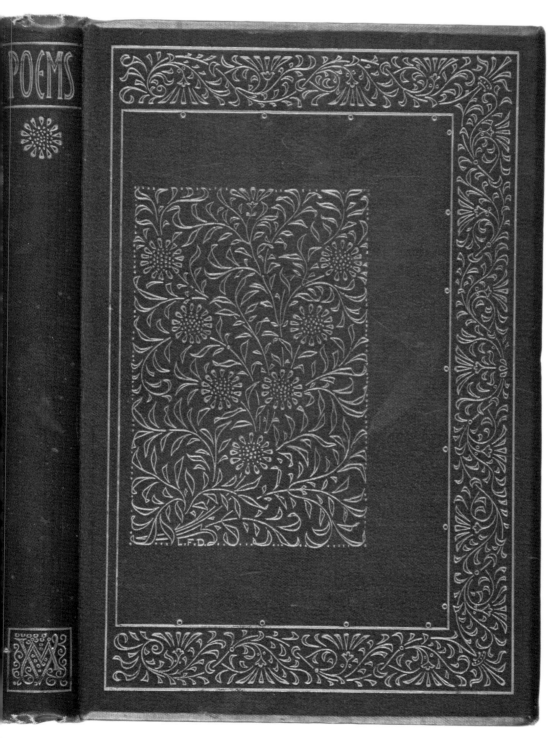

7. Lewis Foreman Day, 1888 (cat. no. 11)

out the impracticality of hand-binding in the modern age. In his opinion:

> It [is] impossible for people to spend large sums on the binding of a single book, considering the enormous number of their books. When they had only two or three books they could afford to treat them like little gods, and worship them, but we [have] changed all that.

Day was far from subscribing to the socialist viewpoint which pervaded the Arts and Crafts movement, but on this occasion he voiced a democratic ideal irreconcilable with the goal, shared by many of the leading figures of the movement, to make everything by hand so that the maker might take pleasure in the making even if that meant the cost became prohibitive to all but the better-off. It was the eternal dilemma which had been famously stated by William Morris when he had reproached himself for "ministering to the swinish luxury of the rich".

The bookbinder Thomas James Cobden-Sanderson (1840-1922) who, like Crane and Day, was at the heart of the emergent Arts and Crafts movement, also contributed to the discussion at the Society of Arts. As might have been expected, he was not at all sympathetic to the stamped cloth book cover, irrespective of its design. He declared that:

> a book should be treated as an individual.... individuality of form was the essence of good bookbinding, and not box-like regularity. Decoration was properly the expression of the craftsman's love of his work; it was the impress of the caress of his hand made upon the book he knew, had made, and loved, or it was nothing.

He found that "the finish of machine-made work....was smooth, even, lifeless", and like Crane maintained that per contra "the finish of hand-work....was uneven, full of life, and bearing everywhere traces of its origin in the sensitive ever-varying hand and mind of man". Over the coming months and years Cobden-Sanderson's opposition to cloth would strengthen until any ambiguity about his attitude would evaporate in 1894 when he would write in the *Fortnightly Review*:

> I should be glad if artists would cease to design for cloth, and if publishers would cease to ask them; and, most important of all, as most effective, if the public would cease to patronise them by selection.[18]

Cobden-Sanderson, "a strange creature highly strung and excitable",[19] had been a founder member of the Arts and Crafts Exhibition Society, and, with Crane and Day, was on the committee planning its inaugural show, due to open that October. On 5 March, two and a half weeks after the discussion at the Society of Arts, it was decided that the show would be held at the New Gallery and a committee was appointed to select items for exhibition. Fortunately for the progress of Arts and Crafts stamped cloth book cover design, Cobden-Sanderson was not on it. Five of its seven members had designed cloth covers: Crane, Morris, Webb, Day and Heywood Sumner (1853-1940); the other two were the metalworker W.A.S. Benson (1854-1924), and Mervyn Macartney (1853-1932) an architect.[20] When the exhbition opened on 1 October 1888, stamped cloth covers designed by Rossetti, Webb, Orrinsmith and Day were on display, probably the same titles as had appeared earlier in the year at the Society of Arts. They were listed in the catalogue as "cover or case for book: cloth decorated in gold" or "case for binding: cloth gilt". In addition, a "cloth case for bookbinding" designed by John Moyr Smith (1868-94) was shown. The manufacturers were named in the catalogue as James Burn & Co for all the covers except one designed by Lewis Day which had been executed by the firm of Matthew Bell; the name of the bindery which had manufactured Moyr Smith's cover was not given in the catalogue. There were also hand-bound books on display including examples by Cobden-Sanderson.

That same October the *Scottish Art Review* published an anonymous article attacking cloth book covers.[21] The writer reiterated many of the old arguments against cloth; the material had no "grain or texture", it was "a mean and unsuccessful imitation", and there was "always a cold shine that prevents the eye from resting on it with satisfaction". The writer went on to commend the lithographed paper covers in which French books were sold before eventually

being bound "in sumptuous leather and fine gold", and the article ends on a scornful note: "Here we *manufacture*, first and last, cloth cases." Whoever may have written this piece, the fact that it was published in a leading avant-garde art journal would indicate that it represented a significant body of opinion, and the fact that it appeared when it did might suggest that it was intended as a brickbat thrown at the Arts and Crafts Exhibition Society's policy of displaying cloth book covers.

The following month the exhibition itself was reviewed in the pages of the same journal, and a much more accommodating line was taken: "The machine-printed book covers of Lewis F. Day here exhibited are a proof of the acceptability of such to the authorities."[22] If this does not necessarily indicate approval of the organisers' decision, the principle of admitting machine-made goods to the exhibition was whole-heartedly endorsed elsewhere in the review. Pottery by Maw & Co. was cited as "a splendid example of what a large firm of manufacturers can accomplish in the education of public taste". By 1888 the modern wholesale bindery could certainly have been reckoned "a large firm of manufacturers". The case-binding of books in cloth-covered boards, having been an entirely new industry, had lent itself to rapid mechanisation to meet an ever-increasing demand. As early as 1851 the jury at the Great Exhibition had noted: "The production of books greatly exceeds that of any former period, and has caused the application of so much machinery to bookbinding that it may fairly be said to have become a manufacturing business." Quoting these words in his report on bookbinding at the 1874 Annual South Kensington Exhibition, H. Trueman Wood had added that "the machinery....alluded to has been most extensively developed both in power and in the variety of its application since that time....while several new machines have been introduced".[23] An inventory taken at James Burn & Co.'s bindery in 1885 had listed two steam-engines driving some sixty machines, including ten stamping presses.[24] According to Lionel Darley:

There were steam-powered machines to fold, nip and sew the book, to trim or guillotine the edges, to chop and square boards for cases, blocking presses to block those cases in gold and ink, and when the books were built up in the hydraulic presses, steam-driven shafting worked the pumps.[25]

In 1854 it had been claimed that at one of the larger binderies "the whole impression of an octavo work, consisting of 1,000 copies, can be done up in cloth, in the course of about six hours", and that such efficiency had been due to "a refined system of division of labour".[26] By 1885 Burn's had been producing about eighty thousand books a week.[27] Many adherents to the doctrine of Carlyle, Ruskin or Morris would have shared Cobden-Sanderson's dismay and would not have wanted to be associated with an industrial process that they would have deemed irreconcilable with the aims and ideals of the Arts and Crafts movement. However, towards the close of 1888 a fresh approach to mass-production was emerging.

When Lewis Day announced in April 1888 that "decorative art in general, from being an affair of craftsmanship, has become a matter of manufacture", few could have been surprised.[28] His advocacy of the machine was long established and well known. Doubts about the ethical probity of designing stamped cloth covers were more likely to have been dispelled by the precedent of covers designed by Arts and Crafts heroes such as Rossetti (figs. 1 and 2), Morris (figs. 4 and 8) and Crane (figs. 5, 12 and 14). More compelling yet would have been the arguments put forward in an address that the architect John Sedding (1838-91) delivered to the National Association for Art and Its Application to Industry at its first congress, held at Liverpool in November 1888, and repeated at a meeting of the Art Workers' Guild the following March. Sedding, a highly respected figure in Arts and Crafts circles, urged artists to come to terms with the machine: "Manufacture," he declared, "cannot be organized on any other basis."[29] He asked for products "of good material and make" and designs which were "well suited to the necessities of modern methods of production". He aired again the argument, previously used by Morris, that the artist should attempt to reach the widest possible public. Morris had declared that "to get all simple people to care about art,

to get them to insist on making it part of their lives....is henceforward for a long time to come the real business of art".[30] Sedding phrased this doctrine in religious terms:

The part of the artist who knows his mission, is to....allure souls by the charm of colour, form, design, expression....His credentials come straight from heaven – "From henceforth thou shalt catch men."

The Christian Socialist theology underlying this idea would be made explicit by Aymer Vallance (1862-1943) writing in 1892:

The shapely fashioning and the decoration of the most ordinary objects is the art which will penetrate to the East-End [sic] dwelling of Lazarus....Thus the talent that else had been fruitlessly perverted can be employed in an apostolate of culture....[31]

With rising literacy rates and the falling price of books, cloth-covered volumes were being issued in their millions each year, and, even if only a small fraction of the total had well-designed covers, so the argument might have run, there should have been at least some impact on the public at large.

In his Liverpool speech Sedding called for "a Morris installed in every factory". At the bindery of James Burn & Co. the position of art director was held by Harvey Edward Orrinsmith (1830-1904). Orphaned in 1843, Orrinsmith had been brought up by his father's partner, the wood-engraver W.J. Linton (1812-97), Walter Crane's early mentor and, in Rossetti's opinion, "the best engraver living".[32] About 1865, Burn's had engaged Orrinsmith "to look after the design of blocks and book covers and attend to the requirements of the customers", and in 1867 he had been made a partner.[33] In 1870 he had married Lucy Faulkner, so strengthening his ties with the nascent Arts and Crafts movement.[34] He would always have been sympathetic to publishers and designers who showed any Arts and Crafts proclivities, and in 1893 he would contribute a chapter on the design of cloth book covers to *Practical Designing*, edited by Gleeson White (1851-98).[35]

Gradually, Sedding's words would seep into the consciousness of several publishers who began increasingly to commission Arts and Crafts artists to design their cloth covers instead of relying on the trade designs offered by binders and die-sinkers. Book cloth would have appealed to the Arts and Crafts sensibility. It was one of those humble materials that many Arts and Crafts makers and designers favoured; like stoneware, oak, or copper it was distinctly belowstairs stuff, and it was sometimes called 'pauper-linen'.[36] With the advent of Arts and Crafts designers to the field of cloth cover design, a modification would be made to the way the material was presented. About 1890 the use of reversed cloths would become widespread; writing in 1894, Gleeson White would explain the advantages:

The cloth with a broken colour, so popular to-day, is obtained by using the back of the fabric. In this way crude orange cloth may yield a delicate salmon; a staring red may supply a dainty flesh-colour, or a strong blue yield a cool greyish blue. The white threads of the fabric having only taken the colour in their interstices, the effect of the back is that of a woven, not a painted fabric. The old-fashioned cloths - grained to imitate leather, with heavy opaque colours - are not in favour to-day, nor are those with arbitrary patterns impressed in the material before it is fixed to the millboard of the covers.[37]

In 1891 the Winterbottom Book Cloth Company would introduce a cloth called 'Art Vellum'[38], apparently in direct response to a demand created by the new style. This cloth allowed the texture of the weave to be clearly seen, with all its "imperfections and peculiarities".[39] The irony of that would not have been lost on the late Archibald Leighton who had striven so hard to make cloth *not* look like cloth.

The background, in both the literal and the figurative sense, to the stamped cloth book cover designs of the Arts and Crafts movement had been laid. What would those designs look like?

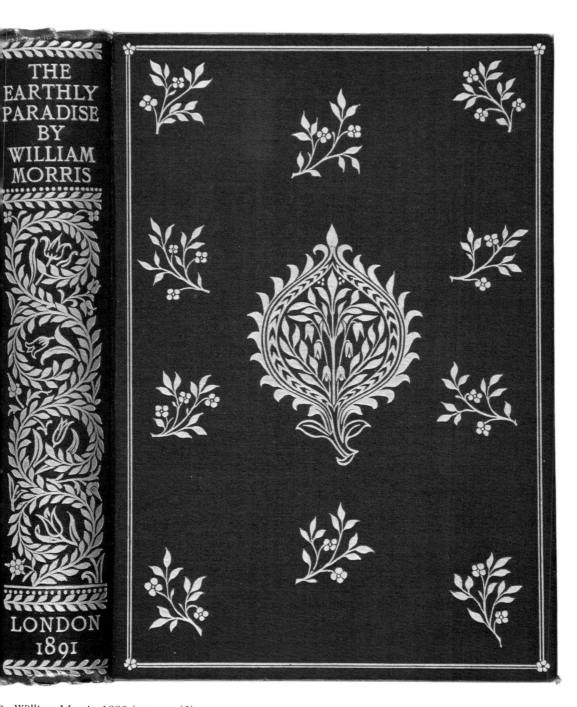

. William Morris, 1890 (cat. no. 43)

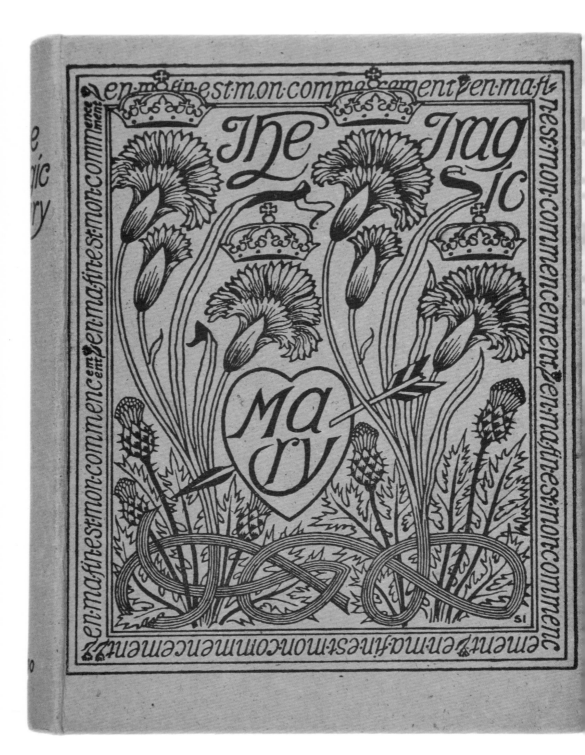

9. Selwyn Image, 1890 (cat. no. 27)

THE DESIGNS

The extent of William Morris's influence on Arts and Crafts cloth book cover design was enormous. Style varied from designer to designer as each artist borrowed more or less of Morris's visual vocabulary, but the sources of the designs and the treatment of motifs were next to universal in their debt to the master's influence.

The treatment given by Morris to the natural world in his wallpaper and textile patterns was known at the time as 'conventional', although that was a word that he himself seldom used. He described the principal characteristics of this treatment in a lecture that he gave in 1882:

> Broadly speaking, one may say that the use of this subordinate, but by no means unimportant art [pattern-designing] is to enliven with beauty and incident what would otherwise be a blank space, wheresoever and whatsoever it may be. The absolute necessities of the art are beauty of colour and restfulness of form....Its colour may be brought about by the simplest combinations; its form may be merely that of abstract lines or spaces, and need not of necessity have any distinct meaning, or tell any story expressible in words. On the other hand, it is necessary to the purity of the art that its form and colour, when these bear any relation to the facts of nature (as for the most part they do), should be suggestive of such facts, and not descriptive of them.[40]

Such treatment was developed by Morris, in part at least, to meet the exigencies of printing on paper or fabric from inked blocks, and was consequently well suited to the process of stamping cloth book covers. It precluded any attempt at a pictorial style; he condemned outright "sham-real boughs and flowers, casting sham-real shadows....with little hint of anything beyond Covent Garden in them".[41] Harvey Orrinsmith, writing in 1893 on the preparation of designs for stamped book covers, gave instructions formulated on the same principles: "The lines should be clean, varying in force, and little reliance should be placed on effects obtained by shading."[42] His advice was given from a technical rather than an aesthetic point of view; the thin lines required to suggest shading were impractical on a metal stamp, just as they were on a wooden block. "For the most part," Orrinsmith wrote, "figure subjects or landscapes are, unless treated decoratively, unsuited to the ornamentation of cloth-covered books."[43]

Another aspect of the pervasive influence that Morris's work had on Arts and Crafts book cover design, was the way in which he composed the different elements in his designs to give each pattern its own dynamic, with its own rhythm independent of the repeat. In an analysis of decorative art which Arthur Heygate Mackmurdo (1851-1942) made in an article published in the *Hobby Horse*, he wrote:

> And since the decorative aspect depends largely on a certain inevitableness of disposition in the parts, as in the case of musical intervals, the ornament should have movement, and this movement should be rhythmic....And in evidence of this decorative quality, we may study the Attic vases, the ornaments of Byzantine buildings, the carpets and cretonnes of William Morris.[44]

The year before (1886), the same journal had published the woodcut 'In Piam Memor. Arturi Burgess' by Selwyn Image (1849-1930), Mackmurdo's colleague and friend, which depicted, in a conventional manner, a bird flying over a row of flowers with drooping heads; the design depends for its effect on the rhythmic arrangement of the flowers and the spaces between them.[45] In 1890, Image made more sophisticated use of this device on the cover of *The Tragic Mary* (fig.9), and the same year Louis B. Davis (1861-1941), another artist associated with the Century Guild, employed a similar composition on the cover of *Object Lessons from Nature* (fig.11). Thereafter, the rhythmic disposition of a plant motif across the cover of a book would recur in the work of Charles Ricketts (1866-1931), Aubrey Beardsley (1872-98), Gleeson White (fig.21), Fred Mason (fig.35), Reginald Knowles (1879-1950; fig.62)

and other designers, both in Britain and abroad (fig.95).

If Morris's decorative designs (and the demands of the medium) determined the treatment given by Arts and Crafts book cover designers to their chosen motifs, often the motifs themselves were derived from the intellectual world mapped by William Morris. He often spoke of two particular themes - nature and history - which informed his designs, and which he urged other designers to fully assimilate. "For your teachers," he demanded, "they must be Nature and History."[46] Nature, to Morris's mind, was closely linked with the art of the past; he bade his audience to go to the countryside, where "we may still see the works of our fathers yet alive amidst the very nature they were wrought into, and of which they are so completely part".[47] He found the man-made landscape of England a rich source of inspiration: "I must have unmistakable suggestions of gardens and fields....or I can't do with your pattern," he said.[48] Gardens became a shibboleth for the Arts and Crafts movement, and garden plants feature prodigiously in Arts and Crafts book cover design. Robert Gossop (1876-1951), who had designed book covers in his earlier years (fig.70), reiterated towards the end of his life this fundamental Arts and Crafts doctrine: "Plants are a subject that you should never be tired of drawing. And if you have a garden you have the most perfect sketching ground imaginable."[49] Should nature not provide, history always could: "It is too late to get the flowers I want to draw from the fields or garden," wrote Rossetti from Kelmscott Manor in 1872, "so I have sent to London for Gerarde's Herbal."[50] Morris owned copies of both the 1599 and 1636 editions of Gerard's book as well as other early herbals which he used both as a pictorial resource and as a tool in his researches into vegetable dyes. Lewis Day defined the artistic merits of the illustrations in herbals:

Modern artists, and especially those with a leaning towards mediaevalism, have often found inspiration in old herbals - where the drawings are not rendered in so purely scientific a spirit as the diagrams of our day, and where the artist has even taken upon himself to design his plants to fit the space of the wood-block allotted to him.[51]

Gardening became one of the crafts embraced by the Arts and Crafts movement. In 1891 John Sedding wrote a book on the subject entitled *Garden-Craft Old and New*: "And where," he asked, "can we find a more promising sphere for artistic creation?"[52] Gertrude Jekyll (1843-1932) considered designing and planting a garden as much a craft as her silversmithing and needlework. In 1883, she contributed a chapter on colour to *The English Flower Garden* by William Robinson (1838-1935). In the preface of this best-selling book Robinson quoted with approval Morris's scornful dismissal of carpet-bedding; he echoed Morris's enthusiasm for the old-fashioned cottage garden, and, like Morris, he decried the popularity of exotic, foreign blooms grown in hothouses. There seemed to be a symbiosis between the garden reformers led by Robinson and the Arts and Crafts movement. But then, in 1891, it was shattered by an article in the *English Illustrated Magazine* entitled 'On Gardens and Grounds'.[53] It was written by the Arts and Crafts architect Reginald Blomfield (1856-1942), who here and in his book *The Formal Garden in England*, published the following year, took Robinson to task for advocating a purely natural approach to garden design. Blomfield insisted that garden design was the sphere of the architect, who alone was qualified to create a formality consonant with the architecture of the house. Not for Blomfield were Robinson's meandering paths, irregularly shaped beds, and blurred boundaries; the architect insisted on straight lines, geometrical shapes, and enclosing walls or fences. The tiff was exaggerated, at least in part, by the polemical prose style of both Blomfield and Robinson. In 1901, Blomfield had to admit: "During the last few years the question of garden design has been discussed with a zeal possibly out of proportion to its intrinsic importance."[54] But its importance to Arts and Crafts design, including the design of cloth book covers, was considerable. "The formal treatment of gardens ought, perhaps, to be called the architectural treatment of gardens" declared Blomfield in his 1892 book, and his words would have struck a chord in the mind of every Arts and Crafts designer, for William Morris had often propounded the ascendancy of architecture over all the decorative arts. "I have

spoken of the popular arts, but they might all be summed up in that one word Architecture," he had said, "they are all parts of that great whole, and the art of house-building begins it all."[55] Blomfield was now applying the maxim to garden design, and he and his friends' preaching sometimes seemed to be offering hints to designers of book covers as well. The Arts and Crafts architect Edward Prior (1852-1932), reviewing Blomfield's and Sedding's books in the *Hobby Horse* recommended a square shape as "the readiest form of enclosure", and added: 'But the oblong shape lends itself with equal readiness to pleasant devices."[56] How to meld natural growth with architectural elements was a dilemma which sometimes created a tension in book cover design. For example, in 1907 A.A. Turbayne (1866-1940) felt constrained to combine on the cover of *Poets' Country* (fig.65) the sinuously-stemmed roses with a geometrical framework which includes a corniced entablature, as a frank acknowledgement of architectural supremacy. Two other designs which suggest a dilemma in the mind of their designers between nature and architecture are shown in fig.43 and 69. The significance of garden design in Arts and Crafts philosophy is demonstrated by the number of books on the subject published around 1900 which had covers designed in the Arts and Crafts style (fig.55, 59, 67 and 99). The Arts and Crafts concept of architecture and horticulture combined left a legacy in the garden-city movement of the first half of the twentieth century.

Between 1876 and 1883, William Morris incorporated birds in several of his textile patterns. The birds were usually shown in pairs, facing each other and often singing. Partly because it is traditionally an allusion to poets and poetry, the motif was frequently used by Arts and Crafts cover designers on books of verse. In 1894, for instance, J. Walter West (1860-1933) decorated the covers of a series of collections of poems by John Davidson (1857-1909) with a pair of singing birds (fig.26). Talwin Morris (1865-1911) used the same motif on the covers of poetry books in Blackie's Red Letter Library, begun in 1902; that year, he also included them on the cover of *The Universe* (fig.61), also published by Blackie. In 1897, John Illingworth Kay (1870-1950) incorporated a pair of birds in

a design for the Silver Studio which paraphrases William Morris's 'Brer Rabbit' pattern; it was used on books of children's fiction, again published by Blackie (fig.44). The German designer F.W. Kleukens (1878-1956) designed the cover for the *Insel-Almanach* of 1908 (fig.80) which featured a pair of birds, and two distant descendants of the doves in William Morris's pattern 'Dove and Rose' are to be found stamped on the cover designed by Olle Hjortzberg (1872-1959) for the 1910 Swedish book *I Ungdomsår* (fig.88).

Like the illustrations to old herbals, the motif of a pair of birds is an indication of the twin wellsprings of Morris's inspiration - nature and history. For Morris had found this device on antique textiles in the South Kensington Museum, and he may well have been aware, too, of its occurrence in the decoration of early printed books. He became a keen collector of these during the 1860s, when the poet Algernon Swinburne (1837-1909) introduced him to the bookseller Frederick Startridge Ellis (1830-1901) who became a close friend. Another friendship, with his Hammersmith neighbour the printer Emery Walker (1851-1933), reinforced Morris's enthusiasm in the 1880s. In 1882, Walker wrote: "It is a melancholy reflection on our 'progress' that nearly every really beautiful book in existence was produced in the first hundred years after the invention of printing."[57] Interest among artists and designers in the typography, illustration and decoration of early printed books began to grow apace. The January 1888 issue of the *Hobby Horse* carried an article by Herbert Horne (1864-1916) and Richard Garnett (1835-96) on the illustrations to the *Quadriregio*, a book printed at Florence in 1508; two of the original woodcuts from the book were reproduced.[58] The same year, the Department of Art and Science issued a facsimile edition of the 168 woodcut illustrations from the *Poliphili Hypnerotomachia*, originally printed by Aldus Manutius at Venice in 1499. The pictures and ornament in this book had long fascinated the Pre-Raphaelites. Rossetti had owned a copy as early as 1863, and in 1866 the poet William Allingham (1824-89) recorded in his diary Edward Burne-Jones (1833-98) finding inspiration in "old Woodcuts, especially those in *Hypnerotomachia*, of which he has a fine

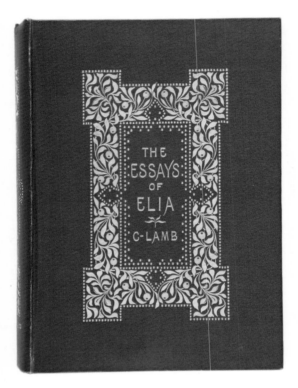

10. Frederick Colin Tilney, 1890 (cat. no. 56)

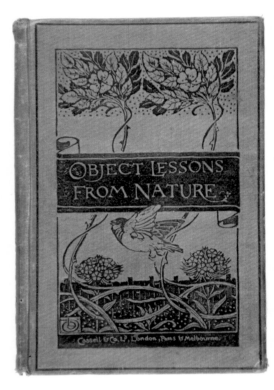

11. Louis Barraud Davis, 1890 (cat. no. 10)

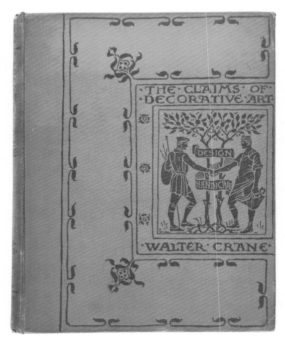

12. Walter Crane, 1892 (cat. no. 9)

13. Laurence Housman, 1892 (cat. no. 19)

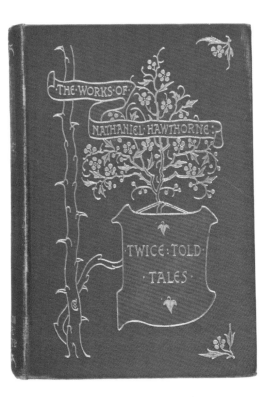

14. Walter Crane, 1893 (cat. no. 9)

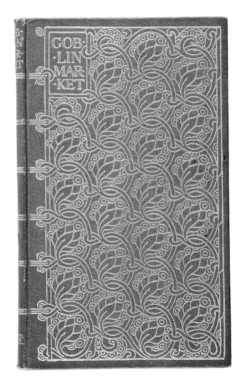

15. Laurence Housman, 1893 (cat. no. 20)

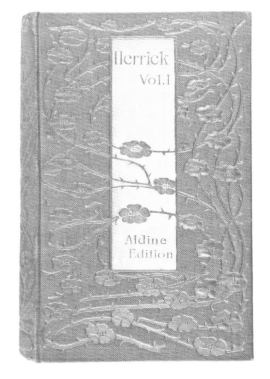

16. Gleeson White, 1893 (cat. no. 67)

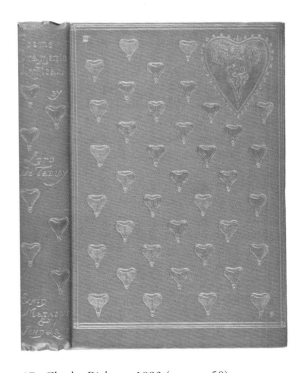

17. Charles Ricketts, 1893 (cat. no. 50)

copy".[59] Morris, too, had a copy. Writing in 1896, Walter Crane described the appeal of the book's illustrations: "The style of the designer, the quality of the outline, the simplicity yet richness of the designs," were, in his opinion, worthy of emulation.[60]

The *Hypnerotomachia* was but one of many early printed books which helped to form the graphic vocabulary of book cover designers during the two decades either side of 1900. Noone did more to acquaint artists with these books than Alfred William Pollard (1859-1944), assistant in the Department of Printed Books at the British Museum. He had begun his job in 1883, and two years later a copy of the *Hypnerotomachia* had been put on display in the department.[61] In 1888 he contributed to the *Hobby Horse* an article 'On Some Old Title-Pages', where he described the collection of about 25,000 examples removed from early printed books by the seventeenth-century bibliographer John Bagford, who had planned but never completed a history of printing. Pollard invited the reader to come and look:

[I]f there be any reader of this paper possessed of a little learned leisure, it is suggested to him that he might employ it to many worse purposes than in working at this vast collection, and ascertaining if no useful results can be extracted from the materials so laboriously amassed.[62]

This was typical of Pollard's eager promotion of the collections in his department at the British Museum. His emphasis on accessibility was ahead of its time, and Arts and Crafts book cover designers, at least on the evidence of their work, responded. Through his connection with the *Hobby Horse*, edited by Mackmurdo and Horne, with Selwyn Image a multiple contributor of articles, poems and designs, Pollard was in touch with key members of the Arts and Crafts movement. At Oxford University he had become friendly with A.E. Housman (1859-1936), and through him he had met the poet's brother Laurence, to whom he had given some useful introductions to editors and publishers. Pollard edited *Bibliographica* (1895-97) which in its first year featured articles by William Morris and Laurence Housman.[63] The periodical was adorned with initial letters and

tailpieces by Laurence Housman "who took his inspiration", according to the editor, "from the initials in the *Hypnerotomachia*, and may fairly be said to have bettered his instruction".[64]

In his writings, Alfred Pollard particularly focussed on title-pages; "in the evolution of the printed book from the manuscript," he wrote, "the title-page was the final complement."[65] Because early title-pages combined ornament and lettering, they were peculiarly pertinent to the design of stamped cloth book covers, and their historical dimension gave them an added attraction to Arts and Crafts designers. Apart from his 1888 article on title-pages in the *Hobby Horse*, Pollard also wrote two much longer ones on the subject in the *Universal Review* the following year, and in 1891 his *Last Words on the History of the Title-Page* was published, illustrated with twenty-seven facsimiles.[66] His contribution was supplemented by the art historian and bibliographer Gilbert Redgrave (1844-1941) whose lecture on Erhard Ratdolt was published the following Spring with copious illustrations of the fifteenth-century German printer's work, including title-pages.[67] Ratdolt was "considered as the initiator of the decoration of books" according to C. Castellani in his introduction to *Early Venetian Printing*, published in 1895.[68] This volume offered a comprehensive collection of facsimiles of work by all the leading printers active in Venice during the late fifteenth and early sixteenth centuries. These books, lectures and journal articles provided designers with a wealth of source material. Borders composed of scrolled and interwoven plants, sometimes rising from vases and often incorporating animals or birds, as well as the complex knot- or strapwork decoration with which these title-pages were embellished, can often be recognised as the inspiration for an Arts and Crafts book cover design (fig.23, 42, 57, 60, 83, 84, 98, 99). Morris himself revelled in such intricacy of design which he regarded as being of the essence of medieval art. His cover for *Love is Enough* (fig.4) testifies to his affection for such decoration, although this design was probably inspired by ornament found on medieval manuscripts.

To a more limited extent, the illustrations in early printed books influenced Arts and Crafts book cover design. The cover that Arthur

Gaskin (1862-1928) supplied for *Stories & Fairy Tales by Hans Christian Andersen* in 1893 (fig.18), with its simple linear style and its beflowered woodland setting, was unmistakably derived from the woodcut illustrations found in early printed books. The year before, William Morris had read a paper to the Society of Arts on 'The Woodcuts of Gothic Books'; there he had said:

> *I do not think any artist will ever make a good book illustrator, unless he is keenly alive to the value of a well-drawn line, crisp and clean, suggesting a simple and beautiful silhouette. Anything which obscures this and just to the extent to which it does obscure it takes away from the fitness of a design as a book ornament.*[69]

When Morris's paper had been published in the *Journal of the Society of Arts*, it had been accompanied by illustrations including a reproduction of 'The Descent of Minerva' from the *Quadriregio* to which Gaskin's cover bears similarities of both composition and treatment. The "well-drawn line, crisp and clean" can be seen again in the cover that Laurence Housman designed for *A Farm in Fairyland*, a collection of his own prose tales published in 1894 (fig.28).

Examples of Arts and Crafts book cover designers seeking to emulate historical bookbinding styles are uncommon, perhaps because the status of the stamped cloth cover as an independent genus had been so recently established. However, the impressed skin bindings of some medieval books, with inscriptions running round the edges, inspired Selwyn Image to employ the same plan on the cover of *The Tragic Mary* (fig.9), and nearly twenty years later A.A. Turbayne adopted the same arrangement on his cover for *Yorkshire* (fig.68); he followed the medieval precedent more closely by filling the central space with a diaper of Tudor roses. A rare instance of an Arts and Crafts designer borrowing from an historical gold-tooled binding is furnished by Laurence Housman's 1898 design for the cover of *Spikenard* (fig.46); the source of the motif that Housman used here seems to have been the stalked trefoil used on a seventeenth-century binding by the French bookbinder Florimond Badier which had been illustrated

in *Bibliographica* three years earlier.[70] Many early bindings were embellished with chased metal mounts, usually in the corners and at the centre of the top cover, and sometimes chased metal clasps and hinges were fitted. This was the source of Rossetti's design stamped on the covers of a volume of his own poems (fig.2), published by Ellis in 1870. He has treated his model only loosely, however; a large hinge and corner mounts on the fore-edge only were an unorthodox arrangement which results in an asymmetry requiring the book to be opened wide to be resolved. Yet the design is highly satisfactory, and it was much imitated by later designers. It is not usually possible to be certain whether such imitations were inspired by Rossetti's design or original historical examples, but often modifications to Rossetti's plan suggest that the designer had at least referred to the latter. In 1886, Lewis Day described the origin of the genre, and explained their artistic efficacy:

> *A cornerwise treatment is seen to advantage when it has been suggested by use, as in the metal garniture of old book bindings, and coffers such as the German smiths of the 15th and 16th centuries delighted to elaborate. These same book-covers and caskets afford excellent examples of a treatment where the design is manifestly "to be continued in our next," the side unseen being necessary to its symmetrical completeness. The need of clasps, hinges, &c., no doubt gave the hint of such manner, which, in spite of the one-sided forms it gives, is eminently satisfactory in effect. We scarcely realise how readily the mind makes good what the eye does not see in design.*[71]

Day's own 1888 design for the cover of *A Marriage of Shadows* (fig.7) indicates some study by him of fifteenth- and sixteenth-century German work, while the cover of *Ornithology of the United States and Canada* (fig.89), published in 1891, suggests that the designer, J.A. Schweinfurth (1858-1931) looked little or no further than Rossetti's 1870 cover. Other examples, showing more or less dependence on one source or the other, are covers designed by Walter Crane (fig.12), Gleeson White (fig.20), A.A. Turbayne (fig.48), and Sarah Wyman

Whitman (1842-1904; fig.92).

A further debt to fifteenth- and sixteenth-century German art owed by the Arts and Crafts book cover designers was for the inspiration provided by the work of Albrecht Dürer. His multifaceted talent was widely admired in the Victorian era. John Leighton hailed him as "Painter, Sculptor, Architect, Author, Etcher, Engraver, and Art Workman".[72] The Arts and Crafts movement felt quite proprietorial about him; William Morris declared that "his matchless imagination and intellect made him thoroughly Gothic in spirit", despite his having been "infected" by the Renaissance, and Thomas Sturge Moore (1870-1944) wrote a book about him.[73] Dürer's ability as both artist and craftsman particularly commended him to people whose paramount object was to combine the two roles. In the words of the printer and typographer John H. Mason (1875-1951), writing in 1913, "in Dürer the twin streams of craftsmanship and art met in noble union."[74] When Walter Crane designed the cover of *The Claims of Decorative Art* (fig.12) in 1892, he chose to incorporate a Düreresque vignette of 'Design' shaking hands with 'Handicraft'.

Dürer as the decorator and illustrator of books made particular appeal to many Arts and Crafts designers. In his essay 'Of Book Illustration and Book Decoration', Reginald Blomfield wrote:

> No better model can be followed than Dürer's woodcuts. The amount of work that Dürer would get out of a single line is something extraordinary, and perhaps to us impossible, for in view of our complex modern ideas and total absence of tradition, probably no modern designer can hope to attain to the great German's magnificent directness and tremendous intensity of expression.[75]

Patten Wilson (1868-1928) managed to achieve at least some of that "directness" and "intensity of expression" in his design for the cover of *Galloping Dick* (fig.37). The figure of the highwayman is a reincarnation of the knight in Dürer's engraving 'The Knight, Death and the Devil', and the wooded hilly landscape behind the figure confirms Wilson's source. The cover of *The House of Joy* (fig.29), designed by Laurence Housman, with its crowded composition and

allusions to classical antiquity, may have been derived from Dürer's art, but his source could equally have been Rossetti, also an admirer of the German artist's work.

The cover designed by Walter Crane for an edition of Nathaniel Hawthorne's novels and stories, issued in 1893 and 1894, was clearly inspired by Albrecht Dürer's graphic work. It includes an armorial shield hanging from a tree, a motif often used by Dürer, who sometimes designed coats of arms for his patrons and, according to Leighton, was the "Great Master of Symbolism and Heraldry".[76] Rossetti's paintings of medieval subjects had sometimes included heraldic emblems, and elements of heraldic art became a regular feature of Arts and Crafts design. This was particularly so in the field of stamped cloth book covers; for centuries, the nobility had had their coat of arms stamped on the covers of the books they owned, and a long, well-illustrated article on English armorial book-stamps appeared in *Bibliographica* in 1897. The arming press used to stamp covers with a coat of arms had been the predecessor of the more sophisticated machines used to stamp designs on cloth covers. In 1895, William Morris, describing illustrations in the early printed books of Ulm and Augsburg, noted that "the armorial cuts, which are full of interest as giving a vast number of curious and strange bearings, are no less so as showing what admirable decoration can be got out of heraldry when it is simply and well drawn".[77] W.R. Lethaby (1857-1931), writing in 1913, observed that in heraldic art "everything is clear, sharp, and bright, the colours are few and the forms must be large and simple", words which echo Orrinsmith's instructions to book cover designers written twenty years earlier.[78] Over the eighteen years between Morris's and Lethaby's pronouncements, the Art Workers' Guild chose heraldic art as a subject for discussion no fewer than four times.[79]

"Heraldry," asserted Lewis Day in 1902, "is with us a province of art long since forsaken by the artist."[80] It was generally agreed in Arts and Crafts circles that contemporary heraldic art was at a low ebb, and that it needed to be restored to the high state to which it had risen during the Middle Ages, and writers on the subject very often expressed this point of view.

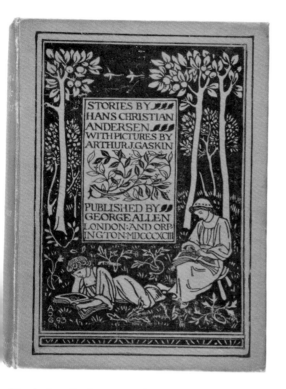

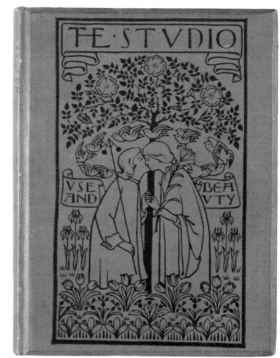

18. Arthur Gaskin, 1893 (cat. no. 14)

19. C.F.A. Voysey, 1893 (cat. no. 64)

20. Gleeson White, 1894 (cat. no. 68)

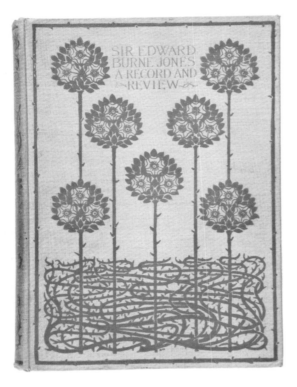

21. Gleeson White, 1894 (cat. no. 69)

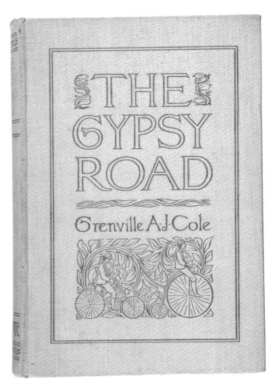

22. Edmund Hort New, 1894 (cat. no. 45)

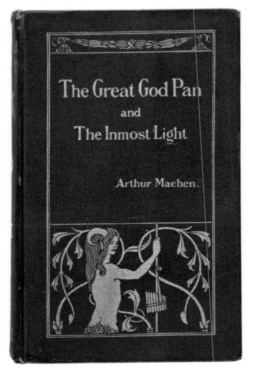

23. Aubrey Beardsley, 1894 (cat. no. 1)

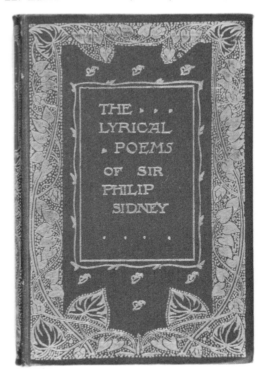

24. H. Granville Fell, 1894 (cat. no. 13)

One author, the Rev. E.E. Dorling, declared:

> [T]he heraldic art of the middle ages is a very different thing from that of the last three hundred years. Even when to modern eyes the old examples seem crude and harsh it is impossible to deny their vigour and power; when, as is most often the case, they attain to beauty their beauty is of a quality that must appeal to the modern craftsman who is trying to import into his own work something of the dignity and charm that distinguish the old.[81]

Such a "modern craftsman" was Harold Nelson (1871-1946). On leaving school, he worked for some years with a herald-painter, designing and engraving coats of arms. He began to recognise the debility of current heraldic art and took himself off to the Lambeth School of Art. His heraldic designs in a number of different media won recognition and praise, and his cover for *Edinburgh* (fig.74), published in 1912, demonstrates his ability to combine successfully elements of heraldry with natural motifs. In 1904, he had written:

> A quaint charm rests upon the work of the medieval heraldic artist. The real knowledge and beauty displayed in the drawing of heraldic forms, the unaffected simplicity, naive in its directness, of their treatment of material; the skilful adaptation of natural forms to conventional decoration, and the strong decorative instinct that pervades the whole, all make a powerful appeal to our sympathy and admiration.[82]

At the Arts and Crafts Exhibition Society's ninth show, held in 1910, Nelson exhibited book plates and a design for a book cover. The same exhibition featured an heraldic design by Reginald Knowles, and an illuminated address by Louise Powell (1882-1956), gilded by Graily Hewitt (1864-1952) and bound by Katharine Adams (1862-1952), embellished with heraldry by George Kruger (1880-1943). The next year, Kruger designed the cover of *The Dragon of Wessex* (fig.72) by Percy Dearmer (1867-1936) which shows at least some of that primitive vitality that the Arts and Crafts movement demanded of heraldic art. Other references to heraldic art in Arts and Crafts book cover design include Fred Mason's cover for *Huon of*

Bordeaux (fig.35), and Paul Woodroffe's for *A Little Beast Book* (fig.60), where the lion, bull, stag and boar, none of which are mentioned in the book, are all heraldic animals and are shown in heraldic postures. The single-masted ship, dolphins and scallop shell on A.A. Turbayne's cover for *Japhet in Search of a Father* (fig.34), and even the open knots featured on the cover of *Aucassin and Nicolette* (fig.70), designed by Robert Gossop, are all heraldic charges. The Tudor rose itself, which occurs again and again in Arts and Crafts book cover design, comes from the art of heraldry.

Although such a large portion of Arts and Crafts design rested on historical precedent, the style was held by contemporary opinion to be new and radical. To more conservative minds, there was even something shocking about its conventional treatment of natural forms. In the semi-autobiographical novel *The Romance of Zion Chapel* by Richard Le Gallienne (1866-1947), published in 1898, there is a chapter entitled 'How They Brought the Good News of a Morris Wall-Paper to Coalchester', which describes one provincial's reaction to the unwelcome incursion:

> When the paper was hung in Theophil's room, so great was the sensation in the household that even old Mr. Talbot ventured to look in at it, keeping very close to his wife...so the old man had stood open-mouthed before the first steam-engine, and here again was the devil plainly at work.

Theophil's mother tries to be more accommodating:

> "I suppose it's all right, boy," she said, "and it sounds silly to say about a lot of harmless lines and flowers, but it seems to your old mother that there's something wrong about that paper, - something almost wicked in it. It reminds me of that nasty music you and Jenny are so fond of playing."[83]

The offending music was by Dvorak, which suggests that it was the sensuality of a Morris wallpaper which appalled some people. In the context of Victorian England where art was supposed to be moralising or educational or both, Morris's art was alarmingly non-didactic. As Aymer Vallance wrote:

No bogey of the pulpit or of the platform lurks within the folds of his velvets; no homily is to be discovered in the colours of his chintzes..... One may enjoy the beauty of them, and one may revel in it to one's heart's content with the confident assurance that the designer is not the man to take a mean advantage of one's being absorbed in admiration for the purpose of cozening one....into swallowing a stealthy pill... [84]

Many, however, suspected Morris's socialism of being that "stealthy pill" wrapped in the beauty of his designs. By association, the Arts and Crafts movement gained a reputation - in many instances justifiably - for radical opinion. Writing in 1892, the artist Charles G. Harper (1863-1943) suggested that "were the artist to live again who, centuries ago, conceived the Tudor rose, whose only desire had been to satisfy the eye, he would be scoffed at as a man of "views"." [85]

The identification of Arts and Crafts design with progressive, if not subversive, ideas, made less likely many publishers' acceptance of the style on the covers of their books. But there were some who recognised the close affinity of Arts and Crafts thinking with the cultural outlook shared by a very considerable number of readers.

SOME PUBLISHERS

Two accounts of the difficulties faced by the designer of stamped cloth book covers describe the problems caused by there being too many cooks spoiling the creative broth. As well as the designer, there were the publisher, the binder and the author. Charles Dawson and David Whitelaw (1876-1971) both worked mainly in the poster style; versatility was an important weapon in the armoury of any designer seeking regular employment. Dawson wrote his account of the designer's vexations in an article entitled 'Modern Book Covers, from the Designer's Point of View', published in *Penrose's Pictorial Annual* for 1908-09. "The artist who seeks a grievance," he declared, "would find in cover designing the following drawbacks:

1. That the publisher's idea of remuneration is not enough to enable the artist to more than barely skip the MS or "copy" of the book which is to bear his design.
2. The time allowed for the work rarely admits of the preparation of sufficient rough sketches or preliminary studies from the model.
3. The publisher is usually under the impression that since he "pays the piper", he can alter the colour of the cloths or inks to suit any old whim or caprice.
4. The most carefully planned cover design may be cut up by the label of the libraries with as little regard for its proportions as an old woman gives to the materials which she chops up to make a crazy patchwork quilt.
5. Lastly, the author is an obtrusive person with a definite idea of what the cover should be like, and is invariably a cause of friction to all concerned.[86]

In his autobiography, published in 1933, David Whitelaw explained why he had given up designing book covers twenty-five years earlier:

I had on my list of clients some twenty publishers and binders, but the work was hard and none too satisfactory, as in many cases the prepared design had to be agreed upon, not only by the binder and the publisher, but in some cases by the author

also. It is hardly to be expected that four great minds should think alike, and one dissentient voice would perhaps mean rejection or, at least, considerable alterations in the original design. But one thing was necessary, and that was that I should read the proofs of the book in order to select the subject for my design. Bundles of proofs of innumerable novels would come to my house near Guildford, and I would read them in the garden, or maybe in the local hostelry, and after that, with my two dogs as companions, would take long walks, mentally digesting what I had read. All this was but preliminary to the work itself, and when one considers that the publishers paid about three guineas [£3.15], and sometimes less, for an accepted design, it will be seen that one cannot wax really prosperous on bookcover designing.[87]

What Dawson's and Whitelaw's descriptions make clear is that cover designing had become an area of commercial art, and for that reason alone, Arts and Crafts designers were less likely to participate in the work on any regular basis. Of the English artists whose work is represented here only Gleeson White, A.A. Turbayne, Talwin Morris and Reginald Knowles would probably have regarded cover designing as a major part of their activities. For the rest, a design might have been undertaken because the author or publisher was a personal friend, or, in several instances, because the author was the designer, or perhaps sometimes simply because the designer was glad to pocket the fee. Publishers usually commissioned a cover design from an Arts and Crafts designer when the style was appropriate to the subject of the book. Those subjects were primarily poetry, art history or criticism, and gardening; not surprisingly, it is often the name of a publisher with a list strong in one or more of those categories whose name is found on the title-page of a book with an Arts and Crafts cover. The publisher was the fulcrum on which the style and quality of a stamped cloth book cover rested. The consequential problems that the publisher faced were described by Charles Dawson, who recognised that "the publisher,

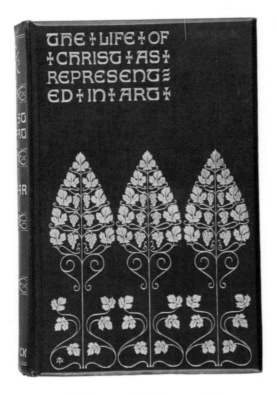

25. A.A. Turbayne, 1894 (cat. no. 57)

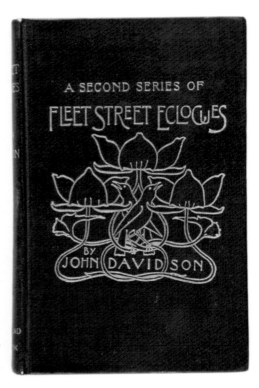

26. J. Walter West, 1894 (cat. no. 66)

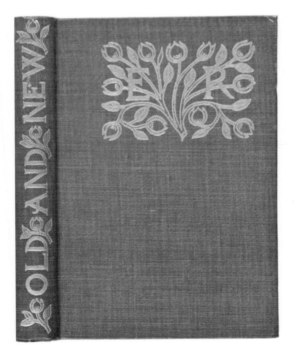

27. Selwyn Image, 1895 (cat. no. 28)

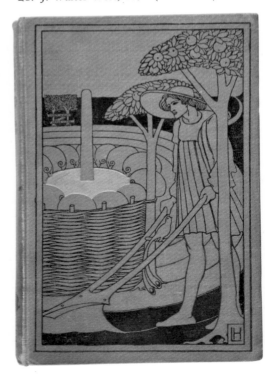

28. Laurence Housman, 1894 (cat. no. 21)

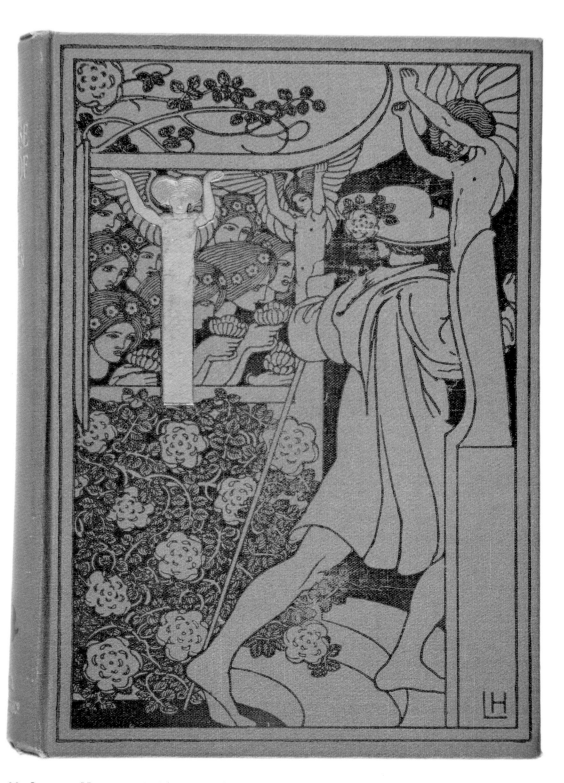

29. Laurence Housman 1895 (cat. no. 22)

poor man, stands betwixt the printer and the binder, the author and the artist; everybody's troubles are his troubles, whilst his troubles are of course his own".[88] H.B. Wheatley, addressing the Society of Arts in 1888, described the publisher's pivotal role in more positive terms: "If publishers will only employ good artists we should do well, but, unfortunately this is not always the case."[89]

There were a handful of publishers who regularly used "good artists", and the house most readily identifiable with the Arts and Crafts movement is Macmillan & Co. When the firm opened its London office in 1858, gatherings of authors and friends were held on Thursday evenings in Henrietta Street. Novelists, poets, historians, scientists, and artists attended the 'Tobacco Parliaments', as they were called, and "a round table was made for these occasions by a member of the Working Men's College".[90] Among the guests were Holman Hunt (1827-1910) and the Pre-Raphaelite sculptors Alexander Munro (1825-71) and Thomas Woolner (1825-92), and the poets William Allingham and Coventry Patmore (1823-96); another was Richard Garnett, an assistant at the British Museum library.[91] In 1862, Macmillan's published *Goblin Market and Other Poems* by Christina Rossetti (1830-94) with a cover and two illustrations by her brother Dante Gabriel. This, and the slightly modified design that Rossetti made for the second edition in 1865, were simple arrangements of rules and small circles, which offered a stark contrast to the showy ornament then in vogue. His cover for *The Prince's Progress*, another book of poetry by Christina Rossetti, published by Macmillan's in 1866 was slightly more elaborate but still notable for its sobriety in the context of 1860s cover design (fig.1). Alexander Macmillan (1818-96) had overseen the introduction of a restrained style for the books that he published. "He could not draw himself," wrote his biographer, "but he was full of ideas about bindings, titles, title pages, etc., which his binder James Burn, and Orrinsmith, the woodcutter (formerly assistant to W.J. Linton and afterwards Burn's partner), loyally carried out."[92] He was among the earliest publishers to recognise the commercial value of the well-designed book; as he told his brother, Daniel: "You don't know the influence of prettiness even on sensible people."[93] In 1861, he had instructed Burn to include in "our little design" for the house signet a butterfly "for beauty pure and aimless", an advanced concept to have been entertained by somebody born the year before Ruskin (1819-1900).[94]

When Harvey Orrinsmith married Lucy Faulkner in 1870, the couple went to live in Beckenham, close to the home of George Lillie Craik (1837-1905) who had been Macmillan's junior partner since 1865. The nexus was extended in 1875 to include Walter Crane; he had known Orrinsmith since 1859 when he had been apprenticed in the engraving workshop run by Orrinsmith and Linton, and now he was commissioned by Macmillan's to illustrate two books written by Craik's wife, Dinah Maria Mulock (1826-87). The same year, Crane illustrated for Macmillan's the first of seventeen children's books written by Mrs Molesworth (1839-1921) for which he also designed the covers (fig.5). In 1877, Macmillan's published Lucy Orrinsmith's *The Drawing-Room* in their 'Art at Home' series, which she dedicated to George Lillie Craik and scattered with reference to Morris & Co. furnishings. In 1884 she designed the double cover for *The Collected Works of Alfred Lord Tennyson* in a style close to that of the patterns designed by her sister Kate Faulkner (d.1898) for Morris & Co. (fig.6).

In 1883, Macmillan's launched the *English Illustrated Magazine* under the editorship of J. Comyns Carr (1849-1916). There was always a flavour of the Arts and Crafts movement about the magazine's content, both literary and artistic. The articles and poems that it printed were embellished with decorative designs by such artists as Walter Crane and Heywood Sumner. When Emery Walker was appointed art editor in 1889, the Arts and Crafts component was enlarged. William Morris's poem *The Hall and the Wood* appeared in the magazine in 1890, and his fantasy *The Story of the Glittering Plain* was serialised in its pages. There were articles by W.A.S. Benson and T.J. Cobden-Sanderson. Among new artists supplying decorative designs and illustrations were Louis Davis and A.A. Turbayne, as well as three young designers from Birmingham, Edmund New (1871-1931), Arthur Gaskin and C.M. Gere

(1869-1957). Turbayne and New went on to design book covers for Macmillan's (fig.22, 34). It is difficult to judge the full extent of the influence on Macmillan's output exerted by Emery Walker, "to whom the firm was for many years indebted for counsel of unrivalled authority".[95] Was he, for instance consulted in 1893 when Macmillan's agreed to publish an edition of *Goblin Market* with illustrations and a cover by Laurence Housman (fig.15)? Surely his advice underpinned the firm's decision to publish that year an edition of Tennyson's *Maud* printed by the Kelmscott Press. After the death of Alexander Macmillan in 1896, the house continued to support the Arts and Crafts movement. Cover designs were commissioned from William Macdougall (1865-1936) and Thomas Sturge Moore (fig.76). Frederick Macmillan (1852-1936) who took charge of the company on his father's death, served on the Advisory Committee of the *Imprint* (1913), an Arts and Crafts oriented journal of typography and printing edited by F. Ernest Jackson (1872-1945), John H. Mason (1875-1951) and Edward Johnston (1872-1944).

By 1900 the house of Macmillan had grown to be a whale among publishers. In contrast, Frederick Ellis's firm was never more than a minnow, but its significance to Arts and Crafts stamped cloth book cover design far outweighed its size. Between 1870 and 1873, Ellis issued two books with covers designed by Dante Gabriel Rossetti, one with a cover by Philip Webb and one with a cover by William Morris (fig.2,3,4).[96] The four covers broke the mould of High Victorian book cover design; they were simple, restrained, and quite without symbol, allegory or moral. Nothing had surpassed them in their field by 1888 when they were given a new lease of life, first by H.B. Wheatley who included them in a small exhibition at the Society of Arts, and then by the Arts and Crafts Exhibition Society at their inaugural show. They were still fresh enough then to have an impact on designers and publishers which initiated a modest deluge of Arts and Crafts stamped cloth book covers over the next twenty-five years.

Frederick Startridge Ellis had studied at Paris and Frankfurt before serving his apprenticeship with a bookseller in Chancery Lane. About 1857, he opened his own bookshop in King Street, Covent Garden. His clientele soon included John Ruskin, Algernon Swinburne and Dante Gabriel Rossetti, and, from 1864, William Morris. Four years later, Ellis started publishing books by William Morris and soon added to his list poetry by Swinburne, Rossetti and his sister Christina. He was an accommodating publisher who recognised both the literary and artistic talents of his authors. He "thought publishers would stand very much in their own light if they interfered with an artist, when they found one capable of illustrating their books in a proper manner".[97] The care and consideration given by designer and publisher to details of the cover and end-papers for Rossetti's *Poems* is revealed by the artist's letters to Ellis at the time the book was in preparation.[98] For example, Rossetti wrote to Ellis in April, 1870: "The blue cloth is just the one I meant & I think it quite satisfactory"; there were other letters about the colour of the gold to be used and about the difficulties of using the cover design on a large-paper edition.[99] It is clear that Ellis was thinking about the design of the book just as hard as Rossetti, and that he was content to indulge the artist's wishes. The amount of engraving on the stamps for the *Poems* cover (fig.2), and on Webb's cover for *The Story of the Volsungs and Niblungs* (fig.3), must have been prodigiously expensive, but even Ellis would have been reluctant to endorse William Morris's claim that the "publishers' part was to open their purse as widely as possible, not to be afraid to spend a good deal of money on a good book, though they only sold a few copies".[100] Ellis's liberality was apparently to no commercial avail. Rossetti wrote to a friend in 1872: "Ellis's opinion is that the ornamental covers to the books he has published for Morris, Swinburne and myself have had absolutely no effect either one way or the other."[101] Ellis's publishing business continued for some years with the support of a succession of partners, but the firm never again produced books of such outstanding artistic quality as those designed by Rossetti, Morris and Webb. Ellis remained one of Morris's closest friends, and collaboration between the two men was renewed in the 1890s when Ellis edited some Kelmscott Press books. In 1898, Ellis gave a talk on 'The Life-Work of William Morris' to the Society of Arts. The

chairman of the meeting, Dr Richard Garnett, proposed a vote of thanks to the speaker, saying that he "really thought, in all seriousness, that the friendship of Mr. Morris and Mr. Ellis would go down to posterity along with the many interesting literary friendships which had done honour to the republic of letters".[102]

Another publisher who was closely identifiable with the Arts and Crafts movement was George Allen (1837-1907). As a young carpenter and joiner, he had fallen in love with a lady's-maid called Hannah who was in service to Ruskin's mother. At the bidding of his inamorata, he started attending classes at the Working Men's College in Great Ormond Street. He studied drawing under Ruskin and Rossetti and was regarded as a most promising pupil. He married Hannah in 1856 and at about the same time was appointed assistant drawing master at the College. (Was George Allen the member of the Working Men's College who made the round table used by the 'Tobacco Parliaments' at Macmillan's?) Rossetti invited him to join the firm being set up by William Morris as a partner in charge of the furniture department, but Allen preferred to devote himself exclusively to Ruskin's service. He drew and engraved illustrations to Ruskin's books, and when Ruskin dropped his publisher, Smith, Elder & Co., the author invited Allen to undertake the production and distribution of *Fors Clavigera*; he agreed. The enterprise, based in Allen's cottage at Keston, Kent, grew as more Ruskin titles were added to the list, and, after three years, the Allen family removed to a larger home, Sunnyside at Orpington, Kent. There the business continued to grow rapidly, but Allen's publishing activities were still restricted to Ruskin's oeuvre.

In 1884, George Allen published the first number of the *Hobby Horse* from Sunnyside, and thus initiated a list which included other authors besides Ruskin. It was a slow process and George Allen was not involved in the publication of any subsequent numbers of the *Hobby Horse*, but by 1890 commercial expediency had demanded the opening of a London office at Bell Yard, and this was soon abandoned for larger premises in Charing Cross Road, which were given the name 'Ruskin House'. From here a number of books decorated

and illustrated in the Arts and Crafts style were issued. They bore an elaborate signet showing St George and the Dragon designed by Walter Crane who illustrated an edition of Spenser's *Faerie Queen* for the firm. Like Macmillan, George Allen was eager to employ artists of the Birmingham school, and in 1893 he published *Stories & Fairy Tales by Hans Christian Andersen* with illustrations and a cover by Arthur Gaskin (fig.18). There followed three books of medieval legends with illustrations and covers designed by Fred Mason, perhaps the least well-known of the Birmingham illustrators (fig.35). George Allen again followed a precedent set by Macmillan when he commissioned covers from A.A. Turbayne (fig.48, 54). Other Arts and Crafts designers who created covers for books published by George Allen include Byam Shaw (1872-1919) and Reginald Knowles.

When Charles Kegan Paul gave his lecture on 'The Production and Life of Books' in 1883, he demonstrated an Arts and Crafts attitude to book production, and in the 1880s his publishing company, Kegan Paul, Trench, Trübner & Co., issued the 'Parchment Library'. "The intention of this series," Kegan Paul recalled in 1899, "was to present in thoroughly good paper and print some of the most distinguished English classics, and we certainly set the fashion of really beautiful books."[103] At about this time, Kegan Paul became involved with Toynbee Hall, an East End settlement house which can be counted as an important stimulus to the growth of the Arts and Crafts movement. From 1891, he sat on the board of the Whitechapel Craft School in Little Alie Street, an offshoot of Toynbee Hall's artistic and educational activities. Kegan Paul, Trench, Trübner & Co. published the *Hobby Horse* from 1886 to 1888, and Charles Kegan Paul himself contributed essays and poems to the journal until 1892. It was possibly Kegan Paul who introduced Alfred Pollard to the *Hobby Horse* editors; the two men had met when Pollard had undertaken the translation of some Latin texts for the publisher. Kegan Paul counted his friendship with Pollard as "one of the greatest pleasures of the later period of my life."[104]

Alfred Pollard edited the series 'Books about Books' for Kegan Paul, which included his own *Early Illustrated Books* (1893). He

30. Laurence Housman, 1895 (cat. no. 23)

31. Gleeson White, 1895 (cat. no. 70)

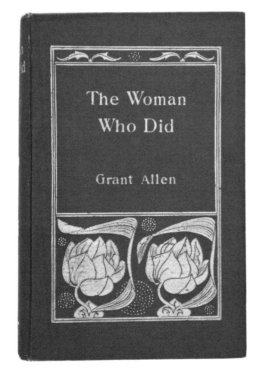

32. Aubrey Beardsley, 1895 (cat. no. 2)

33. A.A. Turbayne, 1895 (cat. no. 58)

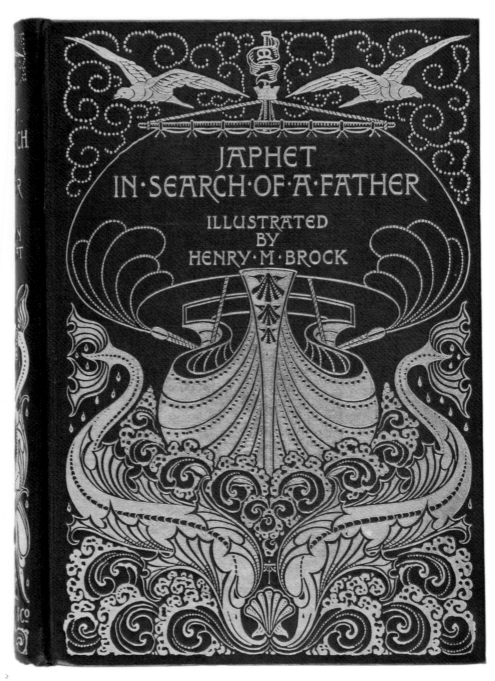

34. A.A. Turbayne, 1895 (cat. no. 59)

introduced Laurence Housman to the publisher who, between 1894 and 1898, issued four books written and illustrated by Housman, all with covers designed by the author; *A Farm in Fairyland* (1894) and *The House of Joy* (1895) were among them (fig.28, 29).[105] Kegan Paul also published *Bibliographica* (1895-97), edited by Pollard and decorated with designs by Housman. In 1897, an edition of Keats's *Isabella and the Pot of Basil* with decorative illustrations and a cover designed by William Macdougall was published by Kegan Paul. Paul Woodroffe was asked to supply a design for the cover of *The Little Flowers of St Francis* (fig.56), published by Kegan Paul in 1899, probably because he was a close friend of Laurence Housman who had had a considerable influence on Woodroffe's style. There is also the possibility that Woodroffe was given the commission by Kegan Paul because both men were Roman Catholic; the book was printed by Bernard Newdigate (1869-1944) at the Art and Book Co. in Leamington. Newdigate too was a Roman Catholic; both he and Woodroffe had been pupils at the same Jesuit school.

Joseph Mallaby Dent (1849-1926) had been a bookbinder before he became a publisher in 1888. He might be described as a cultural altruist; most of the books that his firm issued were intended, by their material form, superior content and modest price to attract the aspiring artisan such as he himself had been. Dent's involvement with the Arts and Crafts movement was a natural outcome of his earnest desire to do good. His son Hugh explained what happened:

In those days he knew nothing of William Morris and the revived interest in old crafts, but he felt instinctively the close relation between the training of hand and eye and the growth of the soul....
When he came to know the work of Morris and Cobden-Sanderson his admiration was at once secured, and he had a strong sympathy with the ideas and ideals of the Arts and Crafts movement. With all his interest in the crafts it is strange that he never produced any great specimen of bookbinding.....But in arranging the binding of his own books most of the designs were based upon ideas which he put before the artists who made the actual drawings.[106]

His bookbinding background is clearly indicated by the cover that Herbert Granville Fell (1872-1951) designed in 1894 for the 'Lyric Poets' series (fig.24). Dent's admiration of Cobden-Sanderson's bookbindings must have defined the brief he gave Granville Fell. The design met some opprobrium from the series editor Ernest Rhys (1859-1946) who, many years later, would describe the volumes as "almost too pretty-pretty in their pale blue and gold".[107] The same year as this series first appeared, Dent published *Le Morte Darthur* with a striking cover by Aubrey Beardsley who illustrated and decorated the work, an attempt by the publisher to make a book comparable to a Kelmscott Press volume at a price the man in the street could afford. Over the next two decades, some notable Arts and Crafts book cover designers worked for Dent. In 1896 William Macdougall designed the innovative cover for *The Book of Ruth* (fig.40); other designers included Laurence Housman, R. Anning Bell (1863-1933), Harold Nelson, Edmund New, Paul Woodroffe and Robert Gossop (fig.70).

Joseph Dent, like Charles Kegan Paul, had been drawn to Toynbee Hall, which lay not far from Dent's premises in Great Eastern Street. He started going there about 1886 and soon became involved in its activities. He joined the Shakespeare Society and was elected to the Education Committee. He must have welcomed the establishment in 1891 of the Whitechapel Craft School in Little Alie Street, and he would have been delighted when, about eight years later, he was able to give work to one of its students. Reginald Knowles, born in Poplar, had attended the school and started designing book covers professionally about 1899, and he soon started working for Dent on a full-time basis. "The association with Dent's did not end when he left the firm to start his own studio as a free-lance," wrote his memorialist, "and he continued to produce many beautiful designs and drawings for them."[108] From the outset, his work owed most to the Arts and Crafts style which would have prevailed at the Whitechapel Craft School (fig.58, 62, 64, 68).

The house of George Bell & Sons was first associated with the Arts and Crafts movement when the Chiswick Press, which it had acquired in 1880, printed the *Hobby Horse* for the

Century Guild. This was in 1884, at a time when the ailing John Bell, George Bell's brother who was to die the following year, was handing over the management of the Press to Charles T. Jacobi (1853-1933). "The Press," wrote Edward Bell, George's eldest son, "remained a kind of supplement to our publishing business under Mr. Jacobi's management until his retirement in 1919."[109] The attraction of the Chiswick Press to Arts and Crafts designers was the quality of its presswork and its use of the generously-proportioned Caslon Old Face type. Jacobi advised William Morris about presses and types, and both *The House of the Wolfings* (1888) and *The Roots of the Mountains* (1890) were printed at the Chiswick Press.

When George Bell died in 1890, his son Edward took charge of the business. Edward's younger brother Arthur George Bell (1849-1916) had worked for the firm briefly in the 1870s before taking up art. He had become a successful watercolour painter who exhibited with the New English Art Club. In this context he may have become acquainted with Selwyn Image and recommended him to his brother as the designer of a cover for *The Tragic Mary* (fig.9). Alternatively, Image might well have come to the publisher's attention through the Chiswick Press and Image's work in the *Hobby Horse*. Image was probably on friendly terms with Arthur Bell because in 1899 Image would design the cover of *Representative Painters of the XIXth Century* written by Nancy Bell, Arthur's wife (fig.52). The couple had a house at Southbourne-on-Sea, Hampshire, and were part of an artistic coterie, largely consisting of summer visitors from London. It used to meet at a bookshop in nearby Christchurch, which was owned and managed by Gleeson White. He was a regular contributor of criticism and verse to a number of journals including the *Scottish Art Review*, and he worked in New York for a year (1890-91) as associate editor of the *Art Amateur*. On his return from New York he was appointed art director at Bell's and started designing covers in an Arts and Crafts style for many of the books that they published. In addition to his work here, he also undertook the editorship of the *Studio*, and he was largely responsible for its launch in April 1893. For the magazine's early issues he turned

to his Christchurch friends for contributions, including Arthur Bell whom he commissioned to write an article on the sketching grounds of Holland.[110] White gave the *Studio* a strong Arts and Crafts flavour, with many articles about the movement's most prominent artists, and he commissioned C.F.A. Voysey (1857-1941) to design the first two bound volumes of the magazine (fig.19). He also wrote an article himself on stamped cloth book covers for the magazine.[111]

In 1894 Gleeson White gave up the editorship of the *Studio*, perhaps finding his work there as well as at Bell's too much of a burden. At Bell's he had the dual role of art director and reader. Dr George Williamson (1858-1942), who would be appointed art director at Bell's following White's death, would later describe White's activities with the firm:

> *Gleeson White was there in charge of the Art Department - a very facile draughtsman, responsible for some beautiful book covers.... He had an amazing ability in editing books that he had suggested should be issued, and in finding suitable writers for them.*[112]

One such suggestion was *Practical Designing* which included chapters by Arthur Silver (1853-96), R.Ll. Rathbone (1864-1939) and Selwyn Image, as well as Harvey Orrinsmith, who wrote about designs for book covers. White edited the book and designed the cover. It was published in 1893, the year that James Burn acquired the firm which bound much of Bell's output. He initiated several series at Bell's for most of which he designed the covers. An exception was the 'Endymion Series', volumes of classic poetry each illustrated by a leading decorative artist who usually designed the cover as well. The series included Anning Bell's *Keats* (fig.45). White's own cover designs for Bell's were consistently Arts and Crafts in style; most of them were art books (fig.21) or volumes of poetry (fig.16). After White's early death from typhoid fever in 1898, Dr George Williamson was appointed art director at Bell's, and he commissioned covers from several Arts and Crafts designers including Christopher Dean (fig.57), Harold Nelson who designed the cover for Bell's 'Handbooks of the Great Craftsmen' (1901) and Laurence Housman;

the cover Housman designed for H. Marillier's 1899 monograph *Dante Gabriel Rossetti* was, in Williamson's opinion, "one of Housman's finest designs....a splendid and stately book".[113]

Elkin Mathews (1851-1921) and John Lane (1854-1925) started publishing books from "a funny little shop, almost the smallest in London", at 6b Vigo Street, London, in 1889.[114] Both partners were immersed in a world of antiquarian books, fine printing and limited editions. But they were also keenly aware of the artistic and literary ferment bubbling around them; those were the days of the Rhymers' Club, the New English Art Club and the Arts and Crafts Exhibition Society. Lane, particularly, saw the direction that he wanted their enterprise to take. Richard Le Gallienne, the publishers' first author and for many years their reader, would later write:

> Lane was the first to apply to general publishing the new ideals in printing and binding that were already in the air, and which, before William Morris had started his Kelmscott Press, had found expression in such beautiful esoteric magazines as the Century Guild Hobby Horse....and the Dial.[115]

Charles Ricketts, the editor of the *Dial*, was among the first designers to work for Mathews & Lane, and most of the covers that he designed for the publishers were in a style more readily identifiable with the Decadence than with the Arts and Crafts movement. Nevertheless, three covers designed by Ricketts for Mathews & Lane were included in the Arts and Crafts Exhibition Society's fourth show in 1893, including Lord De Tabley's *Poems Dramatic and Lyrical* (fig.17). The next year, Mathews and Lane dissolved their partnership; both men continued to publish independently. Lane maintained a policy of trying to attract both wings - Decadent and Arts and Crafts - of modern culture, and some of the covers that Aubrey Beardsley designed for him reflect this duality, for instance the cover of *The Great God Pan* where Beardsley has combined the figure of the perverse deity with an allusion to the ornamental title-pages of early printed books (fig.23). Lane also employed Laurence Housman, a designer whose work appealed to a range of tastes (fig.30, 36). At the same time, Lane was not averse to employing such

unmistakably Arts and Crafts artists as Edmund New and Patten Wilson to design covers for books aimed at readers who might bridle at Decadence. Such recourse became important if not imperative when the scandal of Oscar Wilde's homosexuality broke in April 1895. Aubrey Beardsley, tainted by association, was dismissed and Patten Wilson took over the art directorship of Lane's quarterly the *Yellow Book*. Wilson designed covers for many of the more wholesome books that Lane now thought it politic to publish (fig.37). The issue of the *Yellow Book* for April 1896 was illustrated and decorated entirely by artists of the Birmingham school, and the following year Edmund New designed the cover for an edition of *The Compleat Angler* edited by Richard Le Gallienne, among the most prestigious of Lane's publications of 1897 (fig.43).

After 1896, John Lane spent much time and energy on the New York office that he opened that year, and the care and consideration - not to mention money - that he had lavished on cover designs was missing. Lane was first and last an entrepreneur, and he had flirted with the Arts and Crafts movement when he had seen a commercial advantage in it. He did not entirely desert it, however, commissioning cover designs from Edmund New for the many gardening books that he published at the turn of the century (fig.59).

Before the outbreak of World War One in 1914, publishers had almost ceased to commission designs for stamped cloth book covers, although some ornamental designs in an Arts and Crafts style were still employed for expensive picture books. The series of 'Twenty Shilling' (£1.00) colour books issued by A. & C. Black included many with covers designed by A.A. Turbayne (fig.68). The commercial benefits of a decorated cloth book cover had become more precisely understood by publishers, and ever more competitive conditions in the book trade had demanded the restriction of ornamented covers to a narrower range of categories. The price of gold had risen steadily as the inevitable hostilities had approached, so printed paper book jackets had proved increasingly seductive. All these factors helped to dissuade publishers from commissioning decorative cloth covers, whether

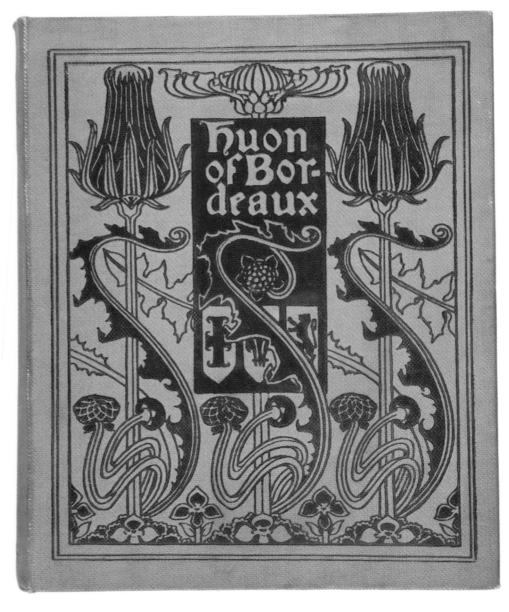

35. Fred Mason, 1895 (cat. no. 40)

36. Laurence Housman, 1896 (cat. no. 24)

in the Arts and Crafts or any other style.

But it is difficult not to suspect that the Arts and Crafts movement itself had started to abandon the stamped cloth book cover as a means of expression. The Central School of Arts and Crafts and its offshoot the Day Technical School of Book Production had concentrated more and more on the typography, calligraphy, illustration and hand-binding of de luxe editions. The Kelmscott Press had spawned the private press movement which, despite all its glorious fruits, was a hothouse plant. The more democratic world of commercial publishing had been almost totally ignored.

Reviewing the Arts and Crafts Exhibition Society's 1912 show for *Imprint*, Bernard Newdigate dealt at length with private press books and hand-bindings; he added, almost blushingly: "There are no examples or designs for cloth-cased books at the Exhibition."[116](In fact, according to the catalogue there were two or three, including Reginald Knowles's cover for *Picturesque Brittany* (fig.64), published six years earlier.) Newdigate continued: "This is a pity, for the ultimate aim of the arts and crafts movement is not so much to encourage the production of a few beautiful but costly objects as to give comeliness to the fashioning and decoration of the common things which we see and use daily."

However, the participation of Arts and Crafts artists in the design of cloth covers left a legacy which would be enjoyed by later generations of designers working in what was already becoming known as 'commercial art'. There were two ways in which this legacy would be handed down - education and co-operation. The need for better technical education had been recognised by the newly-constituted London County Council early in the 1890s. Sidney Webb (1859-1947), elected to the Council in 1892, had made it one of his priorities. He had ordered a review of technical instruction in the capital, and the findings were dire. A Technical Education Board had been established. In 1893, Webb had told the *Daily Chronicle*: "I want the London workman to become once more the skilled craftsman."[117]

The next step had been to start new schools and to raise the quality of instruction given in the existing ones. The introduction to the

catalogue of a book exhibition organised by the Central School of Arts and Crafts in 1912 gave "a short account of the history of the L.C.C. classes in book production", which stated:

> *Classes dealing with several branches of book production were among the first to be formed; and at Bolt Court [off Fleet Street]....a school of Photo-engraving and Lithography was established that has done and is still doing splendid work.*[118]

The Bolt Court school, as it was generally known, had been established in 1895. W.R. Lethaby and the sculptor George Frampton had been appointed members of the committee which ran the school. At its opening, Edwin Bale, Art Director of the publishers Cassell & Co., and formerly a teacher at the Lambeth School of Art, had given an inaugural address; speaking in terms redolent of Arts and Crafts philosophy, he had said:

> *We require not mere machines, but human men with brain and heart in union to work not for wage alone, but because they have a pleasure in their work...*[119]

A list of the visiting lecturers due to come to Bolt Court during the 1895-96 session had included William Morris speaking on 'Early Woodcut Illustration', Gleeson White on 'Posters', T.J. Cobden-Sanderson on 'Bookbinding', and Emery Walker on 'Typography'. In 1898, A.A. Turbayne had been appointed teacher of the design class which had soon doubled the frequency of its meeting to twice a week. A Sketch Club had been started, "considered in those days to be one of the most successful art clubs of its kind in London",[120] and among the artists who had attended its gatherings had been Frank Brangwyn (1867-1956), Robert Anning Bell, Selwyn Image, and Emery Walker. From 1903 until his death thirty years later, Walker was chairman of the Advisory Sub-Committee, equivalent to a board of governors. Instruction was given at the school in all the processes of reproduction used in books, magazines and newspapers, and Turbayne's class studied "design for book decoration, type, lettering, bindings in cloth and paper, and for "tooling" on leather".[12]
The students were the people who would have to deal with illustrators and designers, many

f whom would come from an Arts and Crafts ackground. At least they would all speak the ame language.

A.A. Turbayne was also involved in the econd of the two channels through which rts and Crafts practice and principles were ransmitted from book cover design to the ommercial art of the future - co-operation. As emand from publishers declined, designers ound that alternative clients appeared in the hape of press and advertising art directors. They equired specialisation of subject and treatment ut did not want to waste time searching for the ight artist. Turbayne seems to have been one of he first in Britain to realise that by combining heir talents in a single co-operative enterprise, a umber of artists working under one roof could ttract a greater volume of work for each artist han if they were operating as individuals. About 905, Turbayne started the Carlton Studio with our young Canadian artists fresh out of the Art tudents' League of Toronto; they had come to ondon "to form the Carlton Studio, and o lift the reproach of commercial from trade ropaganda".[122] The American graphic artist nd book designer Dard Hunter (1883-1966), ho arrived in London in 1911 on his way ome after a period of study in Vienna, would ater remember:

My first call was the Carlton Studio, 195 Strand....[the manager] said a place could be found for me, as they were in need of a designer who could work in the modern Viennese manner. I was to receive five guineas [£5.25] a week....My dismal room was between the studios of Garth Jones and Harold Nelson.[123]

Hunter's memories provide a tantalisingly brief glimpse of the new studios and how they operated. Reginald Knowles, too, worked at the studio during the First World War. As well as the Carlton, there were other similar enterprises; the Granville Studio was located on High Holborn. and the Norfolk Studio in Racquet Court, off Fleet Street. Finding his "dismal room" intolerable, Hunter removed his services to the Norfolk Studio, where "there were more than thirty commercial artists working".[124] There he designed the cover, title page, initials and ornament for *Penrose's Pictorial Annual* for 1911-12. "In short," wrote a commentator in *Penrose's* for 1913-14, "the day of the independent commercial artist has gone, for business men have been quick to realise the many advantages offered by really efficient, business-like art-producing concerns, generally called 'Studios'".[125] Even if Robert Gossop was appointed manager of the Carlton Studio after the First World War, it seems a far cry from Rossetti at Kelmscott Manor, drawing from Gerard's *Herbal*, and we have strayed, perhaps, beyond the confines of the subject of this book, but it is gratifyingly evident that even in these "business-like, art-producing concerns", there were people working in the spirit of William Morris and the Arts and Crafts movement.

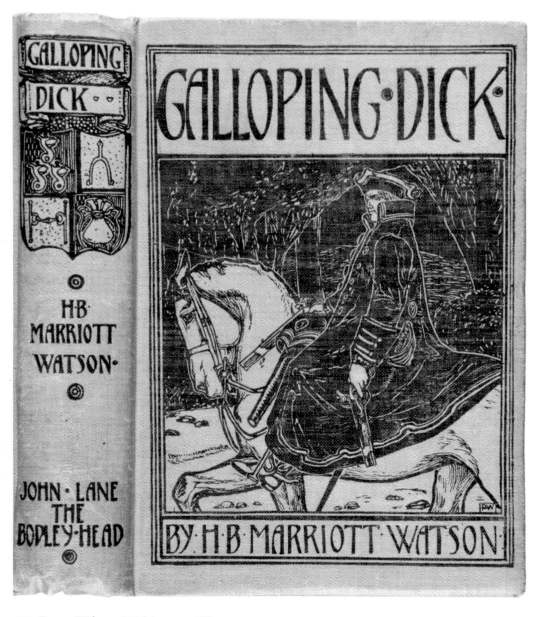

37. Patten Wilson, 1896 (cat. no. 73)

38. Frank Brangwyn, 1896 (cat. no. 5)

39. W. Harry Cowlishaw, 1896 (cat. no. 6)

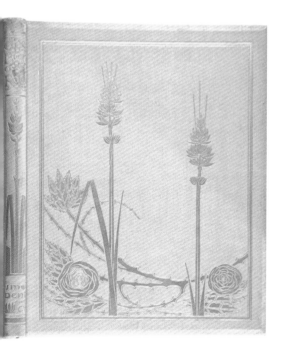

40. William Macdougall, 1896 (cat. no. 38)

41. Gleeson White, 1897 (cat. no. 71)

42. Gleeson White, 1897 (cat. no. 72)

NOTES

1. Henry B. Wheatley, 'The Principles of Design as Applied to Bookbinding', *Journal of the Society of Arts* 36/1840 (24 Feb. 1888) p.375.
2. Ibid., p.368.
3. Ibid., p.375.
4. Quoted by A.R.A. Hobson, 'William Beckford's Binders', *Festschrift Ernst Kyriss* (Stuttgart, 1961) pp.378-79.
5. John Leighton, 'On the Library, Books, and Binding', *Journal of the Society of Arts* 7/327 (25 Feb. 1859) p.214.
6. W. Tomlinson and R. Masters, *Book Cloth 1823-1980* (Stockport,1996) p.9.
7. Ibid., pp.9-10.
8. Letter from D.G. Rossetti to Dr T.G. Hake (25 Sep.1872) quoted by Giles Barber, 'Rossetti, Ricketts, and Some English Publishers' Bindings of the Nineties', *The Library*, series 5, vol.25 (Dec. 1970) p.320.
9. Charles Morgan, *The House of Macmillan (1843-1943)* (London, 1944) pp.105-06.
10. H.T. Wood, 'Bookbinding in the Exhibition', *Journal of the Society of Arts* 22/1123 (29 May 1874) pp.681, 682.
11. Henry B. Wheatley, 'The History and Art of Bookbinding', *Journal of the Society of Arts* 28/1430 (16 Apr. 1880) p.464.
12. Charles Kegan Paul, 'The Production and Life of Books', *Fortnightly Review* n.s. 33 (Jan.-Jun. 1883) p.495.
13. Charles Kegan Paul, *Memories* (London, 1971) p.360.
14. "The Japan Society, the Royal Institution, the Ex-Libris Society - no gathering scientific, literary, artistic or social, was complete without the presence of the dandified, diminutive figure of John Leighton." David Whitelaw, *A Bonfire of Leaves* (London, 1937) p.18; John Leighton was Whitelaw's cousin.
15. Wheatley, op. cit. (1) p.368.
16. Laurence Housman, 'A Forgotten Book Illustrator', *Bibliographica* 1 (1895) p.275.
17. Wheatley, op. cit. (1) pp.371-73.
18. T.J. Cobden-Sanderson, 'Bookbinding. Its Processes and Ideal', *Fortnightly Review* n.s. 332 (1 Aug. 1894) p.217.
19. Sir Reginald Blomfield, *Memoirs of an Architect* (London, 1932) p.74.
20. Peter Stansky, *Redesigning the World* (Princeton, 1985) p.204.
21. 'Book Covers', *Scottish Art Review* 1/5 (Oct. 1888) p.143.
22. F. Elliot, 'The First Exhibition of the Arts and Crafts Exhibition Society', *Scottish Art Review* 1/6 (Nov. 1888) pp.160-62.
23. H.T. Wood, op. cit. (10) p.676.
24. Lionel S. Darley, *Bookbinding Then and Now* (London, 1959) p.81-82.
25. Ibid., p.82.
26. 'Bookbinding', Charles Tomlinson (ed.) *Cyclopaedia of Useful Arts* (London and New York, 1854) p.159.
27. Darley, op. cit. (24) p.82.
28. Lewis F. Day, 'Craftsman and Manufacturer', *Journal of the Society of Arts* 36/1849 (27 Apr. 1888) p.635.
29. John D. Sedding, 'Our Arts and Industries', *Art and Handicraft* (London, 1893) p.129.
30. William Morris, 'The Prospects of Architecture in Civilisation', *Hopes and Fears for Art* (2nd ed. London, 1882) p.191.
31. Aymer Vallance, 'A Provincial School of Art', *Art Journal* 1892, p.346.
32. Quoted by Lona Mosk Packer, *The Rossetti-Macmillan Letters* (London and Berkeley, 1963) p.55.
33. Darley, op. cit. (24) p.50.
34. Emma Ferry, 'Lucy Faulkner and the 'ghastly grin'', *Journal of the William Morris Society* Winter 2008, pp.65-84.
35. H. Orrinsmith, 'Book-Binding', Gleeson White (ed.) *Practical Designing* (London and New York, 1893) pp.227-36.
36. "...pauper-linen, such as is used for packing and bookbinding...", George and Weedon Grossmith, *The Diary of a Nobody* (Ware, 1994) p.48.
37. Gleeson White, 'The Artistic Decoration of Cloth Book-Covers', *Studio* 4/19 (Oct. 1894) p.22.
38. Tomlinson and Masters, op. cit. (6) p.100.
39. Henry P. Kendall, 'Book Cloths', Frederick H. Hitchcock (ed.), *The Building of a Book* (New York, 1906) p.228.
40. W. Morris, 'The History of Pattern-Designing', May Morris (ed.) *The Collected*

Works of William Morris (London, 1914) vol. XXII, p.209.

41. W. Morris, 'Some Hints on Pattern-Designing', op. cit. (40) p.178.
42. H. Orrinsmith, op. cit. (35) p.228.
43. Ibid. p.234.
44. A.H. Mackmurdo, 'Arbitrary Conditions of Art', *The Century Guild Hobby Horse* (hereafter *Hobby Horse*) 2/2 (April 1887) p.60.
45. *Hobby Horse* 1/3 (July 1886) p.[90].
46. W. Morris, 'The Lesser Arts', op. cit. (30) p.19.
47. Ibid.
48. W. Morris, op. cit. (41) p.202.
49. R.P. Gossop, *Boys and Girls Come Out to Draw!* (London, 1949) p.24.
50. Quoted by G. Barber, op. cit. (8) p.320.
51. L.F. Day, 'A Twentieth Century Herbal', *Art Journal* (1903) p.247.
52. J.D. Sedding, *Garden-Craft Old and New* (London, 1891) p.14.
53. R. Blomfield, 'On Gardens and Grounds', *English Illustrated Magazine* 9/99 (Dec. 1891) pp.225-31.
54. R. Blomfield, *The Formal Garden in England* (London, 1936; preface to 3rd edition [1901]) p.v.
55. W. Morris, 'The Beauty of Life', op. cit. (30) p.104.
56. E.S. Prior, 'The Design of Gardens', *Hobby Horse* 7 (1892) pp.48, 49.
57. Quoted by D.A. Harrop, *Sir Emery Walker 1851-1933* (London, 1986) p.9.
58. H. Horne and R. Garnett, 'Of the Illustrations to the "Quadriregio", Florence, 1508', *Hobby Horse* 3/9 (Jan. 1888) pp.34-40.
59. H.T. Dunn, *Recollections of Dante Gabriel Rossetti and his Circle* (Westerham, 1984) p.17; H. Allingham and D. Radford (ed.), *William Allingham. A Diary* (London, 1907) p.140.
60. W. Crane, *The Decorative Illustration of Books* (London, 1994) p.62.
61. J. McIntyre, 'Robert Anning Bell (1863-1933): A Quintessential Illustrator of his Time', *IBIS Journal 4 Phantasies and Dreams* (Guildford, 2011) p.12.
62. A.W. Pollard, 'On Some Old Title-Pages', *Hobby Horse* 3/9 (Jan. 1888) pp.57-58.
63. L. Housman, 'A Forgotten Book Illustrator',

pp.275-90; W. Morris, 'On the Artistic Qualities of the Woodcut Books of Ulm and Augsburg in the Fifteenth Century', pp.437-55: *Bibliographica* 1 (1895).
64. [A.W. Pollard], 'Epilogue', *Bibliographica* 3 (1897) p.490.
65. A.W. Pollard, op. cit. (62) p.58.
66. A.W. Pollard, *Last Words on the History of the Title-Page with Notes on Some Colophons* (London, 1891).
67. G.R. Redgrave, *Erhard Ratdolt and his Work at Venice* (London, 1894).
68. F. Ogania (ed.) *Early Venetian Printing Illustrated* (Venice, London and New York, 1895) p.13.
69. W. Morris, 'The Woodcuts of Gothic Books', *Journal of the Society of Arts* 40/2047 (12 Feb. 1892) p.256.
70. *Bibliographica* 1 (1895) p.257.
71. L.F. Day, 'Principles and Practice of Ornamental Design II', *Journal of the Society of Arts* 35/1780 (31 Dec. 1886) p.109.
72. J. Leighton, *Book-Plate Annual and Armorial Year Book* (London, 1894) f.p.7.
73. W. Morris, op. cit. (63) p.437; T. Sturge Moore, *Albert Durer* (London, 1905).
74. J.H. Mason, 'A Brief Sketch of the History of Wood-Engraving', *Imprint* 1 (17 May 1913) p.299.
75. R. Blomfield, 'Of Book Illustration and Book Decoration', *Arts and Crafts Essays* (London, 1893) p.245.
76. J. Leighton, op. cit. (72) f.p.7.
77. W. Morris, op. cit. (63) p.452.
78. W.R. Lethaby, editor's preface in W.H. St John Hope, *Heraldry for Craftsmen and Designers* (London, 1913) p.9.
79. H.J.L.J. Massé, *The Art Workers' Guild* (Oxford, 1935); heraldic art was discussed in 1895, 1896, 1900 and 1906.
80. L.F. Day, 'An Heraldic Artist of To-day', *Art Journal* (1902) p.50.
81. Rev. E.E. Dorling, *Heraldry of the Church. A Handbook for Decorators* (London and Oxford, 1911) pp.4-5.
82. H.E.H. Nelson, 'On Book-Plates', *Books and Book-Plates* 4/3 (1904) p.59.
83. R. Le Gallienne, *The Romance of Zion Chapel* (London and New York, 1898) pp.63, 64.
84. A. Vallance, *William Morris His Art His Writings and His Public Life* (London, 1986)

p.135.

85. C.G. Harper, *English Pen Artists of To-day* (London, 1892) p.85.

86. Charles E. Dawson, 'Modern Book Covers from the Designer's Point of View', *Penrose's Pictorial Annual* 14 (London, 1908-09) p.176.

87. David Whitelaw, op. cit. (14) p.106.

88. Charles E. Dawson, op. cit. (86) p.177.

89. H.W. Wheatley, op. cit. (1) p.368.

90. Charles Morgan, op. cit. (9) p.50.

91. Ibid., p.51.

92. Charles L. Graves *Life and Letters of Alexander Macmillan* (London, 1910) p.67.

93. Ibid.

94. Ibid., p.176.

95. Charles Morgan, op. cit. (9) p.124.

96. As well as the covers designed by Rossetti, Webb and Morris illustrated here, Rossetti designed the cover of Algernon Swinburne's *Songs before Sunrise*, published by Ellis in 1871.

97. William Morris, op. cit. (69) p.258.

98. Oswald Doughty (ed.), *The Letters of Dante Gabriel Rossetti to his Publisher, F.S. Ellis* (London, 1928) pp.5-24.

99. Ibid., p.41.

00. William Morris, op. cit. (69) p.259.

01. G. Barber, op. cit. (8) p.320.

02. F.S. Ellis, 'The Life-Work of William Morris', *Journal of the Society of Arts* (27 May 1898), p.630.

03. C. Kegan Paul, op. cit. (13) p.290.

04. Ibid.

05. The other two: *All-Fellows* (1896) and *The Field of Clover* (1898).

06. H.R. Dent (ed.), *The House of Dent 1888-1938* (London, 1938) p.43.

07. E. Rhys, *Everyman Remembers* (London, 1931) p.238.

108. A.J.L. Hellicar, 'Charles, Reginald and Horace Knowles, Artists', *East London Papers* 2/2 (Oct. 1959) p.85.

109. Edward Bell, *George Bell Publisher* (London, 1924) p.94.

110. Arthur G. Bell, 'Letters from Artists to Artists. - Sketching Grounds. No.2 - Holland', *Studio* 1/3 (June 1893) pp.116-21.

111. Gleeson White, op. cit. (37) pp.15-23.

112. Dr G.C. Williamson, *Memoirs in Miniature* (London, 1933) p.71.

113. Ibid., p.74.

114. Ernest Rhys, *Wales England Wed* (London, 1940) p.152.

115. R. Le Gallienne, *The Romantic Nineties* (London, 1926) p.127.

116. Bernard H. Newdigate, 'The Arts and Crafts Exhibition', *The Imprint* 1/2 (17 Feb. 1913) p.124.

117. Quoted by L. Radice, *Beatrice and Sidney Webb* (London, 1984) p.115.

118. *Catalogue of a book exhibition at the Central School of Arts and Crafts.....MCMXII* (London, 1912) pp.3-4.

119. Quoted by R. Cannon, *The Bolt Court Connection* (London, 1985) p.13.

120. Ibid. p.46.

121. *London County Council School of Photo-Engraving and Lithography. Prospectus and Time Table. Sixth Session 1900-01.*

122. W. Colgate, *The Toronto Art Students' League 1886-1904* (Toronto, 1954) p.25.

123. D. Hunter, *My Life with Paper* (New York, 1958) pp.50-51.

124. Ibid. p.55.

125. M. Heber Smith, 'The Organised Production of Commercial Art. How to Save Money in Buying Designs and Get Satisfactory Work', *Penrose's Pictorial Annual* 19 (1913-14) pp.207-12.

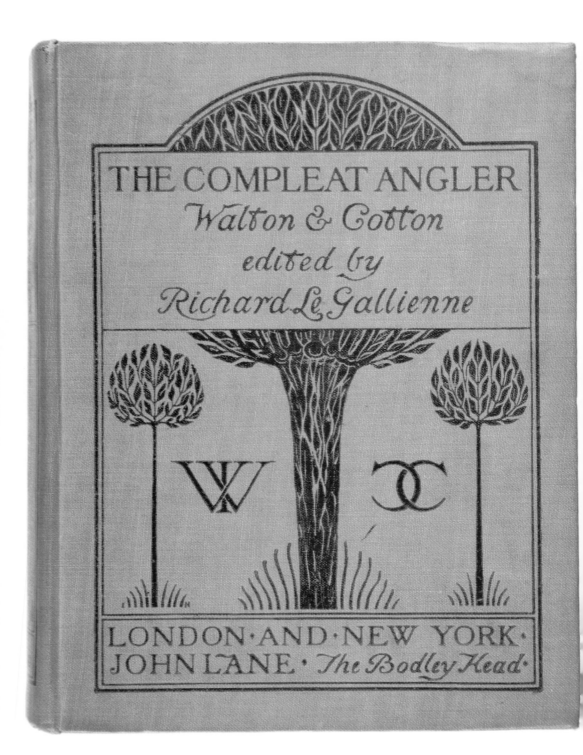

THE COMPLEAT ANGLER
Walton & Cotton
edited by
Richard Le Gallienne

W CC

LONDON·AND·NEW YORK·
JOHN LANE · *The Bodley Head*·

43. Edmund Hort New, 1897 (cat. no. 46)

THE ARTISTS

AUBREY BEARDSLEY fig.23, 32, 47
1872-98

A prolific, though short-lived, draughtsman whose huge influence extended across Europe and America, Beardsley developed his own esoteric art which makes it difficult to classify his work as Arts and Crafts or any other style. He was born in Brighton and was diagnosed as tubercular at the age of seven. On leaving school he went to London where he was employed as an insurance clerk and attended evening classes at Westminster School of Art. He was influenced by a wide range of historical styles, and he visited Burne-Jones in London and Puvis de Chavannes in Paris, both of whom encouraged the young artist. In 1892, he was introduced to the publisher J.M. Dent who commissioned him to illustrate an edition of *Le Morte Darthur*, intended as a popular response to the expensive volumes being printed by the Kelmscott Press; many of Beardsley's designs for this work show the influence of Gothic illustrated books, a source recommended by William Morris in an 1892 lecture. An illustrated article about Beardsley's art in the first number of the *Studio* (April 1893) brought him fame and more than enough work. For two years his principal employers were Mathews & Lane until their partnership broke up, and then John Lane alone. He illustrated, and designed the cover for, Oscar Wilde's *Salome*, and covers for the first twenty-three volumes of the Keynote Series of fiction. For Lane he also edited the quarterly *The Yellow Book* and designed the covers of the first four issues, but in 1895 he was dismissed at the height of the Wilde scandal. From 1896 he worked mainly for the publisher Leonard Smithers, contributing regularly to the quarterly *The Savoy* and designing ten book covers. He died at Menton, aged twenty-five.

AB

Ref: Brian Reade, *Beardsley* (London, 1967); Simon Wilson, *Beardsley* (Oxford, 1983).

ROBERT ANNING BELL fig.45
1863-1933

One of the leading illustrators of his generation, Anning Bell took an active part in the Arts and Crafts movement. Born in London, he attended University College School before being articled for two years to an architect uncle. He trained as an artist at the Westminster School of Art and the Royal Academy Schools, and he spent a year in the studio of Aimé Morot in Paris. On his return to London, he shared a studio with the sculptor George Frampton before spending some months on a visit to Egypt and Italy. His earliest illustrations appeared in a series of books published by Ernest Nister. Subsequently he illustrated books for Dent, Bell, Macmillan and other publishers. He supplied seven illustrations for the *Altar Book* (1896) printed by D.B. Updike's Merrymount Press in Boston, Massachusetts. He also contributed ornaments and illustrations to several journals including the *English Illustrated Magazine*. From 1895 to 1899 he taught painting and drawing at the School of Architecture in Liverpool, and he designed ceramic reliefs for the Della Robbia Pottery, also in Liverpool. He was appointed Professor of Decorative Art at the Glasgow School of Art in 1911, and he succeeded W.R. Lethaby as Professor of Design at the Royal College of Art in 1918. In his later years, he designed stained glass and mosaics; he exhibited paintings at the New English Art Club and the Royal Academy. He was a member of the Art Workers' Guild from 1891 (Master 1921) and exhibited regularly with the Arts and Crafts Exhibition Society. He designed stamped cloth book covers for Dent, Bell, John Lane, Fremantle and Methuen, among other publishers.

R·AN·BEL

Ref: J. McIntyre, 'Robert Anning Bell (1863-1933) A Quintessential Illustrator of his Time', *IBIS Journal* 4 (2011) pp.6-61.

FRANK BRANGWYN fig.38
1867-1956

Born in Bruges, Belgium, Brangwyn moved to London in 1875. In 1882, his talent as a draughtsman was recognised by A.H. Mackmurdo who introduced him to William Morris. He was employed by Morris & Co. at their store in Oxford Street for about two years, and he designed some tapestries for the Firm. In 1885, he took a studio of his own and began exhibiting paintings at the Royal Academy and elsewhere. In 1895, he painted murals for *L'Art Nouveau*, Siegfried Bing's new shop in Paris; he also designed stained glass and a poster for Bing. He designed furniture, textiles, carpets and ceramics, which demonstrate a wide knowledge of historical styles and Oriental art, although his work was imbued with a modern spirit. In 1900, he started making etchings, an art that he would pursue for the rest of his career. He painted murals for a number of prestigious sites including the House of Lords (rejected in 1930 and installed in the Guildhall, Swansea in 1934) and the Rockefeller Center, New York, in 1933. He illustrated books throughout his career, working for publishers in Britain, Austria and the U.S.A. He was elected to the Royal Academy in 1919 and knighted in 1941. In later life he settled at Ditchling, Sussex, where he died. He designed stamped cloth book covers for several publishers including Blackie, Gibbings, T.N. Foulis, Hodder & Stoughton and John Lane.

Ref: Libby Horner and Gillian Naylor, *Sir Frank Brangwyn 1876-1956* (Leeds, 2006).

WILLIAM HARRISON COWLISHAW
 fig.39
1870-1957

Cowlishaw trained as an architect in Leicester before moving to London in 1890 and joining the firm of architects Balfour and Turner. In 1895, he designed a house for Edward and Constance Garnett at Limpsfield Chart, Surrey. At the same time he was studying calligraphy and exhibited pages of illuminated manuscript with the Arts and Crafts Exhibition Society. In this connection he was associated with William Morris for whom he undertook research into writers' materials. In 1895, he was appointed instructor in design at St Bride's Institute, London. An example of his calligraphy, illustrated in the *Studio*, was an inspiration to Edward Johnston, whose early career Cowlishaw helped to promote. He also tried his hand at plasterwork, exhibiting a memorial plaque to J.D. Sedding at the Arts and Crafts Exhibition Society in 1893, and decorating a bedroom ceiling at the Garnett house. In 1905, he built 'The Cloisters', a school of psychology for twenty residents at Letchworth, Hertfordshire. He converted a farmhouse near the town for himself and started the Iceni Pottery, making lustreware there until the outbreak of World War One. In 1917, he was elected to the Art Workers' Guild. From 1917 to 1931 he worked for the Imperial War Graves Commission. He was elected a fellow of the Royal Institute of British Architects in 1931 and joined the architect Charles Holden's practice. Only three stamped book covers designed by Cowlishaw are known, for Longman's, Duckworth and Sands.

Ref: RIBA Library file; *Studio* 2/7 (Oct. 1893) p.10; *Artist* 20 (Sept. 1897) pp.432-36.

WALTER CRANE fig.5, 12, 14
1845-1915

Born in Liverpool, Crane was apprenticed in 1859 to the wood engraver W.J. Linton in London. From 1862, he independently supplied illustrations for magazines and books. In 1870, he began to illustrate books for the colour wood-block printer Edmund Evans. Crane was strongly influenced by Japanese art, and these picture books in colour were enormously popular and helped to define the Aesthetic Movement. He continued also to work in black and white and designed the cover of the *English Illustrated Magazine*, to which he also supplied copious ornaments and illustrations. He became friendly with William Morris and shared his socialist views. In 1889, Crane gave the Cantor lectures at the Society of Arts on 'The Decorative Illustration of

Books' which were published in 1896 with the same title. He designed ceramics, wallpapers, embroideries, textiles, carpets, stained glass, mosaic, and gesso decoration. In 1891, the Fine Art Society held a retrospective exhibition of his paintings and decorative art at its gallery in London, which subsequently toured the U.S.A. and Europe. His reputation abroad flourished, and he received commissions from patrons in Germany and America. In 1897, he was made an honorary member of the Vienna Secession. He started to teach in 1893 when he was appointed Director of Design at the Manchester School of Art, and in 1898 he became Principal of the Royal College of Art in London, a post he occupied for only one year before resigning. He propounded his artistic theories in *The Bases of Design* (1898) and *Line and Form* (1900). He was a founder member of both the Art Workers' Guild (Master 1888-89) and the Arts and Crafts Exhibition Society (President 1888-93 and 1896-1912). He designed stamped cloth book covers for Macmillan, Lawrence & Bullen, Swann Sonnenschein, Walter Scott, Bell, Harper, Houghton Mifflin and Scribner.

Ref: W. Crane, *An Artist's Reminiscences* (London, 1907); I. Spencer, *Walter Crane* (London, 1975).

LOUIS BARRAUD DAVIS fig.11
1860-1941

Little is known of Davis's background or training. He was a painter, illustrator and designer of stained glass, living most of his life at Pinner, Middlesex. He contributed illustrations and decorative designs to the *English Illustrated Magazine* between 1886 and 1892 and designed two coloured prints for the Fitzroy Picture Society which were displayed at the Arts and Crafts Exhibition Society's 1896 show. He designed stained glass and other decoration for several important buildings including Westminster Abbey, Gloucester Cathedral, St Giles' Cathedral in Edinburgh and Welbeck Abbey. He taught life drawing at the Central School of Arts and Crafts (1899/1900). From 1890 he showed work with the Arts and Crafts Exhibition Society, serving on the hanging committee in 1903. In 1908, he and his wife exhibited watercolours and needlework at the Van Wisselingh Gallery in London. Davis was a member of the Art Workers' Guild from 1891 to 1906. Stamped cloth book covers for Cassell and David Nutt are known.

Ref: The Times 23 Oct. 1941, p.7.

LEWIS FOREMAN DAY fig.7
1845-1910

A prominent figure in late nineteenth-century design, Day was heavily involved in the organizational side of the Arts and Crafts movement. He was born in Peckham Rye, London, and started his career in the office of a stained glass manufacturer. In 1870, he worked on the decoration of Eaton Hall, and the same year he opened his own design studio. His stained glass designs were mainly for domestic use, although in 1891 he collaborated with Walter Crane on designs for windows at Christ Church, Streatham Hill. Day designed wallpapers, tiles, textiles and bookbindings among other wares. From 1881, he was Art Director of the textile manufacturers Turnbull & Stockdale. He contributed articles on design topics to the *Magazine of Art*, the *Art Journal*, and the *Journal of Decorative Art*. He wrote several books on design and ornament including *Every-Day Art* (1882), *The Application of Ornament* (1888), *Nature in Ornament* (1892), *Alphabets Old and New* (1898) and *Lettering in Ornament* (1902); he designed the covers for most of the books he wrote. Day was secretary of The Fifteen, a group of artists and designers who met periodically for discussions, and he took the lead in talks with the St George Art Society, a group of architects, which led to the formation of the Art Workers' Guild in 1884. He was also a founder member of the Arts and Crafts Exhibition Society, and regularly showed his work there. Day designed stamped cloth book covers for Macmillan, Batsford, Blackie,

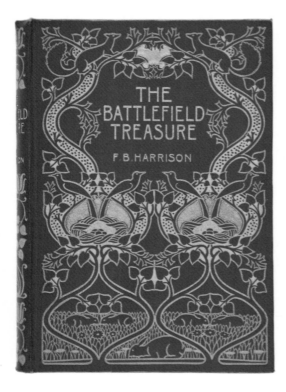

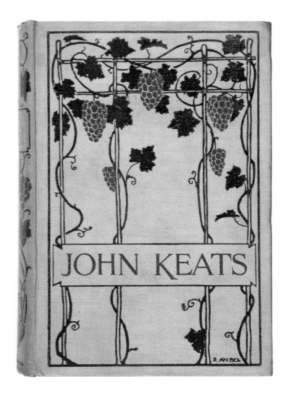

44. Silver Studio, c.1897 (cat. no. 54)

45. R. Anning Bell, 1897 (cat. no. 4)

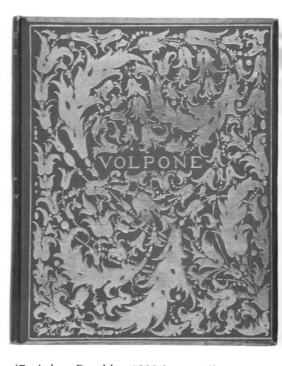

46. Laurence Housman, 1898 (cat. no. 25)

47. Aubrey Beardsley, 1898 (cat. no. 3)

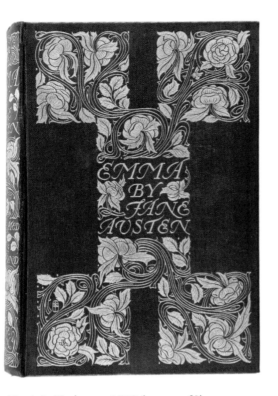

48. A.A. Turbayne, 1898 (cat. no. 60)

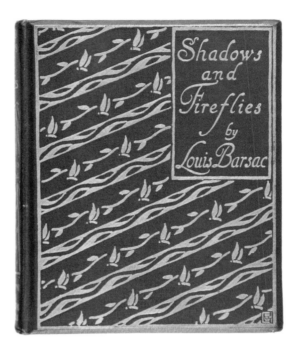

49. James Guthrie, 1898 (cat. no. 16)

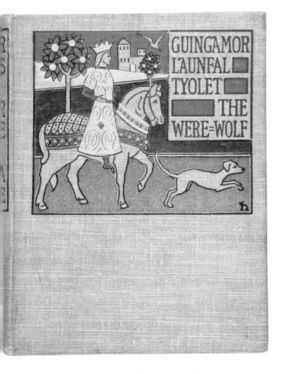

50. W.S. Hadaway, 1898 (cat. no. 17)

51. W.S.Hadaway, 1898 (cat. no. 18)

Cassell, and Smith Elder.

L.F.D.

Ref: Joan Maria Hansen, *Lewis Foreman Day* (1845-1910): *Unity in Design and Industry* (Woodbridge, 2007).

CHRISTOPHER DEAN fig.57
Dates unknown

Information about Christopher Dean is scant. He worked in Glasgow until 1897, exhibiting paintings at the Royal Scottish Academy. That year, he moved to Marlow-on-Thames, and from 1902 he worked from various addresses in London. Illustrations and book covers by Dean were reproduced and discussed in an article printed in the *Studio* (Dec. 1897). Following Gleeson White's death in 1898, he designed many of Bell's book covers. A stamped cloth cover designed by Dean for a book published by Hodder & Stoughton is also known, and he probably worked for other publishers.

Ref: Anon., 'Mr. Christopher Dean, Designer and Illustrator', *Studio* 12/57 (Dec. 1897) pp.183-187; *Year's Art* 1896-1905.

HERBERT GRANVILLE FELL fig.24
1872-1951

Having trained at Heatherley's Art School, Fell quickly gained prominence as an illustrator and decorative draughtsman. By 1891 he was contributing illustrations and decorative designs to the *English Illustrated Magazine*, and he won prizes at the Metropolitan Sketching Club in 1892 and 1893. His designs for *Poems* by W.B. Yeats (Fisher Unwin, 1895), *The Book of Job* (Dent, 1896) and *The Song of Solomon* (Chapman & Hall, 1897) won wide acclaim. However, his links with the Arts and Crafts movement seem never to have been strong, although he did design 'Vellucent' painted

vellum bookbindings for the firm of C. Chivers. He never exhibited with the Arts and Crafts Exhibition Society. He became art director for a succession of magazines, starting in 1910 with *Ladies' Field* and including *Queen* and the *Illustrated London News*. He was a prolific author, writing a handbook for young illustrators (1912) and monographs on Cézanne (1934), Vermeer (1934) and the sculptor Sir William Reid Dick. He designed stamped cloth book covers for many publishers including Dent, Newnes, Isbister, Edward Arnold, Harper, Fisher Unwin, and Chapman & Hall.

H.G.F.

Ref: E.B.S., 'A New Decorative Artist: Herbert Granville Fell', *Studio* 2/11 (Feb. 1894) p.164; *Artist* (Mar. 1897) pp.97-105; Saur.

ARTHUR JOSEPH GASKIN fig.18
1862-1928

Gaskin designed very few stamped cloth book covers, possibly not more than two. He was born in Birmingham, the son of a decorative artist, and educated at Wolverhampton Grammar School. From 1883 he was a student at the Birmingham School of Art, and he became a teacher there two years later. He contributed illustrations and decorative designs to the *English Illustrated Magazine* from 1891 to 1893, and two books illustrated by Birmingham artists were issued under his supervision, *A Book of Pictured Carols* (1893) and *A Book of Nursery Songs and Rhymes* (1895). In 1895, he illustrated *Good King Wenceslas* by J.M. Neale, to which William Morris wrote a preface. On the strength of these illustrations, Morris commissioned Gaskin to illustrate two Kelmscott Press books, and *The Shepheardes Calender*, published in 1896, has twelve full-page designs and ornamental letters by Gaskin. Although Gaskin made several illustrations for the Kelmscott Press edition of Morris's own *The Well at the World's End*, they were rejected by Morris and the book was issued with four illustrations by Burne-Jones. In 1897, Gaskin visited Italy with his friend Joseph Southall

who taught him the technique of painting in tempera. He was influential abroad, particularly in Germany, where the magazine *Die Insel* carried several of his woodcut illustrations, and in the U.S.A., where he exhibited book illustrations at the Society of Arts and Crafts, Boston, in 1899. Collaborating with his wife, Georgina, he turned to jewellery, enamelling and metalwork. In 1903, he was appointed Head Master of the Vittoria Street School for Jewellers and Silversmiths in Birmingham. He exhibited with the Arts and Crafts Exhibition Society and was a member of the Art Workers' Guild (1917-22). He designed stamped cloth book covers for George Allen and Methuen.

Ref: George Breeze, Niky Rathbone, and Glennys Wild, Arthur and Georgie Gaskin (Birmingham, 1982).

ROBERT PERCY GOSSOP fig.70
1876-1951

Apprenticed in 1892 as a wallpaper and fabric designer, Gossop's entire career would be spent as a commercial artist, one of the few who maintained strong links with the Arts and Crafts movement. After attending art classes at Birkbeck College and the Hammersmith School of Art, in 1896 he went freelance as an illustrator. Between 1896 and 1902, he supplied the publisher George Newnes with illustrations and decorative designs for books and magazines. After two years as studio manager at Eyre & Spottiswood, he held a similar position at W.H. Smith the stationers and printers; he designed their distinctive lozenge-shaped trade mark. With Bernard Newdigate he designed the Arden Press edition of R.L. Stevenson's *Virginibus Puerisque*, printed for W.H. Smith in a typeface designed by Herbert Horne. He worked at the Ministry of Information from 1916 until 1919, when he was made joint manager of the Carlton Studio. Continuing to work as a freelance commercial artist, he designed posters for Heal's and London Transport among other

clients. He served on the council of the Design and Industries Association and was one of the founders of the Society of Industrial Artists. He was involved with the garden-city movement, living for a time at Letchworth and later serving on the Hampstead Garden Suburb Trust. He exhibited regularly with the Arts and Crafts Exhibition Society, and he was elected to the Art Workers' Guild in 1920. He designed stamped cloth book covers for Dent, Grant Richards, and probably other publishers.

G **R. P. G.**

Ref: Victoria & Albert Archive of Art and Design AAD/1998/15.

JAMES JOSHUA GUTHRIE fig.49
1874-1952

Born in Glasgow, Guthrie went to London to work for his father's firm of metal merchants. He studied in the evenings at Heatherley's Art School and with the British Museum Students' Group. "I drew illustrations and book ornaments, modestly encouraged by Selwyn Image....and by Gleeson White," he said in a paper that he read to the Double Crown Club in 1933. Between 1897 and 1899 he worked for Reginald Hallward at his private press near Gravesend. In 1899 he set up the Pear Tree Press at Gravesend, moving to South Harting, Sussex, in 1901, and five years later to Flansham, Sussex. He published a magazine, *The Elf*, largely written and illustrated by himself (1899-1903 and 1905-10), and he edited the quarterly *Book of Book-Plates* (1903-04). He exhibited with the Arts and Crafts Exhibition Society. Guthrie was an accomplished craftsman, able to paint, etch, engrave, design and print, who preferred to work independently. The few stamped cloth book covers that he is known to have designed were for books published by Longman's and the Unicorn Press.

Ref: *Private Library* series 2, 9/1 (Spring 1976); number devoted to Guthrie, with articles by Colin Franklin et al.

WILLIAM SNELLING HADAWAY fig.50, 51
1872-1941

Hadaway was born in Chelsea, Massachusetts, the son of a clerk. After moving to Malden, Massachusetts, he attended the Museum of Fine Arts School in Boston from 1891 to 1893. The next two years he spent studying in Sicily and Italy. On his return to Boston, he supplied the cover and page decorations for *Friar Jerome's Beautiful Book* by Thomas Bailey Aldrich, designed by Bruce Rogers and published in 1896 by Houghton Mifflin. His work was noticed and praised in Will Bradley's magazine *Bradley: His Book* (Jan. 1897). He moved to New York and married the Canadian poster artist Jean Carré. The couple moved to London, and Hadaway designed book covers and bookplates for about a year before turning his attention to jewellery, enamels and silver. In 1901, he moved to Bushey, Hertfordshire. He exhibited jewellery made by himself and his wife at the Arts and Crafts Exhibition Society's 1903 show, and in 1907 he wrote *Opals*, a short essay printed for him by James Guthrie at the Pear Tree Press. In England, he designed stamped cloth book covers, all for books issued 1898-99, for several publishers including Constable, David Nutt, S.P.C.K., James Bowden, Horace Marshall, Harper, and Ward Lock.

ｈ

Ref: Victoria & Albert Archive of Art and Design AAD8-1978; Nancy Finlay, *Artists of the Book in Boston* 1890-1910 (Cambridge MA, 1985).

LAURENCE HOUSMAN fig.13, 15, 28, 29, 30, 36, 46, 53
1865-1959

Housman was brought up in Bromsgrove, Worcestershire, one of seven children of whom the eldest was the poet A.E. Housman. In 1882, Laurence and his sister Clemence settled in London and enrolled as students at the City and Guilds Art School in Lambeth (formerly the Lambeth School of Art). There, Charles Ricketts and Thomas Sturge Moore were among his fellow students. From 1887 to 1889 he attended the art school at South Kensington (later the Royal College of Art). At the outset of his career Housman benefitted from the introductions to publishers and editors given him by A.W. Pollard, a family friend who was the assistant curator of printed books at the British Museum. Housman designed most of his book covers during the 1890s, many of them for volumes of poems or stories written, and often illustrated, by himself. At the same time, he was contributing articles, stories, verses and drawings to the literary magazines including the *Yellow Book* and *Bibliographica*. In 1890, Charles Ricketts and Charles Shannon invited him to call at their home in The Vale, Chelsea, and the ensuing friendship between Ricketts and Housman, albeit short-lived, resulted in Housman turning for inspiration to the Pre-Raphaelites, particularly D.G. Rossetti. Ricketts also introduced him to the work of the English illustrators of the 1860s and the graphic art of Albrecht Dürer. In 1895, Housman became art critic on the *Manchester Guardian*, a position he held until 1914. From 1900, when his best-selling novel *An Englishwoman's Love Letters* was published, he devoted a greater part of his time to literature and the promotion of minority rights. At the same time, weakening eyesight led gradually to his withdrawal from art work. He exhibited with the Arts and Crafts Exhibition Society from 1889 to 1896. Housman designed stamped cloth book covers for Kegan Paul, Mathews & Lane, John Lane, Grant Richards, Macmillan, Swann Sonnenschein, Bell, Blackie, Fisher Unwin, John Murray, Constable and Methuen.

Ref: L. Housman, *The Unexpected Years* (London, 1937); R. Engen, Laurence Housman (Stroud, 1983).

52. Selwyn Image, 1899 (cat. no. 29)

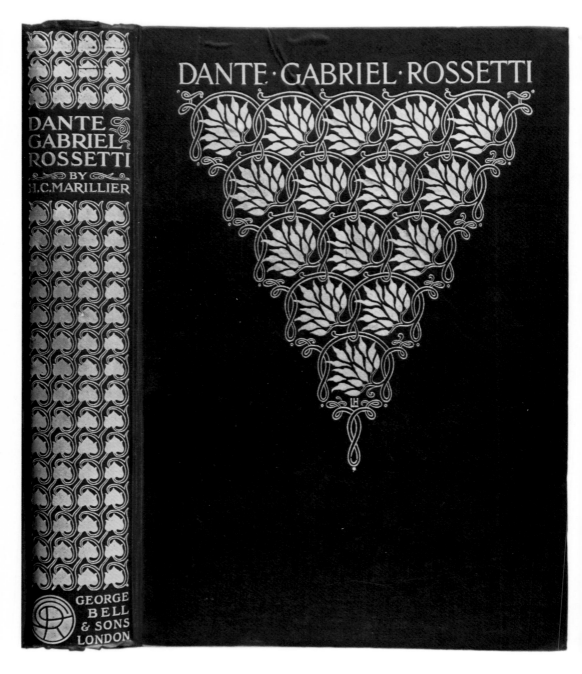

53. Laurence Housman, 1899 (cat. no. 26)

SELWYN IMAGE fig.9, 27, 52
1849-1930

Image was born at Bodiam, Sussex. After attending Marlborough College, he studied for the church at Oxford University and took holy orders in 1873. While at Oxford, he went to classes at Ruskin's drawing school under Arthur Burgess, Ruskin's assistant, with whom Image later shared a studio in London. After eight years as a curate in London, he relinquished holy orders and turned to art full-time. At first he tried to be a painter, but soon found he had a greater aptitude for design. He collaborated with A.H. Mackmurdo whom he had first met at Ruskin's school in Oxford, and his designs for Mackmurdo's Century Guild included the influential cover of the *Century Guild Hobby Horse* (1884). Image himself however, was never a member of the Guild. His art work included designs for stained glass and embroidery, as well as for book covers. He wrote 'On Designing for the Art of Embroidery', which was included in *Arts and Crafts Essays* (1893), and a chapter on stained glass for Gleeson White's *Practical Designing* (1893). Image designed the title page for the bound volumes of the *Scottish Art Review* (1888-90) and the *Pageant* (1896). For the Chicago publisher Way & Williams he designed the title page and ornaments for *The Miracles of Madame Saint Katherine of Fierbois* (1897). He was elected to the Art Workers' Guild in 1887 (Master, 1900) and he was appointed Slade Professor of Art at Oxford University in 1910, a post he held until 1916. He designed stamped cloth book covers for publishers Bell, Fisher Unwin, Blackwell, Sampson Low, Mathews & Lane, and Elkin Mathews.

SI

Ref: P. Stansky, *Redesigning the World* (Princeton, 1985); A.H. Mackmurdo (ed.), *Selwyn Image Letters* (London, 1932).

WILL JENKINS fig.55
Dates unknown

Described in 1899 as a "young Canadian" and a "new-comer in design", there is little information about the life or work of Jenkins. His earliest recorded book cover design is dated 1899, and his last 1902. In 1904, he gave the directory the *Year's Art* an address in Boston, Massachusetts, and, later the same decade, he is known to have illustrated books for the Californian publisher Paul Elder. He exhibited with the Boston Art Club in 1897 and 1905. During his brief sojourn in England he designed stamped cloth book covers for Newnes, and the office of the *Studio*.

W. J.

Ref: 'Modern Bookbindings and Their Designers', *Studio* Special Winter-Number 1899-1900, p.30; *Year's Art* (1904).

REGINALD LIONEL KNOWLES fig.58, 62, 64, 67
1879-1950

Knowles was born at Poplar in the East End of London, the second child of Ebeneezer Knowles, a poet, singer and musician, and his wife Emma, a primary school teacher. After attending a local Wesleyan school and a brief period living with an aunt and uncle in Wareham, Dorset, he trained at the Whitechapel Craft School. An injury to one of his eyes when still quite young did not impair his drawing skills, and on leaving the Craft School he was hired by Dent's as a full-time designer. After a few years he left the firm to become freelance, but Dent's remained his most important client; for them he designed the 'Everyman's Library' books in their original format (1906). He sometimes collaborated with his younger brother Horace, an accomplished illustrator, on book projects and he designed wallpapers through much of his career. Shortly before the outbreak of World War One, he was appointed art editor of the religious journal *Ecclesia*. During the War, he worked at the Carlton Studio. After his marriage, he went to live at Kingston-on-Thames, later moving to Norbury. He remained primarily a book artist, and at the time of his death he was designing book jackets for the publisher Frederick Muller. Knowles exhibited regularly with the Arts and

Crafts Exhibition Society, and he designed the wallpaper used in one of the galleries at the Royal Academy where the Society held its 1916 exhibition. He designed stamped cloth book covers for Dent, Newnes, Cassell, Jarrold, George Allen, Fremantle, Jack, Partridge, and Truslove Hanson.

Ref: A.J.L. Hellicar, 'Charles, Reginald and Horace Knowles, Artists', *East London Papers* 2/2 (Oct. 1959) pp.83-93.

GEORGE EDWARD KRUGER (GRAY)

fig.71, 72, 73

1880-1943

Kruger was born in Kensington, London, and he trained at the Royal College of Art, where he gained a diploma in 1904, and in Italy. He painted landscapes and portraits in watercolour, which he exhibited at the Royal Academy and the New Gallery. Sometime before 1910, he was teaching at the Central School of Arts and Crafts. He specialised in heraldic designs, done in a modern manner, for illuminated addresses, stained glass and metalwork, as well as book covers. He married Audrey Gordon Gray in 1918. After the First World War he designed coinage for several dominions and colonies of the British Empire, including South Africa. He exhibited regularly with the Arts and Crafts Exhibition Society; he was elected to the Art Workers' Guild in 1913 and served on the Committee from 1920 to 1922. He is known to have designed stamped cloth book covers for Mowbray and Batsford.

G. K. GEK

Ref: G.M. Waters, *Dictionary of British Artists Working 1900-1950* (Eastbourne, 1975); S. Backemeyer and T. Gronberg (ed.), *W R Lethaby 1857-1931 Architecture, Design and Education* (London, 1984).

WILLIAM BROWN MACDOUGALL fig.40, 63

d. 1936

Macdougall was born in Glasgow, and trained as an artist at the Glasgow Academy before going to Paris where he was a pupil at the Académie Julian. He was a member of the New English Art Club and exhibited with them in the early 1890s. He visited Edinburgh in 1895 and contributed to the *Evergreen*, an Arts and Crafts periodical produced by the circle of artists and writers who gathered round the reformer and philosopher Patrick Geddes. Macdougall developed a graphic style which was heavily indebted to the work of Aubrey Beardsley; he contributed to both the *Yellow Book* and the *Savoy*. His illustrations and decorative designs attracted various publishers who commissioned a succession of picture books in the Arts and Crafts style which he produced during the late 1890s, working in a studio on Southampton Row, London. He also designed wallpapers and metalwork, which were exhibited at the Arts and Crafts Exhibition Society. In 1898 he returned to Scotland, living in Dunoon, not far from Glasgow. He was married to the poet and novelist Margaret Armour, and he illustrated some of her books. About 1920 the couple settled at Loughton, Essex, where he died. Macdougall designed stamped cloth book covers for Dent, Duckworth, Service & Paton, Chapman & Hall, Kegan Paul, Blackie Macmillan, and Black.

M WBM

Ref: S. Houfe, *Dictionary of British Illustrators and Caricaturists 1800-1914* (Woodbridge, 1978); *Year Art 1891-1936*.

FRED MASON

fig.35

Dates unknown

So little is known about Mason that even the exact nature of his connection to the Birmingham School of Art, with which he has been generally associated, is uncertain. In 1889, a design for a hanging by him was included in an exhibition of student's work

at South Kensington, London. In 1893, he contributed designs to *A Book of Pictured Carols*, a work produced by all the leading artists of the Birmingham group; his illustrations are also found in the *Quest* (1894-96), the periodical published by the group. But after that, apart from the illustrations and decorative designs for *Huon of Bordeaux* (1895) and *Renaud of Montauban* (1897), Mason apparently sank into oblivion. The three stamped cloth book covers known to have been designed by Mason were for books published by George Allen.

Ref: A. Crawford (ed.), *By Hammer and Hand* (Birmingham,1984); *Scottish Art Review* 2/17 (Oct. 1889) p.131.

TALWIN MORRIS fig.61
1865-1911

Born in Winchester, Hampshire, Morris was orphaned at the age of twelve. When he was fifteen, he was articled to the architect Joseph Morris, an uncle, who practised in Reading. Showing some promise as a graphic designer, in 1891 he was hired as assistant art editor on the weekly magazine *Black and White*; his work included designing initial letters and decorative headings. He was married in 1892, and the following year he was appointed Art Manager at the Glasgow publishers Blackie & Son. He met Francis Newbery, the headmaster of the Glasgow School of Art, who introduced him to the work of the Glasgow Four. Morris was impressed, and an exhibition in February 1895, which included posters designed by C.R. Mackintosh and the Macdonald sisters, probably helped transform the style of his book cover designs. Three of these were included in a display of book covers at the Arts and Crafts Exhibition Society's 1896 show. In 1898, the *Studio* printed an article on 'Mr. Talwin Morris's Designs for Cloth Bindings' *Studio* 15/67 [Oct. 1898] pp.38-44), and it was probably as a result of this that Morris was asked to design a book cover for F. Volckmar, a German firm of publishers' suppliers. As well as book covers, Morris designed textiles, metalwork, furniture and interiors (including the entrance-hall and offices of the Blackie headquarters at 17 Stanhope Street, Glasgow). Most of his stamped cloth book covers were designed for Blackie, but he designed some for other publishers, including the Gresham Publishing Co. (a Blackie subsidiary), Morison Brothers (Glasgow), Cassell and Mudie.

Ref: T. Howarth, *Charles Rennie Mackintosh and the Modern Movement* (London, 1952); G. Cinamon, 'Talwin Morris, Blackie and the Glasgow Style', *The Private Library* series 3, 10/1 (Spring 1987) pp.3-47.

WILLIAM MORRIS fig.4, 8
1834-96

Morris was born at Walthamstow, Essex, and was educated at Marlborough College and Oxford University. A trip to northern France and Belgium, in the company of Edward Burne-Jones, aroused in Morris a deep love of Gothic art and architecture. In 1856 he joined the office of the neo-Gothic architect G.E. Street where he met Philip Webb, Street's chief assistant at that time. Soon abandoning architecture, Morris devoted himself to painting and poetry. He married Jane Burden in 1859, and the next year they moved into the Red House, designed by Webb, in the village of Upton, Kent. It was the difficulty of finding any acceptable furniture or hangings for their new home which first drew Morris's attention to the dismal state of the decorative arts in Victorian England, and led to the establishment of Morris, Marshall, Faulkner and Co. in 1861 (from 1875 Morris & Co., 'the Firm'). About 1870, Morris began to study calligraphy and over a six-year period produced several illuminated manuscripts. At the same time, he was collecting early printed books, and the twin interests lie behind his design for the cover of *Love is Enough* (1873), one of only two book covers that he designed; the other was for an 1890 edition of *The Earthly Paradise*. But Morris's influence on stamped cloth book cover design was far greater than the volume of his work in the field might suggest. His enthusiasm for the decoration and illustration of early printed books was a significant factor in the development of Arts and Crafts book design,

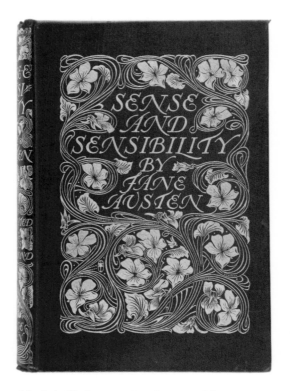

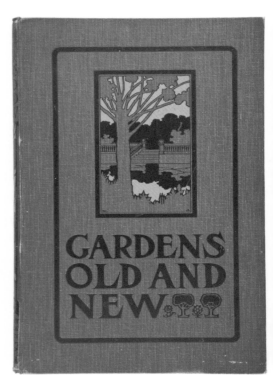

54. A.A. Turbayne, 1899 (cat. no. 61)

55. Will Jenkins, 1899 (cat. no. 30)

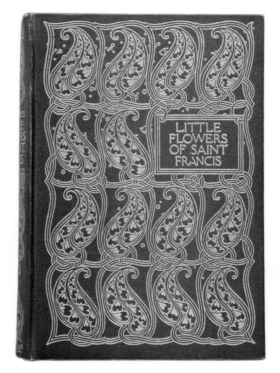

56. Paul Woodroffe, 1899 (cat. no. 74)

57. Christopher Dean, 1901 (cat. no. 12)

58. Reginald Knowles, 1901 (cat. no. 31)

and his lectures and articles on the subject affected the work of several designers. Another source of inspiration for Arts and Crafts cover designers was the decoration Morris himself designed for the books printed at the Kelmscott Press. This enterprise triggered a revolution in the attitude of some publishers and many readers to the production and appearance of books. As happened with any medium that Morris touched, by showing what could be done, albeit at considerable expense, he inspired others to emulate his achievement at a more popular level. It is probably no exaggeration to say that without the Kelmscott Press in 1890, there would have been no 'Everyman's Library' in 1906. Morris exhibited with the Arts and Crafts Exhibition Society and was a member of the Art Workers' Guild from 1888 (Master 1892). The two books for which he designed stamped cloth book covers were published by Ellis & White and Reeves & Turner.

Ref: A. Vallance, *William Morris His Art His Writings and His Public Life* (London, 1986 [1897]); P. Needham and others, *William Morris and the Art of the Book* (New York, 1976).

HAROLD EDWARD HUGHES NELSON
fig.74
1871-1946
Nelson was born at Dorchester, Dorset, and first worked as an assistant to an heraldic artist. Although disillusioned with modern heraldic art as performed by the trade, heraldry always played an important part in his work. In the early 1890s, he attended the City and Guilds Art School in Lambeth (formerly the Lambeth School of Art) and while a student there won first prize in a *Studio* prize competition for a design of an initial letter. The next year he won an honourable mention in a *Studio* competition for a tailpiece, and a silver medal in the National Competition at South Kensington. He was advised by Gleeson White to undertake general decorative work, and Nelson designed bookplates, pottery and stained glass as well as book and magazine decoration. He contributed decorative designs to several magazines including the *Parade, Graphic, Queen, Ladies' Field* and *Sphere*. In 1910, Nelson was working at the Carlton Studio, and in 1912 he was appointed to the advisory sub-committee of the London County Council School of Photo-Engraving and Lithography. He exhibited regularly with the Arts and Crafts Exhibition Society, and he was elected to the Art Workers' Guild in 1912, serving on the Committee 1917-19. He designed stamped cloth book covers for Bell, Blackie, S.P.C.K., Dent, and Seeley Service.

Ref: The Editor, 'Modern Book-Plate Designers. M Harold Nelson', *Journal of the Ex-Libris Society* 5/15 (1905) pp.37-40; D. Hunter *My Life with Paper* (New York, 1958) p.51.

EDMUND HORT NEW fig.22, 43, 59, 66
1871-1931
Described by Professor Gilbert Murray as "half artist and half saint", New was born in Evesham Worcestershire, the son of a solicitor. He was fourteen years old when he was sent to train as an artist at the Birmingham School of Art. As pupil and then as teacher, he was at the School until 1895. He contributed illustrations, mostly of architectural subjects, to the *English Illustrated Magazine* 1891-93, the *Quest* 1894-95, *Daily Chronicle* 1895, the *Yellow Book* 1896 and *Pall Mall Magazine*. In 1895, he visited William Morris at Kelmscott Manor in connection with an article that Morris wrote for the *Quest*. New had started designing book covers in 1894 and that year John Lane commissioned him to design the cover of the first catalogue that Lane issued after breaking up with Elkin Mathews He subsequently illustrated many books for John Lane and designed the covers of several more. In 1905, he settled in Oxford where he spent the rest of his life making the drawings (engraved by Emery Walker) for *The New Loggan Guide to Oxford Colleges* which was published posthumously in 1932 by Blackwell's, and he continued to supply illustrations and cover designs to other publishers. Oxford University made him an honorary MA, and he was an Honorary Associate of the Royal Institute of British Architects. He exhibited with the Arts

and Crafts Exhibition Society in 1899, and he was elected to the Art Workers' Guild in 1905. He designed stamped cloth book covers for Macmillan, Lane, Methuen, and Dent.

Ref: B.N. Lee, *Bookplates by Edmund Hort New* (London, 1999); D. Cox, 'Edmund New's 'Diary of a visit to Kelmscott Manor House'', *Journal of the William Morris Society* 3/1 (Spring 1974) pp.2-7.

LUCY (FAULKNER) ORRINSMITH fig.6
1839-1910

Lucy Faulkner, her sister Kate, and her brother Charles, a friend of William Morris since their time at Oxford University together, were frequent visitors to the Red House and helped with its decoration. During the 1860s, the Faulkners were living in Queen Square, Bloomsbury, where Morris's workshops were located. Charles was one of the original partners in the Firm, and Lucy and Kate both worked there. Lucy's main contribution was painting tiles and tile panels, but she also worked some of the early embroideries and engraved at least one of the woodblocks for the illustrations to Morris's *The Earthly Paradise* (1868-70). She had learnt the technique of engraving woodblocks at the shop run by Harvey Orrinsmith, whom she married in 1870. Orrinsmith had been appointed art director of the bookbinders James Burn & Co. and had been made a partner in 1867. In 1878, Lucy Orrinsmith wrote *The Drawing-Room* for Macmillan's 'Art at Home' series. She exhibited with the Arts and Crafts Exhibition Society in 1888 and 1889. It seems highly likely that Lucy Orrinsmith would have designed many stamped cloth book covers, since James Burn & Co. offered their clients this service in addition to binding their books. However, only one has been recorded, and it was for a book published by Macmillan.

Ref: C. Harvey and J. Press, *William Morris Design and Enterprise in Victorian Britain* (Manchester, 1991); E. Ferry, 'Lucy Faulkner and the 'ghastly grin'', *Journal of the William Morris Society* (Winter 2008) pp.65-84.

CHARLES DE SOUSY RICKETTS fig.17, 75
1866-1931

Ricketts was born in Geneva, the son of a naval officer who painted landscapes in watercolour. He spent much of his childhood abroad, with long stays in Italy and France. In 1882, he went to the City and Guilds Art School (formerly the Lambeth School of Art) to learn wood engraving; fellow pupils included T. Sturge Moore and L. Housman. After leaving art school in 1888, Ricketts and his lifelong partner, Charles Shannon, set up home in The Vale, Chelsea. The following year, Ricketts and Shannon produced the first number of the *Dial*, an occasional magazine; another four numbers were issued between 1892 and 1897. It was designed, and almost entirely written and illustrated, by Ricketts and Shannon. In its pages, Dürer and Rossetti emerged as the dominating influences on Ricketts' art, but traces of Blake, Whistler and the English illustrators of the 1860s are also detectable. From 1891 Ricketts designed stamped cloth book covers for commercial publishers. His work in this field was widely acclaimed and was the subject of an adulatory article by Gleeson White, published in the *Pageant* in 1896. Ricketts, desiring to have complete control over the production of the books that he designed, started the Vale Press, and the number of covers designed by him for commercial publishers dwindled, although he continued into the 1930s to provide cloth cover designs for books written by himself or his friends. After the Vale Press closed in 1904 he turned to oil painting and later to stage design. Work by Ricketts was exhibited at the 1893, 1896 and 1899 Arts and Crafts Exhibition Society shows. He designed stamped cloth covers for books published by Ward Lock, Osgood McIlvanie, Mathews & Lane, John Lane, Henry, Constable, Bell, Fisher Unwin, Eveleigh Nash, Leonard Smithers, Methuen, Sands, Macmillan, Martin Secker, and The Nonesuch Press.

Ref: J.G.P. Delaney, *Charles Ricketts a Biography* (Oxford, 1990); P. van Capelleveen, *A New Checklist of Books Designed by Charles Ricketts and Charles Shannon* (The Hague, 1996).

DANTE GABRIEL ROSSETTI fig.1,2
1828-82

Rossetti was born in London, the son of a refugee professor of Italian from Naples. He attended Sass's Drawing Academy in 1842, and studied painting at the Royal Academy Antique School from 1845 to 1847. In 1848, he spent a brief period in the studio of Ford Madox Brown, and the same year founded the Pre-Raphaelite Brotherhood with Holman Hunt and John Everett Millais. In 1851, the P.R.B. gained the support of John Ruskin, whom Rossetti met three years later. He became a friend and mentor to Edward Burne-Jones and William Morris in 1856, and the following year collaborated with them and others on the decoration of the Debating Hall at the Oxford Union. In 1861, he was a founding member of Morris, Marshall, Faulkner & Co., and over the following three years he designed stained glass and furniture for the Firm . His paintings began to command high prices, and in 1862 he moved to Tudor House, Chelsea, and started collecting blue and white china and early printed books. The number of cloth book cover designs attributed to Rossetti has varied between ten (of which two were only partly his work) and twelve, but the eight completed between 1861 and 1870, the authenticity of which has never been disputed, show the designer at his most innovative and accomplished. Against a background of the typical High Victorian cloth cover, heavily gilt and wildly eclectic, Rossetti's book covers appear simple, fit for purpose and beautiful without being showy. He mostly designed covers for books written (or translated) by himself, his sister Christina, his brother William, or his friend Algernon Swinburne. They were published by Macmillan, Ellis, Moxon, and Smith Elder.

Ref: L. Tickner, *Dante Gabriel Rossetti* (London, 2003); A. Grieve, 'Rossetti's Applied Art Designs - 2: Book-Bindings', *Burlington* (Feb. 1973) pp.79-84.

SILVER STUDIO fig.44
1880-1963

The Studio was founded by Arthur Silver in Hammersmith, London, and produced designs for furnishing textiles, wallpapers, furniture, plasterwork, stencils, complete interiors, and book covers. Silver wrote chapters on 'Printed Fabrics' and 'Floorcloths' for Gleeson White's *Practical Designing* (1893), and in 1894 White wrote about the Silver Studio in the *Studio*. During the 1890s, William Morris, Walter Crane, and C.F.A. Voysey were powerful influences on the designs produced at the Silver Studio. Many of the book cover designs (including cat. no.44) can be attributed on stylistic grounds to John Illingworth Kay (1870-1950) who worked at the Studio from c.1892 to 1900. Working as a freelance, Kay also designed several book covers for John Lane; all the designs for stamped cloth covers produced by the Silver Studio were for books published by Blackie.

Ref: M. Turner, *The Silver Studio Collection* (London, 1980).

THOMAS STURGE MOORE fig.76
1870-1944

Sturge Moore was born at Hastings, the son of a doctor. He was educated at Dulwich College and studied art at the Croydon School of Art and the City and Guilds Art School (formerly the Lambeth School of Art) where he met Charles Ricketts and Charles Shannon who were to remain his friends for life. Sturge Moore specialised in wood-engraving, executing small vibrant designs in a style influenced by Blake, Calvert, Dürer and the German 'Little Masters'. He contributed illustrations and verse to the *Dial*, and helped in the production of several Vale Press publications. He also supplied illustrations for the *Pageant*, and for books issued by the Eragny and Essex House Presses. Apart from his work as a wood-engraver, he was active as a poet, playwright, essayist and critic; he was the author of short monographs on Altdorfer (1900), Dürer (1905), Correggio (1906) and Blake (1910). He exhibited with the Arts and Crafts Exhibition Society, and he designed stamped cloth covers for books published by Macmillan and Elkin Mathews.

Ref: J. Christian (ed.), *The Last Romantics* (London, 1989); S. Legge, *Affectionate Cousins* (Oxford, 1980).

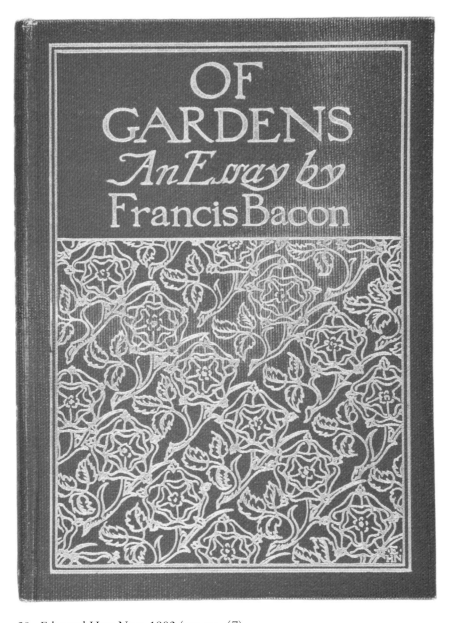

59. Edmund Hort New, 1902 (cat. no. 47)

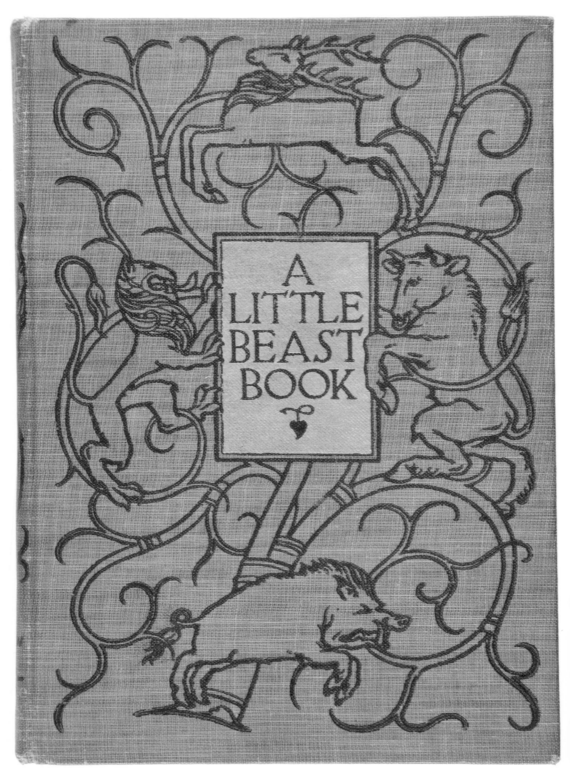

60. Paul Woodroffe, 1902 (cat. no. 75)

FREDERICK COLIN TILNEY fig.10
1870-1951

Painter, etcher, illustrator, designer, photographer and writer, Tilney studied at the Westminster School of Art. The style of his early cover designs suggest that he was a pupil or follower of L.F. Day. He lived at various addresses in north London until c.1905 when he settled in Cheam, Surrey. He contributed illustrations to the *Leisure Hour* and the *Penny Magazine*, and he was a prolific illustrator of books, mainly for children. He edited the series 'Tales for Children from Many Lands' (Dent, 1913-26), and illustrated many of the volumes. He exhibited etchings at the Royal Academy from 1894 to 1938. His writings included books on art (*The Lure of the Fine Arts*, 1931, etc.) and photography (*The Principles of Photographic Pictorialism*, 1930, etc.), and he edited the magazine *Art and Reason*. He designed stamped cloth book covers for Swann Sonnenschein, Dent, Longman, and Routledge.

F.C.T.

Ref: B. Peppin and L. Micklethwait, *Dictionary of British Book Illustrators: The Twentieth Century* (London, 1983).

ALBERT ANGUS TURBAYNE fig.25, 33, 34, 48, 54, 65, 68
1866-1940

In 1898, H. Orrinsmith, the art director of James Burn & Co., a leading firm of bookbinders, declared: "Probably the designs of A.A. Turbayne come nearest to perfection." Turbayne was born in Boston, Massachusetts, the son of a Scottish emigrant. In 1881, he was living in Coburg, Ontario, where he was educated. He worked for Canadian and American publishers before moving to London in 1890, where he soon gained a reputation for his book cover designs. In 1892, he contributed decorative headpieces and initial letters to the *English Illustrated Magazine*, and a poster that he designed for Macmillan's 'Peacock' series won great acclaim, both in Britain and abroad. Lettering was particularly important to him, and

he researched medieval manuscripts and early printed books to find satisfactory typefaces. He developed a technique of modelling cover designs in low relief. In 1898, the *House* printed 'A Chat about Book Covers with Mr. A.A. Turbayne', and the same year he was appointed to teach design at the London County Council School of Photo-Engraving and Lithography (generally known as the 'Bolt Court School'), a position he held until 1920. About 1905, Turbayne, together with four other Canadian artists founded the Carlton Studio in the Strand, London, which supplied graphic designs to publishers, advertisers and other businesses. He compiled two books illustrating samples of his work, in 1904 *Alphabets and Numerals* and in 1905 *Monograms and Ciphers*. He exhibited regularly with the Arts and Crafts Exhibition Society. Turbayne designed stamped cloth book covers for numerous publishers including Black, Macmillan, Service & Paton, Henry Frowde, Jack, Ward Lock, Religious Tract Society, George Allen, Cassell, Lawrence & Bullen, Hurst & Blackett, Oliphant, Methuen, and Wells Darton & Gardner.

Ref: Reports and prospectuses of the London County Council School of Photo-Engraving and Lithography; 'A Chat about Book Covers with A.A. Turbayne', House 2 (1897-98) pp.109-11; W. Colgate, *The Toronto Art Students' League 1886-1904* (Toronto, 1954).

CHARLES FRANCIS ANNESLEY VOYSEY
fig.19
1857-1941

Born near Hull, Yorkshire, Voysey was the son of an unorthodox Church of England clergyman. When his father was unfrocked in 1871, the family moved to London, and in 1874 Voysey was articled to the architect J.P. Seddon. In 1880, he joined the office of George Devey who ran a busy country house practice. Two years later, Voysey set up on his own. Short of jobs at first, he applied to his friend A.H. Mackmurdo for assistance, and this led to commissions from

Jeffrey & Co. for wallpaper designs. Even when Voysey's architectural work picked up, designing flat patterns was to remain an important part of his activity. He exhibited wallpapers and printed textiles at the first Arts and Crafts Exhibition Society show in 1888. For many of the houses that he built, he designed furniture and metal fittings such as hinges, lock plates and door handles. From 1893 he was contracted by Essex & Co. to design wallpapers, and from 1895 by Alexander Morton & Co. to design textiles; he also designed carpets, tiles, cutlery and lighting. In his designs for flat patterns, and in his book plates and other graphic art, he often incorporated heraldry. As a result of articles about him in the *Studio* and elsewhere, he gained a considerable reputation abroad, although he disapproved of Art Nouveau and Modernism, two styles that he strongly influenced. He exhibited regularly with the Arts and Crafts Exhibition Society, and he joined the Art Workers' Guild in 1884, the year it was founded; he was Master in 1924. He designed the cloth cover which was used on the first two bound volumes of the *Studio*.

Ref: J. Brandon-Jones and others, *C.F.A. Voysey: Architect and Designer 1857-1941* (Brighton, 1978).

PHILIP WEBB fig.3
1831-1915

Webb was born in Oxford, the son of a doctor. In 1849, he was apprenticed to the Reading architect John Billing, and in 1854 entered the Oxford office of G.E. Street. There he fell under the influence of John Ruskin and met William Morris who was also working in Street's office. When Street moved his office to London in 1856, both Webb and Morris moved with him. In 1858, he visited France with Morris and Charles Faulkner. Webb set up his own office the same year, and his first significant job was to design the Red House for Morris, and most of its furniture. In 1861, Webb was made a partner in Morris, Marshall, Faulkner & Co. For the Firm, he designed furniture and drew the birds and animals which appeared in some of their designs for wallpapers, printed textiles, tapestries, stained glass and tiles. He also designed the Green Dining Room at the South Kensington Museum (later the Victoria

& Albert Museum). He continued to work as an architect until 1900 when he handed over his practice to his assistant George Jack. Apart from his work for the Firm, he designed iron grates for Longden & Co. and glassware for James Powell & Sons. Webb exhibited regularly with the Arts and Crafts Exhibition Society, but was never a member of the Art Workers' Guild. He is known to have designed only one stamped cloth book cover, which was for a book published by F.S. Ellis.

Ref: S. Jervis, *The Penguin Dictionary of Design and Designers* (Harmondsworth, 1984); A. Vallance, *William Morris His Art His Writings and His Public Life* (London, 1897).

JOSEPH WALTER WEST fig.26
1860-1933

West first came to the attention of the public as a painter of dramatic subject pictures in watercolour. He supplied decorative designs to early issues of the *English Illustrated Magazine* (1884-85), and later he illustrated stories in the *Pall Mall Magazine*. He made a speciality of eighteenth-century subjects, both in his watercolours and his book illustrations. He lived at Norwood, Hertfordshire, and wrote a long poem entitled *Fulbeck a Pastoral*, lamenting the loss of his rural environment to encroaching London suburbia (1901). He exhibited with the Arts and Crafts Exhibition Society, and he designed stamped cloth book covers for John Lane, Dent, and Chapman & Hall.

Ref: A.L. Baldry, 'The Recent Work of J. Walter West', *Studio* 40/168 (Mar. 1907) pp.87-100.

JOSEPH WILLIAM GLEESON WHITE
fig.16, 20, 21, 31, 41, 42
1851-98

White was born in Christchurch, Hampshire, the son of a bookseller, librarian and stationer who owned premises on the High Street known as Caxton House. Here he grew up surrounded by books and magazines that he read voraciously. Gradually taking over the business from his ageing father, White began also to contribute articles to the periodical press. For *Amateur Work Illustrated*, he wrote a series of articles offering schemes of interior decoration

nd ideas for decorative furniture (1881-83). Caxton House became the hub of a circle of rtistic summer visitors to Christchurch, which ncluded Henry Tuke the painter, Charles Kains ackson, the editor of the *Artist*, and husband nd wife Arthur and Nancy Bell, he a painter n watercolours and the son of George Bell the ublisher, and she a prolific author of books on rt, history and travel. In 1887, White wrote he well-received *Ballades and Rondeaus*, a lescription of archaic verse forms with modern xamples contributed by Austin Dobson, Walter Crane, Algernon Swinburne and others; the ook established White's literary reputation. He regularly contributed poems and pieces of rt criticism to the *Artist* and the *Scottish Art Review*, and in 1890 took up the job of associate ditor of the American magazine *Art Amateur* in New York. On his return to Britain the following ear, he was appointed art director at George Bell & Sons where he designed many cloth overs and initiated several series of books on rtistic topics. In 1893, White edited and Bell's ublished *Practical Designing*, which contained a chapter on cloth book cover design written by Harvey Orrinsmith, art director of James Burn & Co., one of the leading firms of bookbinders. The same year, he accepted the editorship of a new monthly art magazine, the *Studio*. By romoting the work of progressive artists and rchitects, such as Aubrey Beardsley and C.F.A. Voysey, in the early issues of the magazine, White quickly gave the *Studio* an international reputation. Although he ceased to be editor fter about a year, he continued to contribute rticles to the magazine, including one on the lecoration of cloth book covers (Oct. 1894). He also wrote an article for the Christmas 1895 ssue of *Bookselling* on 'Some Recent Cloth Bookbindings'. He edited the *Pageant*, a short-ived magazine covering developments in avant-garde art and literature at home and abroad (1896-97). His *English Illustration: 'The Sixties'*, published in 1897, has remained an important study of its subject to this day. White exhibited with the Arts and Crafts Exhibition Society, and he was elected to the Art Workers' Guild in 1895. It was on a visit to Italy organised by the Guild in 1898 that he contracted the typhoid fever which killed him a few weeks later. In 1900, an exhibition of his book covers was held at the National Art Library, Victoria & Albert Museum. The predominant part of his output as a stamped cloth book designer was for Bell, but he also designed covers for books published by Mathews & Lane, Constable, Girl's Own Paper, William Rider and Jack.

G. W.

Ref: C. Ashwin, *Gleeson White - Aesthete and Editor*, Apollo 108/200 n.s. (Oct. 1978) pp.256-61; *Poster* 4/25 (Aug. 1900) p.237.

PATTEN WILSON fig.37
1868-1928
Wilson was born in Cleobury Mortimer, Shropshire, the son of a schoolmaster who was a keen amateur artist. He was the younger brother of the architect, metalworker and jeweller Henry Wilson. He studied briefly at Kidderminster School of Art, but finding the instruction defective he went home and taught himself to draw by copying Dürer prints. After a brief spell in Liverpool, he moved to London where he obtained a position as assistant to a manufacturer of wallpapers. In the evenings, he attended the Westminster School of Art, studying under Fred Brown. He was introduced by Richard Le Gallienne to the publisher John Lane who, from 1895, commissioned illustrations and cover designs from him. When Lane dropped Beardsley, Wilson was made art editor of the *Yellow Book*. He also contributed illustrations to the *Pall Mall Magazine*. He carried out fresco decoration in churches at Hanworth, Norfolk, and Llanfairfechan in Wales, and he experimented with enamels, but book and magazine illustration remained his principal occupation. Wilson exhibited with the Arts and Crafts Exhibition Society. He designed stamped cloth book covers for John Lane, Longmans, and Dent.

P·W RX.

Ref: G.C. Williamson, 'The Decorative Illustrations of Patten Wilson', *Artist* 21 (Jan. 1898) pp.17-24; W.S. Sparrow, 'Some Drawings by Patten Wilson', *Studio* 23/100 (Aug. 1901) pp.186-96.

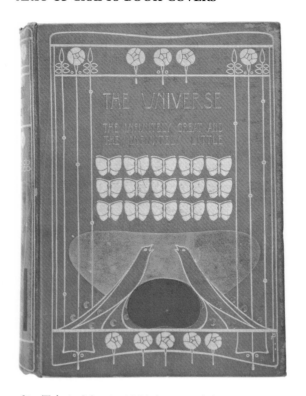

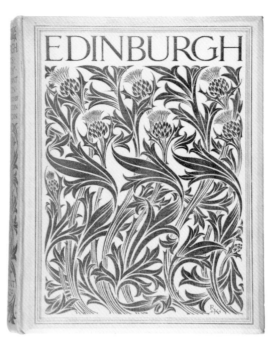

61. Talwin Morris, 1902 (cat. no. 41)

62. Reginald Knowles, 1904 (cat. no. 32)

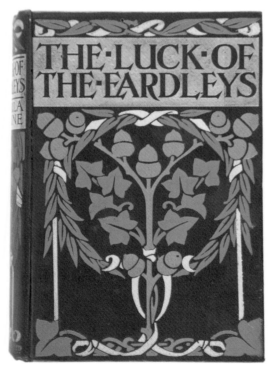

63. William Macdougall, c.1905 (cat. no. 39)

64. Reginald Knowles, 1906 (cat. no. 33)

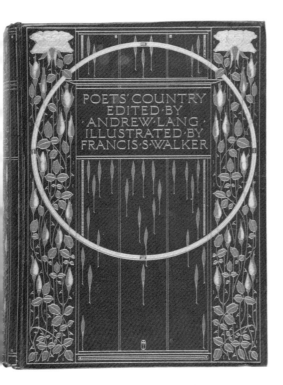

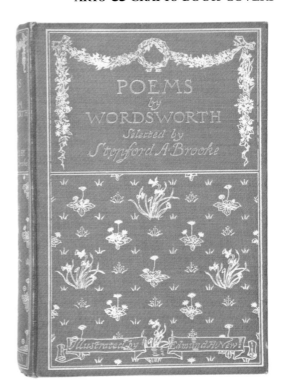

65. A.A. Turbayne, 1907 (cat. no. 62)

66. Edmund Hort New, 1907 (cat. no. 48)

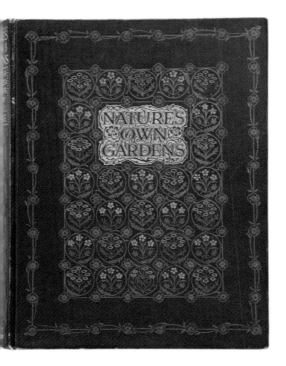

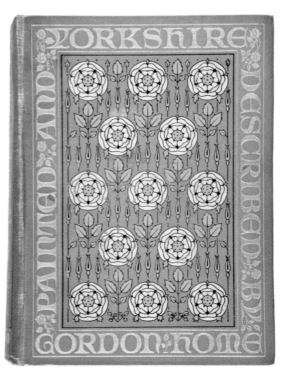

67. Reginald Knowles, 1907 (cat. no. 34)

68. A.A. Turbayne, 1908 (cat. no. 63)

PAUL WOODROFFE
fig. 56, 60, 69
1875-1954

Woodroffe was born in India, the son of a judge in the Madras Civil Service. On the death of his father in 1882, the family moved back to England. Woodroffe was educated at Stonyhurst College, and in 1893 enrolled at the Slade School of Art, London. Also in 1893, his sister married the composer Joseph Moorat, whose published songs would provide Woodroffe with several opportunities for illustration, starting in 1895 with a book of nursery rhymes. He contributed decorative designs to the *Quarto*, a magazine produced by the students at the Slade, and he designed a cloth cover and endpapers for the bound volumes. In 1897, he designed a cloth cover and endpapers for the *Parade*, a gift-book for the young, and decorative headpieces for the *Windsor Magazine*. He met Laurence Housman who profoundly influenced the style of his illustrations and cover designs. In the late 1890s, Woodroffe became a pupil of the Arts and Crafts stained-glass artist Christopher Whall, and henceforward the design and manufacture of stained glass would be his principal activity, although he would continue to illustrate books and design cloth book covers. He set up a stained-glass studio at Chipping Campden, where he often worked in co-operation with C.R. Ashbee's Guild of Handicraft. The most important stained-glass commission Woodroffe received was for the windows of the Lady Chapel in St Patrick's Cathedral in New York; the work, begun in 1909, was finally completed twenty-five years later. Woodroffe also made decorative designs for the Essex House and Shakespeare Head Presses. He exhibited with the Arts and Crafts Exhibition Society and the New English Art Club and at the Royal Academy, and he was elected to the Art Workers' Guild in 1901. He designed stamped cloth book covers for Kegan Paul, Unicorn Press, Jack, Dent, Nister, H. Wilford Bell, Catholic Truth Society, Henry, and Nelson.

P W

Ref: P.D. Cormack, *Paul Woodroffe 1875-1954 Illustrator Book Designer Stained Glass Artist* (London, 1982).

DENMARK

GUDMUND HENTZE
fig. 77
1875-1948

Born in Naestved, Hentze studied at the Technical School in Copenhagen, and then at the Copenhagen Academy where he was a pupil of Kristian Zahrtmann. From 1900 to 1901 he studied in Italy. On his return to Denmark he found work supplying designs for metalwork to Mogens Ballin's Workshop. He was a member from 1905 of 'Frie Udstilling' (Free Exhibition), a secessionist group of artists who exhibited crafts as well as paintings and sculpture. He exhibited widely in Germany and Sweden, showing paintings, woodcuts and engravings. His book illustrations reveal the strong influence of the English Pre-Raphaelite painters. He designed stamped cloth book covers mainly for the Copenhagen publishers Gyldendal.

gudmund Hentze G H

Ref: G. Fanelli and E. Godoli, *Dizionario degl. Illustratori Simbolisti e Art Nouveau* (Florence, 1990).

KRISTIAN KONGSTAD
fig. 78
1867-1929

Kongstad was born in Copenhagen, the son of a brewer and distiller. At a young age, he was apprenticed to a firm of painters and decorators, and in 1884 entered the government-supported, but progressive, Artists' Study School in Copenhagen. After leaving the school, he taught drawing for the next eight years. In 1894, resolving to make a career from the art of the book, he started a book decoration studio, carrying out bespoke decorations on volumes that his clients brought him. The enterprise did not flourish, and in 1895 he turned instead to wood-engraving. He met the printer Simon Bernsteen who earlier that year had visited William Morris and had become his ardent disciple. In 1896, Kongstad settled at Frederiksvaerk, a small town about twenty-five miles north of Copenhagen, where he set up his own press and started printing books in small editions, illustrated with his own colour

woodcuts. In 1913, he sold his printing shop and two years later set up another press in nearby Hillerød; he produced his last book in 1921. Most of his designs for stamped cloth book covers were done during the two-year period between selling up at Frederiksvaerk and starting to print again at Hillerød, and many of them were in a similar style to the illustrations in his private press books, a style derived from the Gothic illustrations that had been so much admired by William Morris. They were mostly done for the Copenhagen publishers Gyldendal.

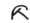

Ref: E. Dal, *Scandinavian Bookmaking in the Twentieth Century* (Urbana IL and London, 1968); T. Sjölin, Kristian Kongstad, Danish Master Printer', *Private Library* sixth series 2/2 (Summer 2009) pp.83-91.

GERMANY

GEORG BELWE fig.82
1878-1954

Belwe was born in Berlin and attended the School of the Berlin Museum of Applied Art, studying graphic art under Emil Doepler jr. In 1900, with classmates F.H. Ehmcke and F.W. Kleukens, he started the Steglitzer Werkstatt in a suburb of Berlin; their inspiration had been the guilds and small workshops which were so much a feature of the Arts and Crafts movement in England. The Werkstatt produced a range of commercial graphics decorated in an Arts and Crafts style, and in 1903 an edition of Elizabeth Barrett Browning's *Sonnets from the Portugese* was designed and printed for the publisher Eugen Diederichs; furniture and metalwork was also made at the Werkstatt. In 1906, Belwe was appointed head of the typography department at the Academy for the Graphic Arts and Book Production in Leipzig, where he was later made a professor. He designed several typefaces, including 'Belwe' (1907) and 'Belwe Gotisch' 1912). He designed stamped cloth book covers for, among other publishers, Quelle & Meyer, Eduard Avenarius, Haessel, and Fleischel.

Ref: A. Mundt, 'Georg Belwe und seine Klasse an der Königl. Akademie für graphische Künste und Buchgewerbe', *Archiv für Buchgewerbe* 47/6 (June 1910) pp.165-171; J. Eyssen, *Buchkunst in Deutschland vom Jugendstil zum Malerbuch* (Hanover, 1980).

HANS EDUARD VON BERLEPSCH (-VALENDAS) fig.79
1849-1921

Born at St Gallen, Switzerland, where his father had sought refuge after the 1848 revolutions in Germany, Berlepsch attended the Zürich polytechnic where he studied architecture from 1868 to 1871 under Gottfried Semper. He abandoned architecture in 1875 and, moving to Munich, he studied painting at the Munich Academy. Dissatisfied with the teaching there, he began to realise the importance of decorative art and design. The 1897 international exhibition of fine art at the Glaspalast in Munich included two rooms of decorative art, which Berlepsch acclaimed as an important breakthrough; writing in the first issue of *Deutsche Kunst und Dekoration*, he welcomed the introduction to Germany of the latest work of the English Arts and Crafts movement. From the mid-1890s he corresponded with Walter Crane, and on visits to England he met Crane and other leading figures of the Arts and Crafts movement. Impressed by C.R. Ashbee's workshop training methods, he started a school of his own run along the same lines at his home in Planegg, near Munich. Berlepsch designed metalwork, jewellery, furniture, ceramics and graphics including book covers. He contributed an article on modern bookbinding to *Münchner Neueste Nachrichten* (1898), and he designed stamped cloth book covers for Nister, Meissner & Buch, and probably other publishers.

Ref: A. Weese, 'Hans Eduard von Berlepsch, München', *Deutsche Kunst und Dekoration* 3 (Oct. 1898) pp.1-20; J. Heskett, *Design in Germany 1870-1918* (London, 1986); K.B. Hiesinger (ed.), *Art Nouveau in Munich* (Munich, 1988)

FRIEDRICH WILHELM KLEUKENS fig.80
1878-1956

Born at Achim, near Bremen, Kleukens first worked as a designer of silverware at a factory near Bremen. He attended the School of the Berlin Museum of Applied Art, studying graphic art under Emil Doepler jr. Inspired by the Arts and Crafts movement in England, in 1900 Kleukens and two classmates, F.H. Ehmcke and G. Belwe, established the Steglitzer Werkstatt in a Berlin suburb. They designed and printed decorative commercial graphics, mostly of an ephemeral nature, although they also produced an edition of *Sonnets from the Portugese* by E. B. Browning for the publisher Eugen Diederichs. He taught at the Academy for the Graphic Arts and Book Production in Leipzig from 1903 to 1906 when he joined the artists' colony at Darmstadt. Under the patronage of the Grand-Duke Ernst Ludwig of Hesse-Darmstadt, a keen admirer of the English Arts and Crafts movement, Kleukens and his brother set up the Ernst-Ludwig-Presse, which, modelled on the Doves Press in England, emphasised typography at the expense of decoration and illustration. F.W. Kleukens, however, favoured a more decorative treatment, and in 1919 he set up his own Ratio-Presse where he printed books, many of them illustrated, in a style more befitting his talents as a painter. He worked for several commercial publishers, including Insel-Verlag, for whom he also designed book covers.

Ref: G. Fanelli and E. Godoli, *Dizionario degli Illustratori Simbolisti e Art Nouveau* (Florence, 1990); J. Eyssen, *Buchkunst in Deutschland vom Jugendstil zum Malerbuch* (Hanover, 1980).

WALTER TIEMANN fig.81, 83
1876-1951

Born at Delitzsch, a few miles north of Leipzig, Tiemann studied art at the Royal Academy of Fine and Applied Art in Leipzig before spells in Dresden and Paris. From 1903, he taught at the Leipzig Academy of Graphic Arts and Book Production, becoming Director in 1920. At first his work was influenced by Jugendstil, but during the first decade of the twentieth century he fell under the spell of the English Arts and Crafts movement, particularly when he

started collaborating with Carl Ernst Poeschel the printer. Poeschel had visited London in order to meet Edward Johnston, Eric Gill and Emery Walker. In 1907, Tiemann and Poeschel founded the Janus-Presse, the first private press in Germany. They shared the ambition to apply ideas about book design formulated by the English private press movement to commercial printing in Germany, and Tiemann worked closely with several publishers and designed commercial typefaces and ornament for the Klingspor foundry in Offenbach. He created the poster for the International Exhibition of Book Production and Graphic Art held in 1914 at Leipzig, as well as covers for the reviews *Hyperion* (1908) and *Das Inselschiff* (1923). He designed stamped cloth (or card) book covers for many publishers including Seemann, Diederichs, Rohwolt, Zeitler, Fischer, Insel, Langen, and Teubner.

Ref: G. Fanelli and E. Godoli, *Dizionario degl Illustratori Simbolisti e Art Nouveau*; H. Eckert 'The Impact of Morris and the Kelmscott Press in Germany', *Journal of the William Morris Society* 11/2 (Spring 1995) pp.20-24.

NETHERLANDS

RICHARD NICOLAAS ROLAND HOLST
fig.84
1868-1938

Born in Amsterdam, Roland Holst trained to be an artist at the Royal Academy of Art, of which he would later become Director. He was at first drawn to Belgian Art Nouveau but was put off by an apparent lack of seriousness in the style. The idealism of the English Arts and Crafts movement appealed to him, as it did to many prominent figures in the Dutch avant-garde. In the Winter 1893-94, he spent some months in England, eager to learn about the Arts and Crafts movement and its activities. He met William Morris and Walter Crane and was particularly impressed by the work of Charles Ricketts and Charles Shannon whom

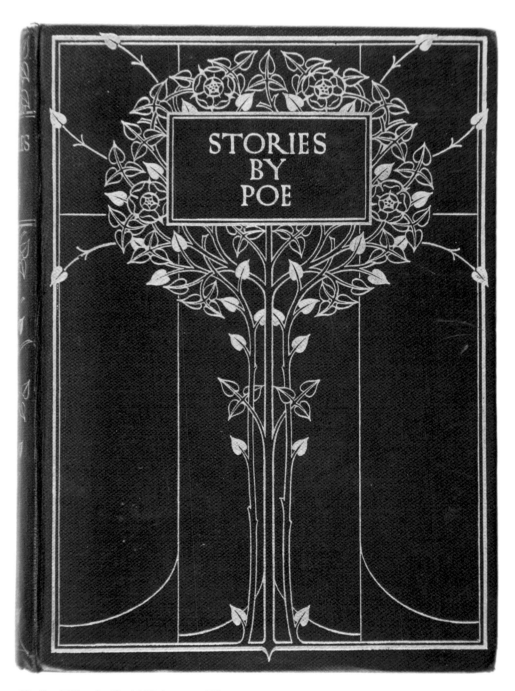

69. Paul Woodroffe, 1908 (cat. no. 76)

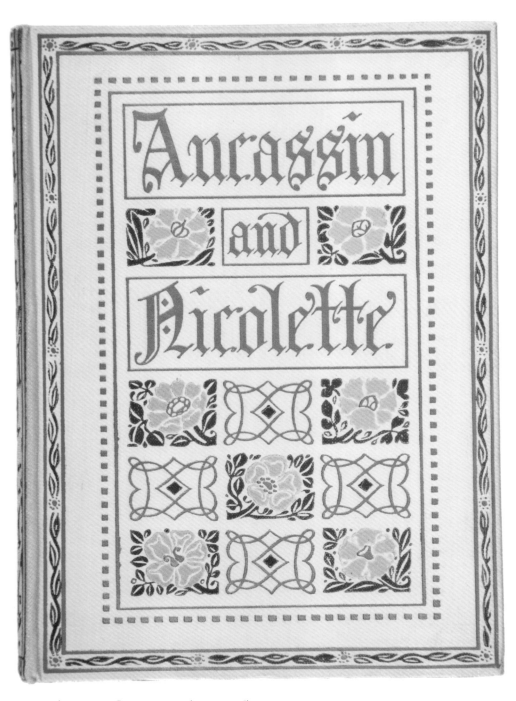

70. Robert Percy Gossop, 1910 (cat. no. 15)

he visited at The Vale, Chelsea. He developed a monumental style which was much in demand for posters and magazine covers, and he gained a reputation as a mural painter and designer of stained glass. He executed murals for two important buildings designed by H.P. Berlage, the Amsterdam Bourse (1903) and the Dutch General Diamond Workers' Union building. Roland Holst designed stamped cloth book covers for Veen and W. Versluys.

Ref: K. Broos and P. Hefting, *Dutch Graphic Design* (London, 1993); E. Braches, *Dutch Art Nouveau and Book Design* (Amsterdam, 2009).

SWEDEN

OLLE HJORTZBERG fig.85, 88
1872-1959

Hjortzberg was born in Stockholm. He was introduced to the art of the book by his brother-in-law, the architect Agi Lindegren, who designed hand-bindings for the firm of Gustaf Hedberg, the leading bookbinders in Sweden. Having taken painting lessons, Hjortzberg worked on the decorations of Uppsala Cathedral (1891-92). From 1892 to 1896, he attended the Royal Academy of Art in Stockholm. During this time Agi Lindegren designed the trademark of 'Sub Rosa', a shop in Stockholm selling products of the English Arts and Crafts movement which was established in Stockholm by Lindegren's close friend Erik Gustaf Folcker. Hjortzberg adopted an Arts and Crafts style when he designed the 1898-99 *Boktryckeri-Kalender* for the printer Walter Zachrisson, who had started publishing the series in 1893 under the influence of William Morris's work at the Kelmscott Press. On visits to Greece, Italy and the Near East, Hjortzberg became interested in the iconography of primitive Christianity, and he drew from this source of inspiration for the illustrations and decorations of Gustav V's Church Bible, on which he was engaged from 1906 to 1927. He designed stained glass and mural decoration for a number of churches and other public buildings and held teaching posts in various institutions. Hjortzberg also designed bookbindings for Gustaf Hedberg and stamped cloth book covers for Bonnier, Lindblad, and possibly other publishers.

Ref: G. Fanelli and E. Godoli, *Dizionario degli Illustratori Simbolisti e Art Nouveau* (Florence, 1990); E. Dal, *Scandinavian Bookmaking in the Twentieth Century* (Urbana IL and London, 1968); E. Stavenow-Hidemark. *Sub Rosa. När Skönheten Kom Från England* (Stockholm, 1991).

ARTHUR SJÖGREN fig.87
1874-1951

Born in Stockholm, Sjögren attended the Technical School there, at the same time taking drawing classes from a portrait painter. In 1890, he began work in the office of the architect I.G. Clason, and from 1893 he attended the Artists' Association Free Academy and was friendly with a group of avant-garde students. By 1894, he had become aware of the Arts and Crafts movement in England, partly through his association with the architect and book designer Agi Lindegren, an admirer of William Morris, and the circle round 'Sub Rosa', a Stockholm shop selling Arts and Crafts wallpapers and textiles imported from England, and partly through the pages of the *Studio*. A wallpaper that Sjögren had designed was illustrated in the Handicraft Society's Newsletter that year. He was particularly impressed by the work of the Kelmscott Press and his earliest forays into the field of book design revealed his mastery of the combination of text and illustration in the Kelmscott manner. Following Morris's lead, he executed hand-written and illuminated manuscripts, and in 1905 one of these, his own verse composition entitled *Maskros*, was published in facsimile. Although he used the medieval forms revived by Morris, Sjögren abandoned any stylistic archaicism. From 1901 he started a fruitful connection with the publisher Albert Bonnier, designing many of the covers for their editions of modern authors'

collected works. As well as Bonnier, he designed stamped cloth book covers for Ljus and Fröléen.

Ref: G. Fanelli and E. Godoli, *Dizionario degli Illustratori Simbolisti e Art Nouveau* (Florence, 1990); A. Kumlien, 'Bokkonstnären Arthur Sjögren', *Form* 40/5 (1944) pp.102-03.

LYDIA MATHILDA PETRONELLA SKOTTSBERG
fig.86
1877-1948

After three years at the Technical School in Stockholm, Skottsberg attended the Higher Industrial Art School from 1896 to 1899. The following year she entered the Royal Academy of Art where she studied under Axel Tallberg who had lived in England during the early 1890s. In 1903, Skottsberg went on a study trip to Denmark, Germany, England and France. These state-funded trips often included visits to the Morris & Co. workshops at Merton Abbey. About 1905, she began to design posters and book decorations. Most of her designs for stamped cloth book covers were for Wahlström & Widstrand, but she worked for other publishers including Beijer.

Ref: Svenskt Konstnärs Lexicon (Malmö, 1967).

U.S.A.

WILLIAM HENRY BRADLEY
fig.93
1868-1962

Bradley was born in Boston, Massachusetts. His father was a cartoonist and his mother a dressmaker. In 1880, he moved to Ishpeming, Michigan, and within two years was working on the local newspaper. In 1886 he went to Chicago, Illinois, and after working for various publishers and printers, he set up his own studio. He designed decorations and illustrations for magazines including the *Inland Printer* and the *Graphic*. In 1893, the year of the World's

Columbian Exposition in Chicago, he was commissioned by the poet Harriet Monroe to design a booklet for her poem *The Columbian Ode*. Bradley rapidly gained a nationwide reputation for his designs for book and magazine covers, as well as posters. He moved to West Springfield, Massachusetts, and in 1895 he studied a collection of printing from the colonial period held in the basement of the newly-opened Boston Public Library; his researches fostered a love of the Caslon typeface and initiated a new phase in his work, less dependent on the art of Aubrey Beardsley. He established the Wayside Press and in May, 1896, he started issuing *Bradley: His Book*, a monthly magazine designed and largely written by himself. Circulation soon rose to over 25,000. The November issue contained a tribute to William Morris. At the first exhibition of the Society of Arts and Crafts, which opened in Boston in April, 1897, Bradley showed book covers, posters, catalogues and furniture designs. In 1901, he drew eight full-page interiors for the *Ladies' Home Journal* which show a modernity and unity of design in the manner of F.L. Wright and C.F.A. Voysey. From 1903 to 1905 Bradley was art director for American Type Founders for whom he designed four typefaces and several booklets on advertising design. He was art editor of several magazines, and from 1915 to 1917 he was the supervising art director for Hearst Publications and Motion Pictures. In 1900, he had taken a course in literature at Harvard University, and he subsequently wrote children's books and stories and a play in free verse, as well as articles forewords and an autobiography. Bradley designed stamped cloth book covers for several publishers of which the most significant were Stone & Kimball, H.S. Stone, Way & Williams, Burrows Brothers, John Lane, Copeland & Day R.H. Russell, Stokes, and Dodd Mead.

Ref: A. Bambace, *Will H. Bradley: His Work* (New Castle DE and Boston MA, 1995)

HENRY HUNT CLARK
fig.9?
Born at Haverhill, Massachusetts, Clark is described in the records of the Society of Art

and Crafts (Boston) as "book-designer and Illuminator", but he is better known today as a distinguished teacher of design. Apart from a few book cover designs, Clark's work as an artist and designer has yet to be discovered. After graduating from the Massachusetts Institute of Technology, he studied at the Boston Museum of Fine Arts School and was a protégé of the design theorist Denman Ross. Clark taught at the Museum of Fine Arts School from 1898 to 1903 and again from 1913 to 1931, and he assisted Ross in his arduous teaching programme at the Harvard Summer School and the Rhode Island School of Design summer courses. In 1903, Clark joined the staff at the R.I.S.D. and rose to become head of the department of design. In 1913, he returned to the Museum of Fine Arts School and became the Director of the Department of Design there. In 1931, he was appointed Director of the Art School at Cleveland, Ohio. The four known stamped cloth book covers designed by Clark were all for books published by Copeland & Day.

Ref: N. Finlay, *Artists of the Book in Boston 1890-1910* (Cambridge MA, 1985); M. Frank, *Denman Ross and American Design Theory* (Hanover and London, 2011).

THOMAS MAITLAND CLELAND fig.98
1880-1964

Cleland was born in Brooklyn, New York, the son of a doctor, but the family moved to the west side of New York city when he was still young. Aged fifteen, he briefly attended art school but left after a few months to take a job in a small printing shop. He was fascinated by a Kelmscott Press *Chaucer* displayed in the window of Scribner's bookshop on Fifth Avenue. He was invited inside by one of the assistants who showed him other Arts and Crafts books from England. At about the same time, Cleland bought a copy of Walter Crane's *The Decorative Illustration of Books*, and he visited the Lenox Library to see medieval illuminated manuscripts and early printed books. He set up a small press in the basement

of the family home, and later established the Cornhill Press in Boston. This was not a success and, disillusioned with Boston, he returned to New York. On a trip to Europe in 1904 he was impressed by the ornamental qualities of sixteenth-century Renaissance design and the eighteenth-century rococo, and these styles were the dual source of his inspiration for the rest of his career. For a few years from about 1907, he worked for the McClure Company, publishers of books and magazines, being appointed art editor of *McClure's* magazine and designing the covers for many of the books that the firm published. He went on to be art editor on other magazines including *Fortune*, and was much in demand for designing advertisements and trade catalogues, particularly for stylishly luxurious products. He designed stamped cloth book covers for Houghton Mifflin, Page, Ginn, Bobbs-Merril, Dodd Mead, McClure Phillips, and McClure.

C

Ref: S.O. Thompson, *American Book Design and William Morris* (New York and London, 1977); J. Blumenthal, *The Printed Book in America* (Boston and London, 1977).

BERTRAM GROSVENOR GOODHUE
fig.97
1869-1924

Born in Pomfret, Connecticut, Goodhue trained as an architect in New York. In 1892, he joined the firm of Ralph Adams Cram and Charles Wentworth in Boston as an equal partner. From 1892 to 1894, Goodhue and Cram were co-editors of the *Knight Errant*, one of the earliest and most sophisticated of the 'little magazines' which sprang up across America in the 1890s. It was modelled on the *Century Guild Hobby Horse*, and in the first issue there appeared an article written by Goodhue and entitled 'The Final Flowering of Age-Old Art' where he acknowledged the debt owed to A.H. Mackmurdo, S. Image and H. Horne and acclaims the work of William Morris at the Kelmscott Press. Goodhue also designed the cover which was suggested by Dürer's

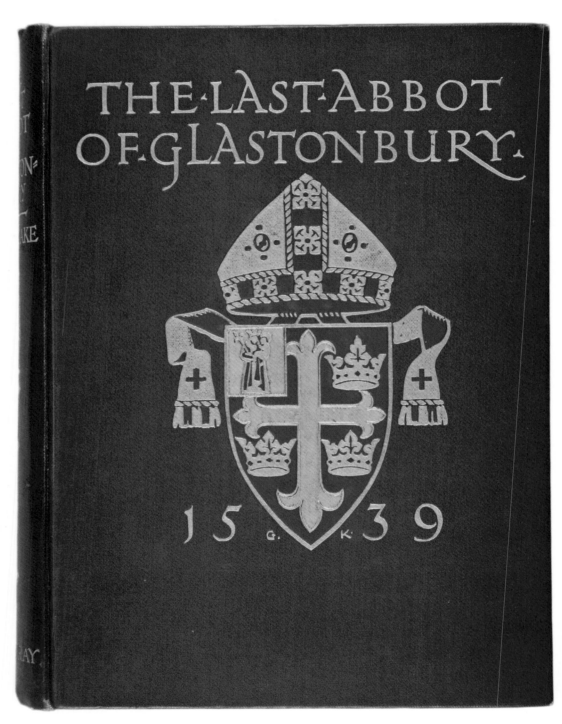

71. George Kruger, 1910 (cat. no. 35)

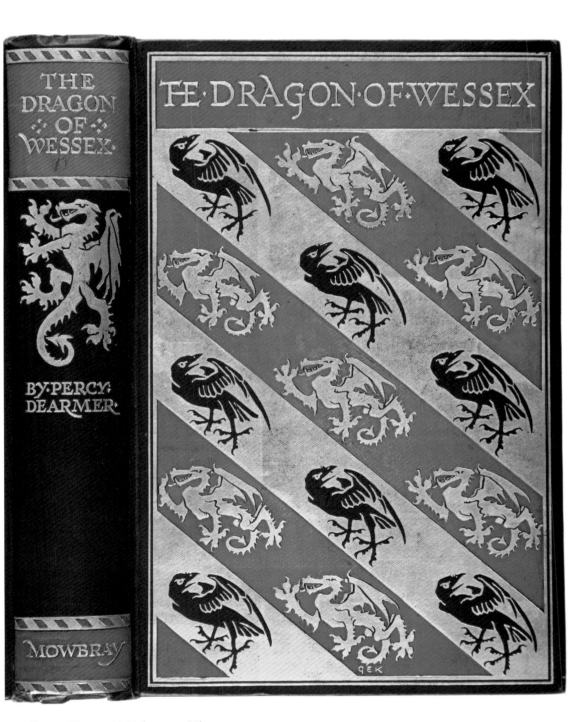

72. George Kruger, 1911 (cat. no. 37)

ARTS & CRAFTS BOOK COVERS

engraving 'The Knight, Death and the Devil'. A feature of the magazine was the regular column 'Regarding Recent Books and Bookmaking' written by Fred Holland Day. Goodhue was closely involved in the early projects of the publishers Copeland & Day, established in 1893 by Day and Aaron Copeland. Goodhue decorated several of the new firm's books in an Arts and Crafts style, providing covers for some of them. He worked in the same style when decorating many of the early volumes printed by Daniel Berkeley Updike at his Merrymount Press. In 1896, Goodhue designed all the page decorations in Updike's *Altar Book*, which was illustrated by Robert Anning Bell and shown that year at the Arts and Crafts Exhibition Society in London. Goodhue also designed typefaces, 'Merrymount', for Updike, and later 'Cheltenham'. He took an active role in the foundation of the Society of Arts and Crafts, Boston, in 1897, and he designed the cover for the catalogue of the Society's first exhibition the following year. As architecture took a growing portion of his time, his book decoration became restricted, although he continued to make cover designs. In 1903, he left Boston never to return. He designed stamped cloth book covers for Copeland & Day, Small Maynard, Houghton Mifflin, Longmans, and John Lane.

BG **B.G.G.**

Ref: N. Finlay, *Artists of the Book in Boston* (Cambridge MA, 1985); S.O. Thompson, *American Book Design and William Morris* (New York and London, 1977).

FREDERIC WILLIAM GOUDY fig.96
1865-1947

Goudy was born in Bloomington, Illinois, the son of a schoolteacher. After working as a clerk in various midwestern towns, in 1890 he arrived in Chicago. Finding work as a bookkeeper, he started a magazine called *Modern Advertising*, for which he commissioned a cover from Will Bradley. At McClurg's bookstore on Wabash Avenue, he was given access to the Arts and Crafts books arriving from England. The head of the rare and foreign books department was George M. Millard, an important conduit between the English Arts and Crafts movement and Chicago; Millard made frequent trips to London where he could have been found on 26 July 1895, for instance, dining at the Hogarth Club with John Lane, Edmund New and Laurence Housman, among others. At McClurg's, too, Goudy bought books about books such as *Early Printed Books* by Gordon Duff and *Early Illustrated Books* by A.W. Pollard. In 1895, Goudy set up the Booklet Press, and his work attracted the attention of W. Irving Way, a bibliophile who regularly wrote for the *Inland Printer*. Way introduced him to Herbert S. Stone the publisher, who commissioned Goudy to set in type the *Chap-Book*, the leading 'little magazine' of its time. Goudy changed the name of his press to 'Camelot', and he gave the same name to his first type. Goudy's considerable fame rests on his types, of which he designed over a hundred in the course of his career. In 1899, he set up as a freelance designer specialising in lettering, but also designing book covers and decoration. The following year, he started teaching lettering and ornament (including the design of book covers) at the Frank Holme School of Illustration in Chicago, and in 1903 established the Village Press at Park Ridge, Illinois. He was now working in an entirely Arts and Crafts manner and decided in 1904 to move his press to Hingham, Massachusetts, in an area where there was a flourishing Arts and Crafts movement. Two years later the Village Press was again moved, this time to New York. In 1908, the Press was completely destroyed in a fire, and henceforth Goudy would concentrate on type designing. In 1909, he made the first of many trips to Europe; in London, he met Emery Walker, Charles T Jacobi of the Chiswick Press, and A.W. Pollard, a curator at the British Library. Goudy designed stamped cloth book covers for books published by H.S. Stone, McClurg, Bowen-Merrill and Crowell.

G

Ref: F.W. Goudy, *A Half-Century of Type Design and Typography* (New York, 1946); J. Blumenthal, *The Printed Book in America* (Boston and London, 1977); S.O. Thompson, *American Book Design and William Morris* (New York and London, 1977); J.W. Lambert and M. Ratcliffe, *The Bodley Head*

1887-1987 (London, 1987) p.120; *Brush and Pencil* (Chicago) 5/2 (Nov. 1899) p.86.

THEODORE BROWN HAPGOOD JR
fig.99
1871-1938

Hapgood was born in Boston, Massachusetts, and educated at the Boston Latin School. He studied for two years at the School of the Museum of Fine Arts, Boston, and in 1894 he won a $15 (£3.00) prize in a competition for book cover designs, organised by Scribner's the publishers. About 1895, he moved into a studio at 69 Cornhill, Boston, and began a long career in the design of decoration and lettering, and particularly the combination of the two, in a wide variety of media and styles. At first he favoured medieval woodcuts and Renaissance ornament as the sources of his inspiration, but he was also influenced by colonial decoration and the sort of conventionalised floral patterns characteristic of the English Arts and Crafts style. He worked with the Craftsman Guild, established in Boston around 1900 to make illuminated manuscripts; Hapgood created the lettering and borders which were then illuminated by other members of the Guild. He designed a wide range of decorated inscriptions, from tombstones to shipping labels, working in stone, marble, bronze and paper, as well as stamped cloth book covers. Embroidered ecclesiastical vestments that he designed for the Church of St Catherine of Genoa at Somerville, Massachusetts, reveal his knowledge of, and affection for, medieval ornament. During the latter part of his career, he worked at Watertown, Massachusetts, where he died. He designed stamped cloth book covers for a great number of publishers, of which the most significant were Lamson Wolffe, Crowell, Houghton Mifflin, Stone & Kimball, Ginn, Rand McNally, Small Maynard, Dodd Mead, Badger, Stokes, and Doubleday Page.

TBH H *TBH* ₮ℍ

Ref: Lewis Buddy III, 'The Decorative Work of Theodore Brown Hapgood', *Graphic Arts* 4/6 (May 1913) pp.369-80; W.A. Kittredge, 'Theodore Brown Hapgood American Designer', *Print: A Quarterly Magazine of the Graphic Arts* 3/2 (Summer 1942) pp.1-24; *Book Buyer* 11/8 (Sep. 1894) p.384; J.-F. Vilain, 'The Arts and Crafts Book', *Second Annual Arts and Crafts Symposium* (Lambertville NJ, 1994) pp.20-30.

FRANK HAZENPLUG
fig.94
1873-1931

Hazenplug was born in Dixon, Illinois, the son of a furniture maker. He moved with his family to Chicago in 1882, and in 1891 he attended a three-month course in design at the School of the Art Institute of Chicago. After working for a short time at architectural modelling in plaster, he was doing routine office work when he approached the publishers Stone & Kimball, newly arrived from Cambridge, Massachusetts, and showed them some decorative drawings in the manner of Aubrey Beardsley. They were persuaded to give him a trial and for the next dozen years he designed covers and title pages for many of the books published by Stone & Kimball and, after the dissolution of the partnership, by H.S. Stone & Co. He also contributed decorative illustrations and covers to the house magazine, the *Chap-Book*, and designed posters for it and other Stone publications. In 1894, Hazenplug returned to the Art Institute School and for one year studied decorative design under Louis J. Millet. Not long after this, Hazenplug became a resident at Hull-House, the Chicago settlement house opened by Jane Addams in 1889 and run by her along the lines of Toynbee Hall in London (Rev. Samuel Barnett, the founder of Toynbee Hall, was among visitors to Hull-House in the 1890s, and other guests included Prince Kropotkin, W.B. Yeats and C.R. Ashbee). Instruction in a range of handicrafts took place at Hull-House, and Hazenplug took part in these activities, teaching local children the use of tools and the rudiments of cabinetmaking and metalwork. In April, 1897, a small exhibition of arts and crafts was held at Hull-House, and in October the Chicago Arts and Crafts Society was founded there; Hazenplug was a charter member and took part in their exhibitions. As well as designing book covers, he illustrated books printed by the Blue Sky Press and the Philosopher Press. In

1911, he moved to New York and continued to design book covers until 1920, when he retired. Hazenplug designed stamped cloth book covers for Stone & Kimball, H.S. Stone, Way & Williams, Fleming Revell, Doran, John Lane, McClurg, Bowen-Merrill, Reilly & Britton, Macmillan, and the University of Chicago Press.

Ref: H.G. Rhodes, 'A Little Boy Among the New Masters', *Chap-Book* 4/9 (15 Mar. 1896) pp.412-18; C. Gullans, 'The New Generation: Sarah Whitman and Frank Hazen', S. Allen and C. Gullans, *Decorated Cloth in America* (Los Angeles, 1994); S.S. Darling, *Chicago Furniture* (New York and London, 1984).

LOUIS JOHN RHEAD fig.90
1858-1926

Rhead was born in Staffordshire, England, where his father was a successful ceramic artist. He trained as a china painter at the Minton factory in Stoke-on-Trent, and in 1878 he joined Wedgwood. He then moved to London to study at the Art Training School in South Kensington. In 1882, he returned to Wedgwood as a designer but the following year he was offered the position of art director and illustrator with the New York publisher Appleton. He worked for Appleton for the next six years, gaining a reputation for his cover designs. During this time, he designed for other clients, including the bookbinder William Matthews. He contributed a series of Japanesque designs for ceramics and interiors to the *Art Interchange*, a magazine aimed at amateur decorators. In 1889, he began to design posters, and the style he developed, influenced by Walter Crane and Eugène Grasset, proved very popular. In 1890, he visited London en route for Paris where he settled until 1894, when he returned to the United States. He produced over ninety posters over the next six months, and in 1895 a one-man show of his posters was held at the Wunderlich Gallery in New York. Further exhibitions of his posters were held at the Salon des Cent in Paris (1896) and at Hare & Co. in London (1896 and 1897). After 1900, his poster activity dwindled and he spent more time on book illustration.

He designed stamped cloth book covers for Copeland & Day, Stone & Kimball, Lamson Wolffe, Harper, and Appleton.

L R R
 H
 E
 A
 D

Ref: L. Scholz, 'Louis John Rhead', *Rhead Artists & Potters 1870-1950* (London, 1986) pp.11-14.

BRUCE ROGERS fig.91
1870-1957

Rogers was born in Lafayette, Indiana, and studied art at Purdue University from 1886 to 1890. After graduation he worked as an illustrator for the *Indianapolis News*. In 1893, he began working for the Indiana Illustration Company where he designed his first book decorations. The same year he started contributing decorative designs to *Modern Art*, an Indianapolis periodical edited by Joseph Moore Bowles, an art store clerk. The magazine's success led to commissions for book cover design from Chicago publishers Stone & Kimball, Way & Williams, and A.C. McClurg. The Arts and Crafts character of *Modern Art* attracted the attention of Louis Prang & Co., a Boston firm of lithographers, who agreed to underwrite the costs of publication. Rogers and Bowles moved to Boston in 1895, and the following year Rogers was hired by Houghton, Mifflin & Co as a designer. His work for them over the next sixteen years included the Riverside Press Special Editions; for each volume in the series, Rogers selected typeface, ornament, paper and binding appropriate to the subject and period of the original text. In 1915, Alfred W. Pollard addressed the Bibliographical Society in London on 'The Work of Bruce Rogers, Printer', and the following year Rogers himself arrived in England. In 1917, Rogers and Emery Walker set up the Mall Press in Hammersmith, London; they completed only one book, Albrecht Dürer's *On the Just Shaping of Letters*. Rogers returned to America in 1919 and worked for a period at the Press of William E. Rudge in Mount Vernon, New York. Rogers designed stamped cloth covers for books published by Stone & Kimball, Way &

Williams, McClurg, and Houghton Mifflin.

Ref: S.O. Thompson, *American Book Design and William Morris* (New York and London, 1977); D.A. Harrop, *Sir Emery Walker 1851-1933* (London, 1986).

JULIUS A. SCHWEINFURTH fig.89
1858-1931

Not much is known about this architect and designer, who was born in Auburn, New York. From the age of thirteen he was associated with the firm of Peabody & Stearns, architects in Boston, Massachusetts. In 1884, he became a partner of C.F. Schweinfurth in Cleveland, Ohio. In 1886, he went to Europe and spent two years in study and travel. After he returned to the United States, it was seven years before he set up as an architect on his own, and it was during this interim period that he produced most of his book cover designs. As an independent architect he designed several school and municipal buildings in Boston and Brookline, Massachusetts, as well as buildings at Wellesley College. Presumably to be near the site of the College buildings, he set up home at Wellesley Farms, Massachusetts, where he died. It is uncertain whether a 'J.A. Sweinfurth' listed in the records of the Society of Arts and Crafts, Boston, as 'ceramic worker' exhibiting with the Society in 1897, can be identified with J.A. Schweinfurth. He designed stamped cloth book covers for Roberts Brothers and Little Brown.

J. A S.

Ref: *New York Times*, 30 Sep. 1931.

SARAH WYMAN WHITMAN fig.92
1842-1904

One of the earlier American artists to enter the field of cloth book cover design, Whitman was born in Lowell, Massachusetts. She married in 1866, and after living two years in Cambridge, Massachusetts, she and her husband set up home in Boston. She studied painting under William Morris Hunt from 1868 to 1871 and later under Hunt's mentor, Thomas Couture, at Villiers-le-Bel, near Paris. She painted in oils, watercolour and pastel, exhibiting regularly in Boston and New York. She made her first cover design in 1880 for a book published by Roberts Brothers, but it was the book covers she designed for Houghton, Mifflin & Co. from 1884 which established her as one of the leaders in the field in America. George Mifflin, who was in charge of the firm's production facility at the Riverside Press in Cambridge, had been among the first fifty members to join the Grolier Club, which had been founded in New York in January 1884; one of the Club's expressed aims was to improve the quality of books currently being produced in America. Also in 1884, Whitman carried out her first important commission in stained glass, for the Congregational Church at Worcester, Massachusetts. About 1887, she started the Lily Glass Works for the design and fabrication of her stained glass. Apart from her artistic activities, she was a fervent supporter of Elizabeth Agassiz' campaign for women's higher education, which culminated in the foundation of Radcliffe College. She also played an active role in the administration of the School of the Museum of Fine Arts, Boston, becoming a member of the Council in 1885. She designed the Houghton Mifflin pavilion in the Liberal Arts Building at the Chicago World's Exposition of 1893. The following year, she gave an informal talk to the Boston Art Students' Association on 'Book Illustration, Inside and Out', which was later published. She was a founder member of the Society of Arts and Crafts in 1897, and she showed book covers at the Society's first exhibition. In 1905, the Society held a memorial exhibition of her work. Most of the stamped cloth covers that Whitman designed were for books published by Houghton Mifflin; other publishers that she worked for included Roberts Brothers, Little Brown, Crowell, Harper, Century, Scribner, W.B. Clarke, and the Merrymount Press.

Ref: B.S. Smith, 'Sarah de St. Prix Wyman Whitman', *Old-Time New England* 77/266 (Spring/Summer 1999) pp.46-64; E.E. Hirshler, *A Studio of Her Own Women Artists in Boston 1870-1940* (Boston MA, 2001).

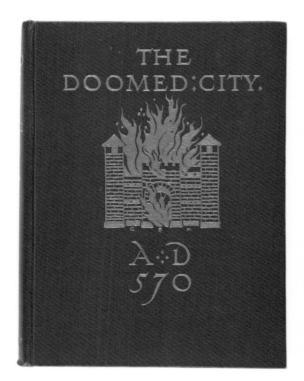

73. George Kruger, 1911 (cat. no. 36)

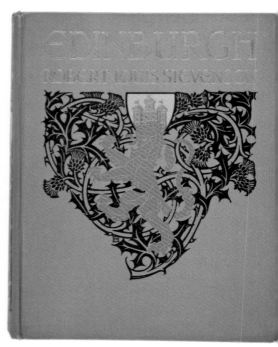

74. Harold Nelson, 1912 (cat. no. 44)

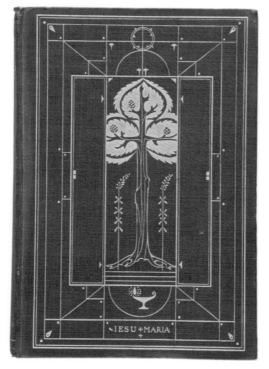

75. Charles Ricketts, 1913 (cat. no. 51)

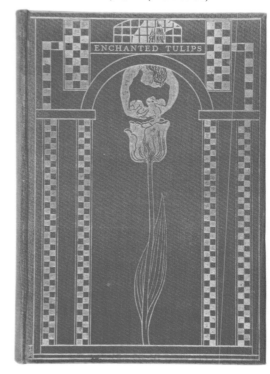

76. Thomas Sturge Moore, 1914 (cat. no. 55)

CATALOGUE

The books are listed by designer in alphabetical order; Britain is followed by overseas countries in alphabetical order.

The books are bound in cloth-covered boards unless otherwise stated.

The books were published in London unless otherwise stated.

The date given is the date which appears on the title page; if no date appears on the title page, or if the book is not a first edition, the date of the first edition is given in square brackets.

The dimensions given are those of the front cover, height before width, in mm.

Aubrey Beardsley fig.23

1. Arthur Machen THE GREAT GOD PAN
(Keynote Series vol.6)
John Lane, 1894
200 x 118
Unsigned

Beardsley made decorative designs for all but one of the first twenty-three volumes of the Keynote Series. On each volume, the same design was used on the title page and front cover, and an ornamental key design incorporating a monogram of the author's initials was stamped on the spine and back cover. Here Beardsley has paraphrased the kind of decorative border found on the title page of many early printed books where grotesque figures inhabit scrolling stems.

Aubrey Beardsley fig.32

2. Grant Allen THE WOMAN WHO DID
(Keynote Series vol.8)
John Lane, 1895
200 x 120
Unsigned

See note to cat. no.1.
For this cover Beardsley has re-used a motif that he had included in one of the decorative borders of *Le Morte Darthur*, published two years earlier (vol.I, p.367). *Le Morte Darthur*, Beardsley's first major commission, had been intended by its publisher, J.M. Dent, to be a cheaper, more popular version of the de luxe volumes printed at the Kelmscott Press.

Aubrey Beardsley fig.47

3. Ben Jonson VOLPONE
Leonard Smithers, 1898
288 x 219

Signed and dated 'AB 1898 PARIS', lower left

Towards the end of Beardsley's brief career, the artist turned his attention to the arts of France, and this design was perhaps inspired by 16th- or 17th-century French bookbinding. This was the last book that Beardsley illustrated and designed, and it remained unfinished at his death.

Robert Anning Bell fig.45

4. POEMS BY JOHN KEATS
(Endymion Series)
George Bell & Sons, 1897
208 x 134
Signed 'R.AN.BEL', lower right

Anning Bell designed covers for two other volumes in the Endymion Series: *English Lyrics from Spenser to Milton* (1898) and *Poems by Percy Bysshe Shelley* (1902). His illustrations for this volume were largely inspired by the woodcuts of the *Hypnerotomachia*, but the cover design depends rather on William Morris's wallpaper and textile patterns.

Frank Brangwyn fig.38

5. THE THOUSAND AND ONE NIGHTS
Gibbings & Co., 1896 (vol.3/6)
180 x 111
Unsigned

P.G. Konody suggested that the design for this cover might have been inspired by Persian tiles ('The Decorative Design of Mr Frank Brangwyn', *Magazine of Art* [May 1903] p.394). Brangwyn would have been exposed to Persian art when he had worked for Morris & Co. in the early 1880s.

William Harrison Cowlishaw fig.39
6. Ford M. Hueffer FORD MADOX BROWN
Longman, Green, & Co., 1896
234 x 150
Signed 'WHC' in monogram, lower right

In 1895 Cowlishaw had decorated a bedroom ceiling at the house that he had designed for Edward and Constance Garnett with a briar-rose pattern in plasterwork, and the design on this cover is similar. Ford Madox Hueffer, the author of this monograph of his grandfather's art, wrote an article describing at length Cowlishaw's work which illustrates both the ceiling and the book cover (*The Artist* [Sep. 1897] pp.432, 436).

Walter Crane fig.5
7. Mrs Molesworth 'GRANDMOTHER DEAR'
Macmillan and Co., 1878
174 x 115
Unsigned

Crane illustrated and designed the cover of 17 children's books by Mrs Molesworth for Macmillan's between 1875 and 1890. For most of the covers he used black ink and gold-leaf on red, textured cloth. Here he has used only black ink, which supports the claim that he made in 1888, that his "designs for book covers [have] been with a view to production in a cheap form" (*Journal of the Society of Arts* 36/1840 [24 Feb. 1888] p.371).

Walter Crane fig.12
8. Walter Crane THE CLAIMS OF DECORATIVE ART
Lawrence & Bullen, 1892
225 x 171
Unsigned

Crane's design is derived from the chased metal mounts found on fifteenth- and sixteenth-century bindings.

Walter Crane fig.14
9. Nathaniel Hawthorne TWICE-TOLD TALES
Walter Scott, n.d. [1893]
183 x 110
Signed 'WC' in monogram, lower left

Crane's design is inspired by the engravings of Albrecht Dürer. The publisher Walter Scott specialised in cheap but well-presented editions of the standard authors, as well as such progressive literature as books by Marc-André Raffalovich and George Moore. Aluminium foil was used from c.1890 to achieve the effect of silver without tarnishing.

Louis Barraud Davis fig.11
10. L.C. Miall OBJECT LESSONS FROM NATURE
Cassell & Co., 1890
189 x 120
Signed 'LD' in monogram, lower left

Davis achieved a dynamism in his design through the rhythmic arrangement of repeated elements, a compositional device borrowed from Selwyn Image who had first used it in his woodcut 'In Piam Memor. Arturi Burgess' (1886), and who had employed it again in his design for the cover of *The Tragic Mary* (fig.9).

Lewis Foreman Day fig.7
11. Margaret Veley A MARRIAGE OF SHADOWS
Smith, Elder, & Co., 1888
183 x 118
Signed 'L.F.D.', lower left

Referring to an illustration of this design, Day wrote: "In the rendering of the marguerite.... the idea was that the meaning should be there (just as there is a meaning in the arrangement of the flowers) for the satisfaction of a personal sentiment, but that it should not be too obvious....one may sometimes hint in ornament what one does not care to say quite plainly." (*Nature in Ornament* [1892] pp.246-47).

Christopher Dean fig.12
12. Edward C. Strutt FRA FILIPPO LIPPI
George Bell & Sons, 1901
233 x 164
Signed 'CD' in monogram with a cross, bottom right

The motif of flowers in a vase had inspired some of William Morris's patterns, and occurs in book ornament of the fifteenth and sixteenth centuries.

Herbert Granville Fell fig.24
13. Ernest Rhys (ed.) THE LYRIC POEMS OF SIR PHILIP SIDNEY (The Lyric Poets)
J.M. Dent & Co., n.d. [1894]
153 x 96
Unsigned

The design was possibly inspired by T.J. Cobden-Sanderson's bookbindings. It is known that the publisher J.M. Dent admired Cobden-Sanderson's work, and that he personally briefed artists from whom he commissioned cover designs.

Arthur Joseph Gaskin fig.18
14. Hans Christian Andersen STORIES & FAIRYTALES (vol.2/2)
George Allen, 1893
206 x 140
Signed 'AJG.' vertically and dated '93', lower left

Gaskin's design is related to 'The Descent of Minerva', a woodcut illustration from the *Quadriregio* (Florence, 1508). The woodcut had been reproduced in the *Journal of the Society of Arts* as an illustration to 'The Woodcuts of Gothic Books', the report of a paper that William Morris had read to the Society in January, 1892 (*Journal of the Society of Arts* 40/2047 [12 Feb. 1892] p.256). Morris had a high opinion of Gaskin's work at this time, and he commissioned the Birmingham artist to illustrate two Kelmscott Press books.

Robert Percy Gossop fig.70
15. AUCASSIN & NICOLETTE
J.M. Dent & Sons, 1910
182 x 124
Unsigned

The Gothic lettering and the open knot motif give the design a medievalism appropriate to a romance emanating from thirteenth-century Picardy.

James Joshua Guthrie fig.49
16. Louis Barsac SHADOWS AND FIREFLIES
Unicorn Press, 1898
155 x 120
Signed 'JJG' in monogram, bottom right

The Unicorn Press was founded in 1897 by Ernest J. Oldmeadow, a former non-conformist clergyman who became a novelist and publisher. The style of this design suggests that it was cut in wood by Guthrie. He valued the woodcut medium for its power of individual expression.

William Snelling Hadaway fig.50
17. GUINGAMOR LAUNFAL TYOLET THE WEREWOLF (Arthurian Romances no.3)
David Nutt, 1900 (series design, first used 1898)
144 x 103
Signed 'h', middle right

The design is based on a scene from the frescoes by Benozzo Gozzoli in the Palazzo Medici-Riccardi, Florence (1459-61), which Hadaway could have seen while visiting Italy on a protracted study-trip (1893-95).

William Snelling Hadaway fig.51
18. Rev. R.E. Welsh GOD'S GENTLEMEN
James Bowden, 1900 [1898]
194 x 129
Signed 'h', middle left

Hadaway's decorative panel is placed so that the margin round it increases in size from top to right to bottom, a format sometimes used on the pages of early printed books and adopted by William Morris at the Kelmscott Press.

Laurence Housman fig.13
19. Harry Quilter PREFERENCES IN ART, LIFE, AND LITERATURE
Swann, Sonnenschein & Co., 1892
286 x 189
Unsigned

This cover and no.20 were included in a display of cloth book covers at the Arts and Crafts Exhibition Society's 1893 show. Housman had been introduced to Quilter by A.W. Pollard, the assistant curator of printed books at the British Museum. Housman had contributed stories and illustrations to Quilter's *Universal Review*, and he had illustrated and designed a cover for an edition of George Meredith's *Jump to Glory Jane* edited by Quilter (1892).

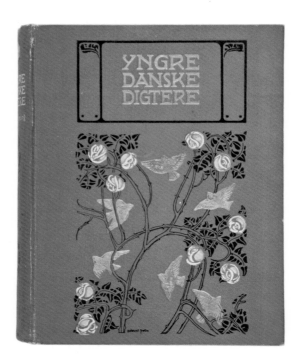

77. Gudmund Hentze, 1906 (cat. no. 77)

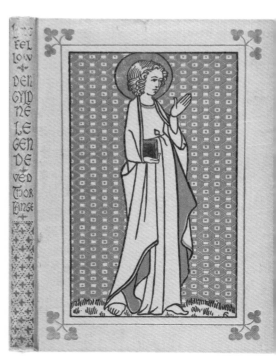

78. Kristian Kongstad, 1915 (cat. no. 78)

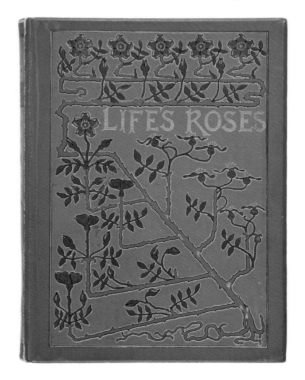

79. H.E.von Berlepsch, 1898 (cat. no. 80)

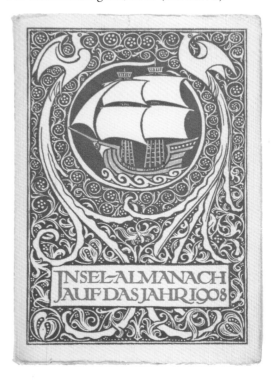

80. F.W. Kleukens, 1907 (cat. no. 81)

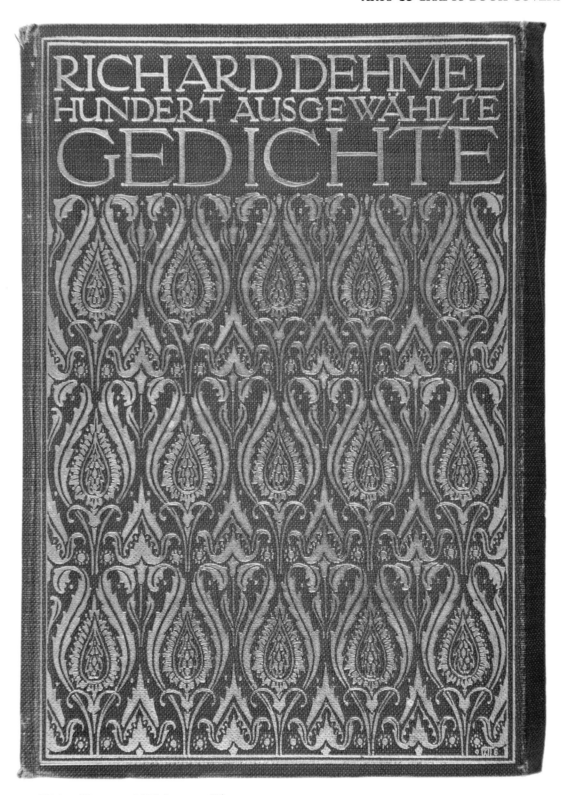

81. Walter Tiemann, 1909 (cat. no. 82)

Laurence Housman fig.15
20. Christina Rossetti GOBLIN MARKET
Macmillan & Co., 1893
188 x 102 (design repeated on back cover)
Signed 'LH', lower right on back cover

The bands on the spine connecting the designs on front and back covers suggest that Housman had in mind metal-mounted bindings of the late Middle Ages. See note to no.19.

Laurence Housman fig.28
21. Laurence Housman A FARM IN FAIRYLAND
Kegan Paul, Trench, Trübner & Co., 1894
199 x 130
Signed 'LH', bottom right corner

The ploughman and his plough had an iconic status in the philosophy of the Arts and Crafts movement. They were a symbol of the natural world ordered by the activity of humans, a theme often treated by William Morris in his lectures and writing.

Laurence Housman fig.29
22. Laurence Housman THE HOUSE OF JOY
Kegan Paul, Trench, Trübner & Co., 1895
199 x 130
Signed 'LH', bottom right corner

The crowded, compartmentalized composition reflects Housman's admiration for the art of Dante Gabriel Rossetti. The simple, fluid lines of the principal figure indicate a debt to the wood engravings of Albrecht Dürer, an artist whose work struck a special resonance in the mind of Arts and Crafts designers; William Morris acclaimed Dürer's art as "thoroughly Gothic in spirit", and his dual ability as both artist and craftsman fulfilled an Arts and Crafts ideal.

Laurence Housman fig.30
23. Charles Newton Robinson THE VIOL OF LOVE
John Lane, 1895
199 x 123
Unsigned

This is perhaps the richest and most exuberant of Housman's cover designs. It was included,

with *Green Arras* (cat. no.24), in a display of book covers at the Arts and Crafts Exhibition Society's 1896 show.

Laurence Housman fig.36
24. Laurence Housman GREEN ARRAS
John Lane, 1896
199 x 128
Unsigned

See note to no.23.
"I was just then designing book-covers for John Lane," wrote Housman, "so naturally I did what I thought was an extra good one for myself." (L. Housman, *The Unexpected Years* [London, 1937] p.162).

Laurence Housman fig.46
25. Laurence Housman SPIKENARD
Grant Richards, 1898
Paper-covered boards
199 x 139
Unsigned

The floral motif was probably adapted from a stalked trefoil used by the 17th-century French bookbinder Florimond Badier on an example of his work illustrated in *Bibliographica* (1895).

Laurence Housman fig.53
26. H.C. Marillier DANTE GABRIEL ROSSETTI
George Bell & Sons, 1899
347 x 231
Signed 'LH', lower centre

Housman rose well to the challenge of a much larger book cover than those that he was used to designing. Dr George Williamson, then art director at Bell's, considered this cover "one of Housman's finest designs", and described the book as "splendid and stately" (*Memoirs in Miniature* [London, 1933] p.71).

Selwyn Image fig.9
27. Michael Field THE TRAGIC MARY
George Bell & Sons, 1890
Paper-covered boards
195 x 140 (design repeated on back cover)
Signed 'SI', lower right

In 1891, the aunt and niece couple who wrote

under the pseudonym of 'Michael Field' recorded that Oscar Wilde "told us that in his belief our *Tragic Mary* and Rossetti's Poems were the two beautiful books (in appearance) of the century" (Michael Field [T. and D.C. Sturge Moore ed.], *Work and Days* [London, 1933] p.139).

Selwyn Image fig.27
28. Ernest Radford OLD AND NEW
T. Fisher Unwin, 1895
194 x 128
Unsigned

The poet Ernest Radford was close to the Arts and Crafts movement; he served as secretary to the Arts and Crafts Exhibition Society from 1888 to 1893.

Selwyn Image fig.52
29. Mrs Arthur Bell REPRESENTATIVE PAINTERS OF THE XIXTH CENTURY
Sampson, Low, Marston and Company, 1899
299 x 208
Signed 'SI', bottom left

In 1887, Image offered a radical definition of design: "It is the inventive arrangement of abstract lines and masses in such a relation to one another, that they form an harmonious whole, a whole, that is, towards which each part contributes, and is in such a combination with every other part that the result is a unity of effect, which completely satisfies us." ('On Design', *Century Guild Hobby Horse* 2/4 [Oct. 1887] p.118).

Will Jenkins fig.55
30. GARDENS OLD AND NEW (Country Life Library)
George Newnes, n.d. [1899]
375 x 247
Signed 'WJ', centre

"This decoration," noted Esther Wood, "with its bold and simple letters and its singular harmony of parts, forms one of the most satisfying book-covers of the year." ('British Trade Bookbindings and Their Designers', *Modern Bookbindings and Their Designers* [The Studio Special Winter-Number 1899-1900], p.30). This cover was firmly committed to the

cause of a strong architectural component in garden design, a cause championed by the Arts and Crafts architect R. Blomfield in his book *The Formal Garden in England* (London, 1892).

Reginald Lionel Knowles fig.58
31. George Herbert THE TEMPLE/A PRIEST TO THE TEMPLE (Cloister Library)
J.M. Dent & Co., 1902 (series first issued 1901)
164 x 107
Signed 'RK', foot of spine

Knowles's design evokes a passage from William Morris's lecture on pattern designing: "Is it not better," he asks, "to be reminded....of the swallows sweeping above the garden boughs towards the house-eaves where their nestlings are, while the sun breaks through the clouds on them?" (*The Collected Works of William Morris* [1992] vol.22, p.178).

Reginald Lionel Knowles fig.62
32. Oliphant Smeaton EDINBURGH AND ITS STORY (large paper edition)
J.M. Dent & Co., 1904
283 x 204
Signed 'RK' and dated '04', bottom right, and 'K', foot of spine

One of the many cover designs which achieve their dynamic effect through the rhythmic repetition of a plant motif across its space.

Reginald Lionel Knowles fig.64
33. Mrs Arthur G. Bell PICTURESQUE BRITTANY
J.M. Dent & Co., 1906
232 x 158
Signed 'RK', foot of spine

The motif of interlocked circles alludes to the traces of Celtic art found in Brittany. The cover design was shown at the Arts and Crafts Exhibition Society in 1913.

Reginald Knowles fig.67
34. Maud U. Clarke NATURE'S OWN GARDENS
J.M. Dent & Co., 1907
266 x 197
Signed 'RLK', lower centre; and 'K', foot of spine

Knowles uses a device which was employed by William Morris for some of the Kelmscott Press books, and which became a characteristic of Arts and Crafts book ornament - the lettering of the title over a panel of one decorative design against a field of another.

George Edward Kruger fig.71
35. Rev. A.D. Crake THE LAST ABBOT OF GLASTONBURY
A.R. Mowbray & Co., 1910
187 x 132
Signed 'G.K.', lower centre

Kruger captured here the primitive splendour of medieval heraldry. The year after this book had appeared, its publisher, A.R. Mowbray, issued *Heraldry of the Church. A Handbook for Decorators* by Rev. E.E. Dorling. In 1914, James Hogg published W.H. St John's *Heraldry for Craftsmen and Designers* in their 'Artistic Crafts Series', with a foreword by W.R. Lethaby, the editor of the series, who wrote with enthusiasm about the aesthetic merits of medieval heraldry. Lethaby had been Principal of the Central School of Arts and Crafts when Kruger had been on the staff. Another member of staff at the School was Edward Johnston, whose calligraphic style of lettering has been closely imitated by Kruger on this cover.

George Edward Kruger fig.73
36. Rev. A.D. Crake THE DOOMED CITY
A.R. Mowbray & Co., 1911
187 x 131
Signed 'GEK', lower centre

See note to no.35.
Kruger has used here the heraldic device for a castle - a large gate-tower flanked by two lesser towers.

George Edward Kruger fig.72
37. Percy Dearmer THE DRAGON OF WESSEX
A.R. Mowbray & Co., n.d. [1911]
222 x 140
Signed 'GEK', bottom right

Rev. Percy Dearmer, married to the book illustrator Mabel Dearmer, had close connections with the Arts and Crafts movement.

As the incumbent at St Anne's, South Lambeth, he had commissioned Herbert Horne and Selwyn Image to decorate the church (1892-93). Dearmer edited Mowbray's 'The Arts of the Church' series, which included Rev. E.E. Dorling's *Heraldry of the Church* (see note to no.35).

William Brown Macdougall fig.40
38. THE BOOK OF RUTH
J.M. Dent & Co., 1896
247 x 185
Unsigned

The austere elegance of this cover design contrasts with the much richer and more elaborate designs and illustrations with which Macdougall embellished the text.

William Brown Macdougall fig.63
39. Sheila E. Braine THE LUCK OF THE EARDLEYS
Blackie & Son, n.d. (design used for more than one title, c.1905)
185 x 120
Signed 'M', foot of spine

Macdougall sometimes used strong verticals in a cover design to give it an architectonic structure, as demanded by William Morris. He was a Glaswegian, living at Dunoon when this design was probably commissioned, and he would have been acquainted with Talwin Morris who was Blackie's art director and worked at their Glasgow premises.

Fred Mason fig.35
40. Robert Steele HUON OF BORDEAUX
George Allen, 1895
227 x 176
Unsigned

As well as the cover, Mason designed ornamental pages in the style of the Kelmscott Press at the beginning of each chapter in this book. He was a member of the Birmingham group of artists whose decorative book illustrations had been approved by William Morris, and publishers sympathetic to the Arts and Crafts movement, such as George Allen, were keen to employ them.

82. Georg Belwe, 1911 (cat. no. 79)

83. Walter Tiemann, 1912 (cat. no. 83)

84. R.N. Roland Holst, 1893 (cat. no. 84)

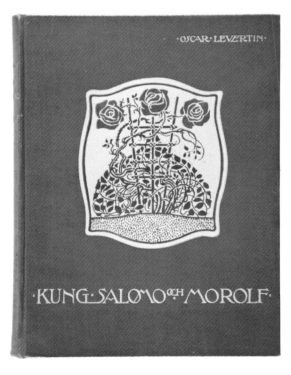

85. Olle Hjortzberg, 1905 (cat. no. 85)

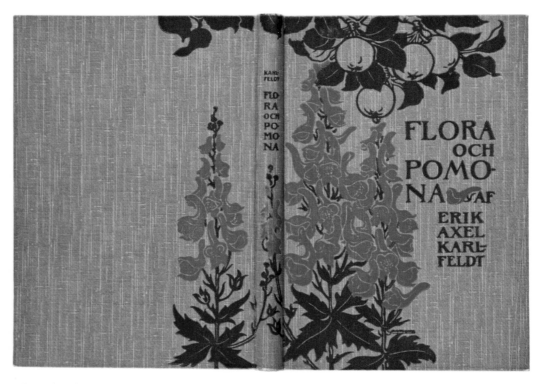

86. Lydia Skottsberg, 1906 (cat. no. 88)

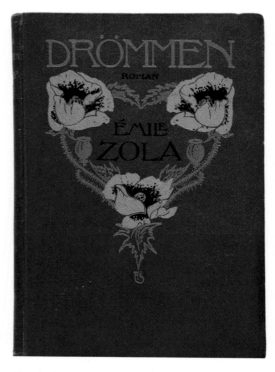

87. Arthur Sjögren, 1910 (cat. no. 87)

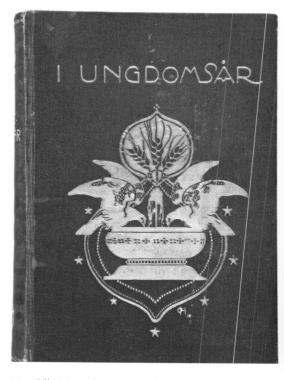

88. Olle Hjortzberg, 1910 (cat. no. 86)

Talwin Morris fig.61
41. F.A. Pouchet THE UNIVERSE
Blackie & Son, 1902
226 x 150
Signed 'TM' in monogram, bottom right

It is quite surprising that Blackie's deemed a cover designed in the progressive Glasgow style appropriate for a book aimed at the popular science market. Many of those who had received the benefit of the new statutory elementary education and could assuage their thirst for knowledge by reading this kind of informative literature, were drawn to this modern style because they identified the Arts and Crafts movement with William Morris's socialism, an ideology they often shared.

William Morris fig.4
42. William Morris LOVE IS ENOUGH
Ellis & White, 1873
206 x 144
Unsigned

At the time of this book's publication, Morris was engaged in trying to master the medieval art of the illuminated manuscript, and this simple design, radical in the context of High Victorian decorated book covers, is similar to the borders that he was giving some of the pages of his manuscripts.

William Morris fig.8
43. William Morris THE EARTHLY PARADISE
Reeves & Turner, 1890
216 x 143 (the same design is blind-stamped on the back cover)
Unsigned

The central motif indicates the extent to which Morris had assimilated Persian ornamental design by this date.

Harold Edward Hughes Nelson fig.74
44. R.L. Stevenson EDINBURGH
Seeley, Service & Co.,1912
258 x 194
Signed 'N', lower left
Nelson's early training as a heraldic artist is evident in this design. At this time, he was working at the Carlton Studio which was

managed by A.A. Turbayne, and his influence can be seen in the treatment of the thistles.

Edmund Hort New fig.22
45. Grenville A.J. Cole THE GYPSY ROAD
Macmillan & Co., 1894
199 x 126
Unsigned

E.H. New integrated the cyclists with the scrolled ornament in a very accomplished manner. The influence of William Morris's art on the alumni of the Birmingham School of Art was strong, and is clearly reflected in this design by New, who had been a student at the School since 1885, and in 1894 was still there as a teacher. In February, 1894, Morris had given an address at the School's prize-giving.

Edmund Hort New fig.43
46. Izaak Walton and Charles Cotton THE COMPLEAT ANGLER
John Lane, 1897
243 x 176
Unsigned

The pollarded willow and the architectural framework of this design express the idea of nature tamed, a theme at the heart of Arts and Crafts thinking.

Edmund Hort New fig.59
47. Francis Bacon OF GARDENS
John Lane, 1902
151 x 100
Signed 'EHN', bottom right

The book is one of many gardening titles published by John Lane round the turn of the century for which the naturalness and elegance of New's cover designs made his an appropriate style.

Edmund Hort New fig.66
48. Stopford A. Brooke POEMS BY WILLIAM WORDSWORTH
Methuen & Co., 1907
228 x 142
Unsigned

This book was published eleven years after the death of William Morris who had abhorred all historical styles since the Renaissance, and the

floral wreaths and swags of eighteenth-century decoration were beginning to enter the canon of Arts and Crafts design; Adamesque ornament started to appear in wallpapers, carpets, silverware and jewellery. Only the clumps of daisies and daffodils serve as a reminder that New's artistic roots were in the Arts and Crafts movement.

Lucy (Faulkner) Orrinsmith fig.6
49. THE WORKS OF ALFRED LORD TENNYSON (vol.6/7)
Macmillan & Co., 1884
187 x 125 (design extended over spine and back cover)
Unsigned

During the late 1870s, Lucy Orrinsmith's sister Kate Faulkner had designed a number of textile patterns for Morris & Co., and, like many of them, the design for this book cover is a 'net' pattern.

Charles de Sousy Ricketts fig.17
50. John Leicester Warren Lord De Tabley POEMS DRAMATIC AND LYRICAL
Mathews & Lane, 1893
198 x 128 (design repeated on back cover)
Signed 'CR' in monogram, top left, and marked 'LSH' in monogram (for Leighton, Son and Hodge, the binders), bottom right

Ricketts borrows for this design the metaphor of a petal for a poem from his friend Oscar Wilde, who wrote in 'To My Wife. With a Copy of My Poems':
> For if of these fallen petals
> One to you seem fair,
> Love will waft it till it settles
> On your hair
The cover was included in a display of Ricketts' covers shown at the Arts and Crafts Exhibition Society in 1893.

Charles de Sousy Ricketts fig.75
51. Michael Field MYSTIC TREES
Eveleigh Nash, n.d. [1913]
199 x 128
Unsigned
Ricketts gave his later book cover designs an architectonic geometry and an almost diagramatic treatment of the natural world,

which echo the style of the illustrations in the *Hypnerotomachia*.

Dante Gabriel Rossetti fig.1
52. Christina Rossetti THE PRINCE'S PROGRESS
Macmillan & Co., 1866
177 x 109 (design extended over spine and back cover)
Unsigned

The design suggests the iron hinges on a medieval door, and, when the book is opened, the frontispiece shows the prince entering through such a door into his lady's chamber. Rossetti was very concerned to get the thickness of the lines and the colour of the cloth right (L.M. Packer [ed.], *The Rossetti-Macmillan Letters* [1963] pp.38, 48-50, 54).

Dante Gabriel Rossetti fig.2
53. Dante Gabriel Rossetti POEMS
F.S. Ellis, 1870 (the same design was used on the poet's *Ballads and Sonnets*, published in 1880)
197 x 127 (design extended over spine and back cover)
Unsigned; marked 'DE LACY' (die-cutter), lower centre of back cover

Rossetti's letters to F.S. Ellis reveal the great amount of care and consideration that he gave to his cover designs. The colour of the cloth and even the colour of the gold were to Rossetti matters of great importance. The design set a precedent for the imitation of metal-mounted bookbindings using gold leaf stamped on cloth. It was exhibited at the first Arts and Crafts Exhibition Society show in 1888.

Silver Studio fig.44
54. F.B. Harrison THE BATTLEFIELD TREASURE
Blackie & Son, n.d. (design used for more than one title, c.1897)
188 x 123
Unsigned

A gouache on cartridge paper drawing of this design is in the Silver Studio Collection and is illustrated in *The Silver Studio Collection. A London Design Studio 1880-1963* (London, 1980) p.96. The design follows closely the

schema of the 1882 printed cotton 'Brer Rabbit', designed by William Morris.

Thomas Sturge Moore fig.76
55. A., E. and M. Keary ENCHANTED TULIPS
Macmillan & Co., 1914
187 x 123
Signed 'TSM', bottom left

An architectural framework and chequered decoration were common features of the style adopted by some late Arts and Crafts designers who favoured Byzantine over Gothic art.

Frederick Colin Tilney fig.10
56. Charles Lamb THE ESSAYS OF ELIA
J.M. Dent & Co., 1890 (design used on more than one title)
178 x 122
Signed 'F.C.T.', lower left

The style of Tilney's design suggests that he was a student or follower of L.F. Day. No fewer than three of his cover designs were illustrated in Gleeson White's seminal article 'The Artistic Decoration of Cloth Book-Covers' (*Studio* 4/19 [Oct. 1894] pp.15-23).

Albert Angus Turbayne fig.25
57. Frederic W. Farrar THE LIFE OF CHRIST AS REPRESENTED IN ART
Adam & Charles Black, 1894
232 x 142
Signed 'AAT' in monogram, bottom left

In 1904 Turbayne wrote that, at the outset of his career, the "want of good examples of severe readable types induced me to make a search for the same, and this search led me back to the early manuscripts and printed books." (*Alphabets and Numerals* [1904] p.ix). In the same book, he illustrates lettering of 1529 by Geofroy Tory which is close to the face used on this cover (ibid. pl.9, 10).

Albert Angus Turbayne fig.33
58. J.G. Frazer PASSAGES OF THE BIBLE
Adam & Charles Black, 1895
192 x 131 (design repeated on back cover)
Signed 'AAT' in monogram, lower right

Turbayne is here indebted to the decoration of Kelmscott Press books and their illustrations by E. Burne-Jones.

Albert Angus Turbayne fig.34
59. Captain Marryat JAPHET IN SEARCH OF A FATHER
Macmillan & Co., 1895 (design used on other titles by the same author)
187 x 120
Signed 'AAT' in monogram, lower centre

The elements of this design, most of them drawn from heraldic art, had been used by John Leighton in his design for the cover of W. Falconer *The Shipwreck*, published by A. & C. Black in 1858. Turbayne worked mainly for Black's, and his attention would have been drawn to Leighton's work by the *Book-Plate Annual & Armorial Yearbook*, edited by Leighton and issued by Black's in 1894 and 1895.

Albert Angus Turbayne fig.48
60. Jane Austen EMMA
George Allen, 1898
186 x 118
Signed 'AAT' in monogram, lower left

This design and no. 61 show Turbayne striving successfully to keep his writhing plants in order by confining them within geometrical shapes. In both designs a tension is created which makes them visually more interesting to look at. Turbayne has used lettering based on examples found in early sixteenth-century writing books (see A.A. Turbayne, *Alphabets and Numerals* [1904] plates 23-27).

Albert Angus Turbayne fig.54
61. Jane Austen SENSE AND SENSIBILITY
George Allen, 1899
186 x 121
Signed 'AAT' in monogram, lower left

See note to no.60.

Albert Angus Turbayne fig.65
62. Andrew Lang (ed.) POETS' COUNTRY
T.C. & E.C. Jack, 1907
241 x 163
Signed 'T', lower middle

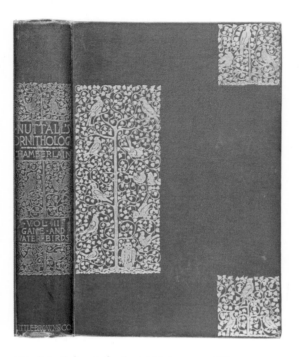

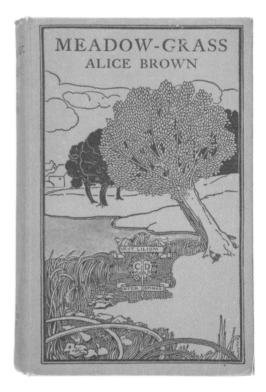

89. J.A. Schweinfurth, 1891 (cat. no. 98)

90. Louis Rhead, 1895 (cat. no. 96)

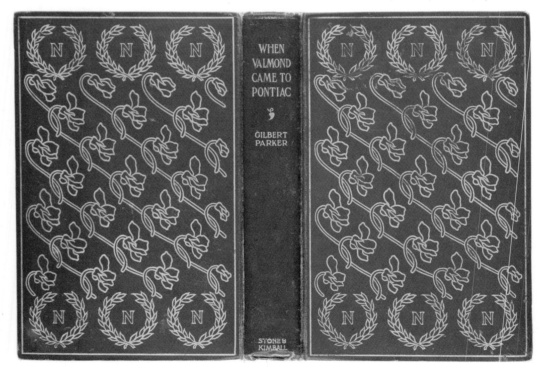

91. Bruce Rogers, 1895 (cat. no. 97)

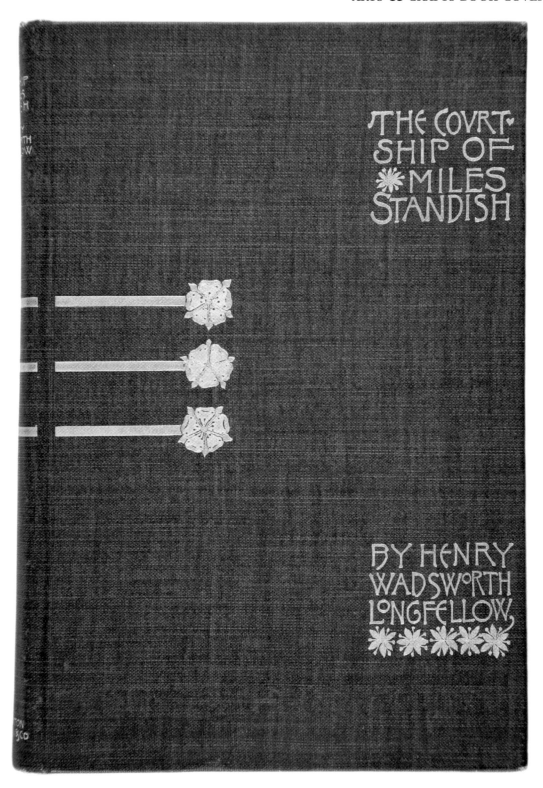

92. Sarah Wyman Whitman, 1896 (cat. no. 99)

As occurs so often in Turbayne's work, the success of this design depends on the contrast between natural growth and the architectonic setting which confines it; the circle serves to bind the whole design together.

Albert Angus Turbayne fig.68
63. Gordon Home YORKSHIRE (The 20s. [£1] Series)
Adam & Charles Black, 1908
228 x 158
Signed 'T', lower spine

The design on this cover, with its lettering running round the edges and its diaper infilling, is derived from medieval blind-impressed hide bookbindings of the sort which provided the model for the Doves Bindery binding of 48 copies of the Kelmscott Chaucer.

Charles Francis Annesley Voysey fig.19
64. Charles Holme and Gleeson White (ed.)
THE STUDIO volume 1(/2)
The Studio, 1893
291 x 203
Unsigned

Voysey's design concept may have been based on Walter Crane's design for the cover *The Claims of Decorative Art* (fig.12), published the previous year, and there may well have been some input from William Morris's lecture on Gothic book illustration which had also occurred the previous year.

Philip Webb fig.3
65. Eiríkr Magnússon and William Morris
THE STORY OF THE VOLSUNGS AND NIBLUNGS
F.S. Ellis, 1870 (design repeated on back cover)
197 x 128
Unsigned; marked 'DE LACY' (die-cutter) bottom left

There seems to have been confusion about the authorship of this design from the start. In Spring 1870 Rossetti wrote to Ellis and, referring to William Morris, he commented: "His binding for the Volsungs is most lovely - quite perfect" (O. Doughty [ed.] *Letters of Dante Gabriel Rossetti to His Publisher, F.S. Ellis* [1928] p.64). H.B. Wheatley, when he

exhibited the book at the Society of Arts in 1888, seems to have been under the same misapprehension. The attribution of the design to Webb was made in the catalogue of the Arts and Crafts Exhibition Society's first show later the same year. Vallance helped to dispel the confusion when he explained that the design was not "from Morris's pencil, yet it was made at his instance" (*William Morris* [London, 1897] p.379).

Joseph Walter West fig.26
66. John Davidson FLEET STREET ECLOGUES (2nd series)
John Lane, 1896 (the design was first used on the same author's *Ballads and Songs* [1894])
180 x 108
Unsigned

West's design reflects the current vogue for C.F.A. Voysey's decorative style which had been featured in some of the illustrations to a lengthy article in the September 1893 issue of the *Studio*.

Joseph William Gleeson White fig.16
67. George Saintsbury (ed.) THE POETICAL WORKS OF ROBERT HERRICK (Aldine Edition, vol.1/2)
George Bell & Sons, 1893
179 x 104
Unsigned

The onlaid panel of white vellum gives the book a handmade look which would have appealed to followers of the Arts and Crafts movement.

Joseph William Gleeson White fig.20
68. J.L.W. Thudichum A TREATISE ON WINES
George Bell & Sons, 1894
194 x 127 (design extended over spine and back cover)
Unsigned

White's design could be a rare instance (at this date) of a British designer being influenced by the work of an American artist, in this case Sarah Wyman Whitman. She had developed this style of cover design, inspired by metal-mounted bindings of the late Middle Ages, but having the lettering serve as the vestigial clasp or clasps (for

a late example of a Whitman cover design in this style, see fig.92). White had been associate editor of an American art magazine in New York (1890-91), and would have been familiar with Whitman's cover designs, some of which had anyway been used on the British editions of American books that she had designed.

Joseph William Gleeson White　　　fig.21
69.　Malcolm Bell SIR EDWARD BURNE-JONES
George Bell & Sons, 1894
296 x 206
Signed 'G.W.', bottom centre

In his October 1894 article on 'The Artistic Decoration of Cloth Book-Covers', White explained the advantages of reversed cloths. "In this way," he wrote, "....a strong blue [may] yield a cool greyish blue." Such is the cloth used here; the colour only shows in the interstices between threads, so that its strength is dissipated and the weave is visible. A preliminary drawing for this design is included in a collection of White's artwork held at the Houghton Library, Harvard University, Cambridge MA.

Joseph William Gleeson White　　　fig.31
70. THE GIRL'S OWN ANNUAL (vol.16)
The Girl's Own Paper, 1895
285 x 207
Signed 'GW', bottom right and foot of spine

Most designs on the covers of the *Girl's Own Annuals* had been more distinctly feminine, and evidently White's Arts and Crafts style design was not a particular success, for the following year (and most years after that) the cover designs reverted to being more appropriate to the readership.

Joseph William Gleeson White　　　fig.41
71.　Gleeson White ENGLISH ILLUSTRATION 'THE SIXTIES'
Archibald Constable & Co., 1897
265 x 176
Signed and dated 'G.W.1896', bottom left

Naturally White designed the cover of his own book, and the rich, gilt design stamped on a cream cloth give the volume an air of luxury and distinction. A drawing for the design is

among the collection of White's artwork held at the Houghton Library, Harvard University, Cambridge MA.

Joseph William Gleeson White　　　fig.42
72.　Anna Jameson SHAKESPEARE'S HEROINES
George Bell & Sons, 1897
210 x 135 (border repeated on back cover)
Signed 'G.W.' bottom centre

With this cover, White meets William Morris's demand - that nature or history should inform any design - by alluding to both in a single composition. The borders of briar rose have the natural freshness of the hedgerow, and at the same time the scrolling plants are arranged with the formal intricacy, which characterises the ornate border of the title pages in early printed books.

Patten Wilson　　　fig.37
73.　H.B. Marriott Watson GALLOPING DICK
John Lane, 1896
198 x 129
Signed 'P.W', bottom right

Albrecht Dürer was an artist much admired by the Arts and Crafts movement, both because he embodied the union of art and craft and because of his mastery of line and composition. Here Wilson pays homage, basing his design for this cover on Dürer's engraving 'The Knight, Death and the Devil'.

Paul Vincent Woodroffe　　　fig.56
74.　THE LITTLE FLOWERS OF ST FRANCIS
Kegan Paul, Trench, Trübner & Company, 1899
198 x 128
Signed 'PW', upper right

Soon after leaving the Slade School of Art in 1895, Woodroffe met Laurence Housman who strongly influenced both the style of Woodroffe's illustrations, and, for a time, his book cover designs. This cover, and another one for *The Little Flowers of St Benet* (1901), which was also published by Kegan Paul, are in the style of several covers designed by Housman, for example *Goblin Market* and *The Viol of Love*.

Paul Vincent Woodroffe fig.60
75. Israfel [Gertrude Hammond] A LITTLE BEAST BOOK
At the Sign of the Unicorn, 1902
207 x 139
Signed 'PW', lower spine

Against a background of scrolling ornament in the manner of title-page borders in early printed books, Woodroffe has arranged four heraldic beasts, with the lion and the bull acting as heraldic supporters to the title panel. For the Unicorn Press, see note to cat. no.16.

Paul Vincent Woodroffe fig.69
76. Arthur Ransome (ed.) STORIES BY EDGAR ALLAN POE (The World's Story Tellers)
T.C. & E.C. Jack, 1908 (design used on other titles in the series)
177 x 120
Unsigned

The clipped rosebush and the architectonic framework are characteristic of Arts and Crafts design. Nature which reflected human activity indicated the movement's belief in an ordered ruralism.

DENMARK

Gudmund Hentze fig.77
77. YNGRE DANSKE DIGTERE
Copenhagen, Christiania: Gyldendal/Nordisk Forlag, 1906
177 x 123
Signed 'gudmund hentze', bottom left

As an illustrator, Hentze usually worked in a style influenced by the English Pre-Raphaelite painters, and in the design for this cover he has used the Burne-Jonesian motif of the briar rose.

Kristian Kongstad fig.78
78. H.W. Longfellow DEN GYLDNE LEGENDE
Copenhagen, Christiania: Gyldendal/Nordisk Forlag, 1915
182 x 125
Signed 'k', lower right

Kongstad was influenced by the English private press movement and this Gothic design indicates his debt to William Morris in particular. In

1891, when Kongstad was teaching drawing at an art school in Copenhagen, *Tidsskrift for Kunstindustri*, the leading Danish decorative arts magazine had reproduced an illustration from the *Hypnerotomachia* which may well have drawn the attention of the young artist to the illustration of early printed books.

GERMANY

Georg Belwe fig.82
79. Erich Marcks MÄNNER UND ZEITEN vol.2/2)
Leipzig: Quelle & Meyer, n.d. [1911]
236 x 155
Unsigned

Belwe's lettering shows the designer trying to reconcile black letter and Roman types. A resolution of the controversy which raged among German typographers at this time seemed to be offered by the calligraphic letter forms developed by Edward Johnston. His work had been promoted in Germany by his former pupil at the Central School of Arts and Crafts Anna Simons, who had translated his seminal handbook *Writing & Illuminating & Lettering* (1906) into German.

Hans Eduard von Berlepsch fig.79
80. LIFE'S ROSES
Ernest Nister, n.d. [1898]
228 x 164
Unsigned

Von Berlepsch appears to have assimilated from the Arts and Crafts movement not only the conventional treatment of the rose but the use of old herbals as source books. He admired the work of Walter Crane, who had recommended the illustrations in sixteenth-century herbals which, he declared, "are not only faithful and characteristic as drawings of the plants themselves, but are beautiful as decorative designs" (*The Decorative Illustration of Books* [1896] p.97).

Friedrich Wilhelm Kleukens fig.80
81. Anton Kippenberg (ed.) INSEL-ALMANACH AUF DAS JAHR 1908
Leipzig: Insel-Verlag, n.d. [1907]
Design stamped on card
185 x 126

93. Will Bradley, 1896 (cat. no. 89)

94. Frank Hazenplug, 1897 (cat. no. 95)

95. Henry Hunt Clark, 1897 (cat. no. 90)

96. F.W. Goudy, 1901 (cat. no. 93)

97. B.G. Goodhue, 1901 (cat. no. 92)

Unsigned

For this cover, Kleukens has used the visual language of English Arts and Crafts design. Anton Kippenberg, who had taken charge of Insel-Verlag in 1905, was also an admirer of contemporary English decorative art, and he enlisted the help of Eric Gill and Emery Walker to design Insel-Verlag editions of the classics.

Walter Tiemann fig.81
82. Richard Dehmel HUNDERT AUSGEWÄHLTE GEDICHTE
Berlin: S. Fischer, 1909 [1908]
187 x 117
Signed and dated 'WT', in monogram and '08', bottom right

Both the typeface, which is related to the type designed by Emery Walker and Thomas Cobden-Sanderson for the Doves Press, and the ornament, which echoes some of William Morris's Persian-inspired designs, reflect the high regard Tiemann had for the English Arts and Crafts movement.

Walter Tiemann fig.83
83. Arthur Graf Gobineau DIE RENAISSANCE
Leipzig: Insel-Verlag, 1912
Paper-covered boards
221 x 138 (border repeated on back cover)
Signed and dated 'WT 1912', bottom centre

For this cover Tiemann has plundered the title pages of early printed books, a rich store of motifs often raided by English Arts and Crafts designers.

NETHERLANDS
Richard Nicolaas Roland Holst fig.84
84. Louis Couperus MAJESTEIT
Amsterdam: L.J. Veen, n.d. [1893]
210 x 156 (design extended over spine and back cover)
Signed 'RNRH' in monogram, lower right on back cover

The sunflowers and the thickish line suggest the influence of Walter Crane whose work was much admired in the Netherlands. An exhibition of Crane's work had toured the country a few months before this book was published in November 1893. The publisher,

Lambertus Jacobus Veen, had gained experience of the publishing trade working in London before he started his own firm in Amsterdam in 1887.

SWEDEN
Olle Hjortzberg fig.85
85. Oscar Levertin KUNG SALOMO OCH MOROLF
Stockholm: Albert Bonnier, 1905
226 x 164
Unsigned

Hjortzberg had been exposed to the work of English Arts and Crafts designers while studying art at the Stockholm Academy in the early 1890s, and his assimilation of the movement's visual vocabulary is affirmed by this cover. Throughout his career he would make use of Arts and Crafts motifs, usually treated in his own individual manner.

Olle Hjortzberg fig.88
86. A. Ohlden and A. Thomander (ed.) I UNGDOMSÅR
Köping: J.A. Lindblad, 1910
226 x 151
Signed 'OH' in monogram and dated '10', lower right

See note to cat. no. 85

Arthur Sjögren fig.87
87. Emile Zola DRÖMMEN
Stockholm: Fröléen & Co., 1910
225 x 150
Signed 'AS' in monogram, lower centre

Turning to book design and illustration around 1900, Sjögren produced a number of title pages in a style strongly influenced by the Kelmscott Press. This design, however, depends rather on the patterns that Morris designed for textiles and wallpapers.

Lydia Skottsberg fig.86
88. Erik Axel Karlfeldt FLORA OCH POMONA
Stockholm: Wahlström & Widstrand, 1906
208 x 141 (design extended over spine and back cover)
Signed 'L.SKOTTSBERG , lower centre

Skottsberg's treatment of flowers and fruit has the same level of conventionalization that the English Arts and Crafts designers used; naturalness has not been lost and a sense of growth is successfully conveyed.

U.S.A.

Will Bradley fig.93
89. Richard Le Gallienne THE QUEST OF THE GOLDEN GIRL
New York: John Lane, 1899 [1896]
195 x 126
Unsigned

In 1896, John Lane opened a New York office at 140 Fifth Avenue, and this was one of the first books he issued in America. By December, he was advertising "Chic Books for Chic Readers" in the American literary journals. Bradley's paraphrase (or parody?) of a Housman cover design suggests that the English artist's work was already well known in America.

Henry Hunt Clark fig.95
90. Kate Whiting Patch MIDDLEWAY
Boston: Copeland & Day, 1897
179 x 108 (design repeated on back cover)
Signed 'HHC' in monogram, bottom left

This design recalls Selwyn Image's cover of *The Tragic Mary* (fig.9), but Clark has reduced the arrangement of flowers to a much leaner, almost abstract, composition. Clark was a protégé of Denman Ross, a design theoretician who was a founder member of the Society of Arts and Crafts, established in Boston the year Middleway was published.

Thomas Maitland Cleland fig.98
91. Marjorie Bowen THE SWORD DECIDES
New York: The McClure Company, 1908
(design first used on the same author's *The Lily and the Leopard* [1906])
196 x 127
Signed 'C',

Aged sixteen, Cleland bought himself a copy of Walter Crane's *The Decorative Illustration of Books* (1896) which contains several illustrations of title pages from early printed books, where the ornamental vase of flowers is a motif which is often included.

Bertram Grosvenor Goodhue fig.97
92. John Franklin Genung STEVENSON'S ATTITUDE TO LIFE
New York: Thomas Y. Crowell & Co., 1901
194 x 124
Unsigned

This book was printed by Daniel B. Updike at his Merrymount Press in Boston. The same combination of Updike's talents as a printer and Goodhue's as a decorative artist had produced the *Altar Book* (illustrated by R. Anning Bell) which had been exhibited at the Arts and Crafts Exhibition Society's 1896 show in London.

Frederic William Goudy fig.96
93. George Horton THE TEMPTING OF FATHER ANTHONY
Chicago: A.C. McClurg & Co., 1901
194 x 124
Signed 'G', lower centre

Goudy was a regular visitor to A.C. McClurg's Chicago bookstore where George M. Millard, who ran the rare books department, showed him all the private press and limited edition books arriving from England. With its integration of knotwork and floral motifs, this design calls to mind the work of Laurence Housman, for example, his cover for *The Viol of Love* (fig.30).

Theodore Brown Hapgood, Jr fig.99
94. Neltje Blanchan THE AMERICAN FLOWER GARDEN
New York: Doubleday, Page and Company, 1909
300 x 200
Signed 'TBH' in monogram, bottom centre

While the bottom row of flowers between the vases echoes a similar row on the *Studio* cover designed by C.F.A. Voysey (fig.19), the overall configuration is an example of the inspiration that American as well as English Arts and Crafts designers found in the title pages of early printed books.

Frank Hazenplug fig.94
95. William Allen White THE REAL ISSUE
Chicago: Way and Williams, 1897 [1st edition 1896, without the Hazenplug cover]
175 x 114

Signed 'FH' in monogram, lower left

For this cover Hazenplug has variant of the diaper-patterned covers that Housman had designed for *The Viol of Love* (fig.30), *Green Arras* (fig.36) and other books. But, because White's was a book of realist short stories rather than romantic verse, Hazenplug has made his design of maize ears starker and he has chosen the complementary colours of blue and yellow rather than the 'Aesthetic' combination of green and gold.

Louis John Rhead fig.90
96. Alice Brown MEADOW-GRASS
Boston: Copeland & Day, 1895
179 x 108
Signed 'RHEAD', bottom right

Rhead has here borrowed a number of devices from Laurence Housman's design for the cover of *A Farm in Fairyland* (fig.28), published a year earlier. Both covers are stamped in black and gold on green cloth, both include areas of water rendered in gold, and both incorporate the publisher's signet in the design. Copeland & Day were the American publishers of the *Hobby Horse* and sold books printed at the Kelmscott Press.

Bruce Rogers fig.91
97. Gilbert Parker WHEN VALMOND CAME TO PONTIAC
Chicago: Stone & Kimball, 1895
174 x 110 (design repeated on back cover)
Unsigned

When Stone & Kimball moved their publishing operation from Cambridge, Massachusetts, to Chicago in 1894, Rogers was working in Indianapolis on the magazine *Modern Art*. He was commissioned by Stone & Kimball to design covers for two books, of which this was the second. The repeated initial 'N' within a wreath recalls the work of the sixteenth-century French bookbinder Clovis Eve, and the pattern of violets invokes the natural world - history and nature in a single, very Arts and Crafts design.

Julius A. Schweinfurth fig.89
98. Montague Chamberlain ORNITHOLOGY OF THE UNITED STATES AND CANADA (vol.2/2)
Boston: Little, Brown & Company, 1891
206 x 131
Unsigned

Schweinfurth has copied the configuration given by D.G. Rossetti to the vestigial metal mounts on the cover of his Poems (fig.2). Birds perched amongst dense foliage is a motif found in thirteenth-century Persian decorative art.

Sarah Wyman Whitman fig.92
99. Henry Wadsworth Longfellow THE COURTSHIP OF MILES STANDISH
Boston: Houghton, Mifflin & Company, 1896
201 x 123
Unsigned

Towards the end of the 1880s, Whitman, whose book cover designs reveal an admiration for D.G. Rossetti's work in this field, adopted his scheme of imitating the metal mounts found on old books. She had the inspired idea of placing the lettering of title and author's name in the position of the vestigial clasps.

98. Thomas Maitland Cleland, 1908 (cat. no. 91)

THE AMERICAN FLOWER GARDEN

NELTJE · BLANCHAN

99. Theodore B. Hapgood Jr, 1909 (cat. no. 94)

INDEX